Wings of Paradise

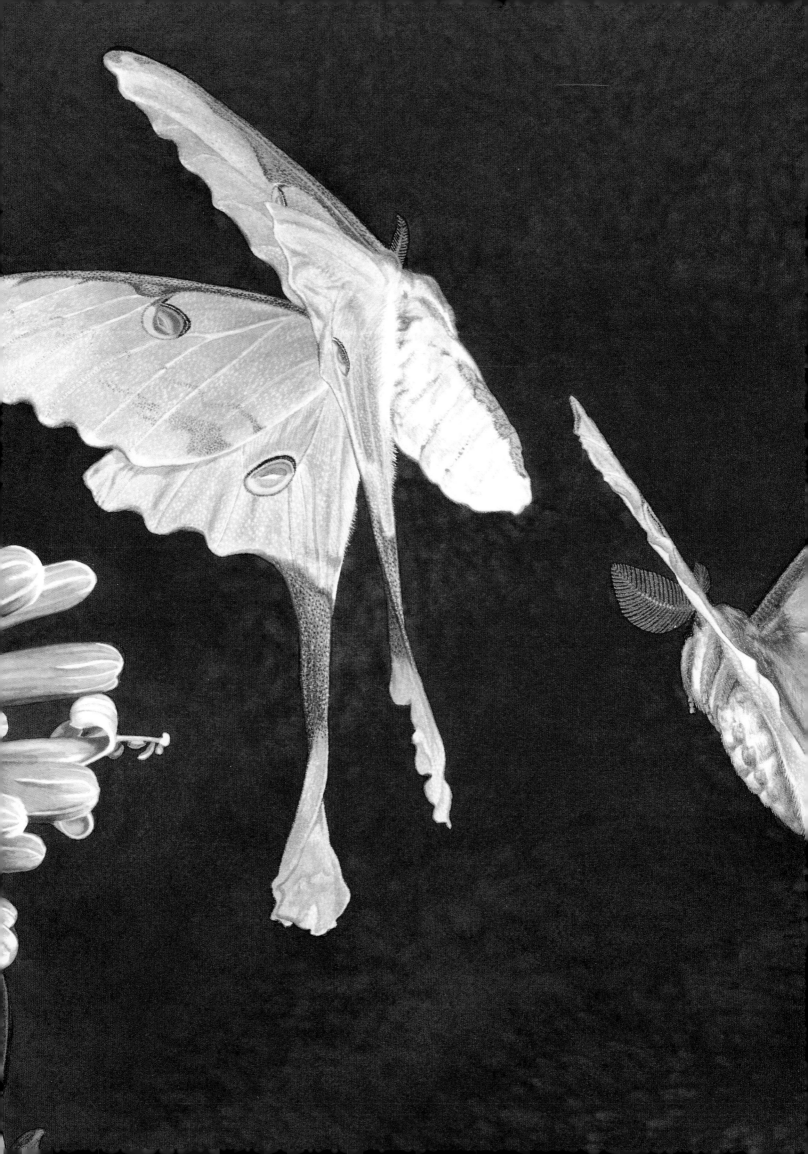

PAINTINGS & TEXT BY JOHN CODY

Wings of Paradise

THE GREAT SATURNIID MOTHS

The University of North Carolina Press 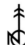 Chapel Hill & London

© 1996

The University of North Carolina Press

All rights reserved

Designed by Richard Hendel

Set in Monotype Garamond by Eric M. Brooks

Printed in Japan by Toppan Printing Company

The publication of this book was made possible

in part through a generous grant by Moore Tours

International Inc. of Hays, Kansas.

The paper in this book meets the guidelines

for permanence and durability of the Committee

on Production Guidelines for Book Longevity

of the Council on Library Resources.

Library of Congress

Cataloging-in-Publication Data

Cody, John, 1925–

Wings of paradise : the great saturniid moths /

paintings and text by John Cody.

p. cm.

Includes bibliographical references (p.)

and index.

ISBN 0-8078-2286-8 (cloth : alk. paper)

1. Saturniidae. 2. Saturniidae—Pictorial works.

3. Zoological illustration. I. Title.

QL561.S2C63 1996

595.78'1—dc20 95-47138

CIP

00 99 98 97 96 5 4 3 2 1

To

Zachary Ryan Shaiken

&

Ethan Cody Russell,

with love from Grandpa

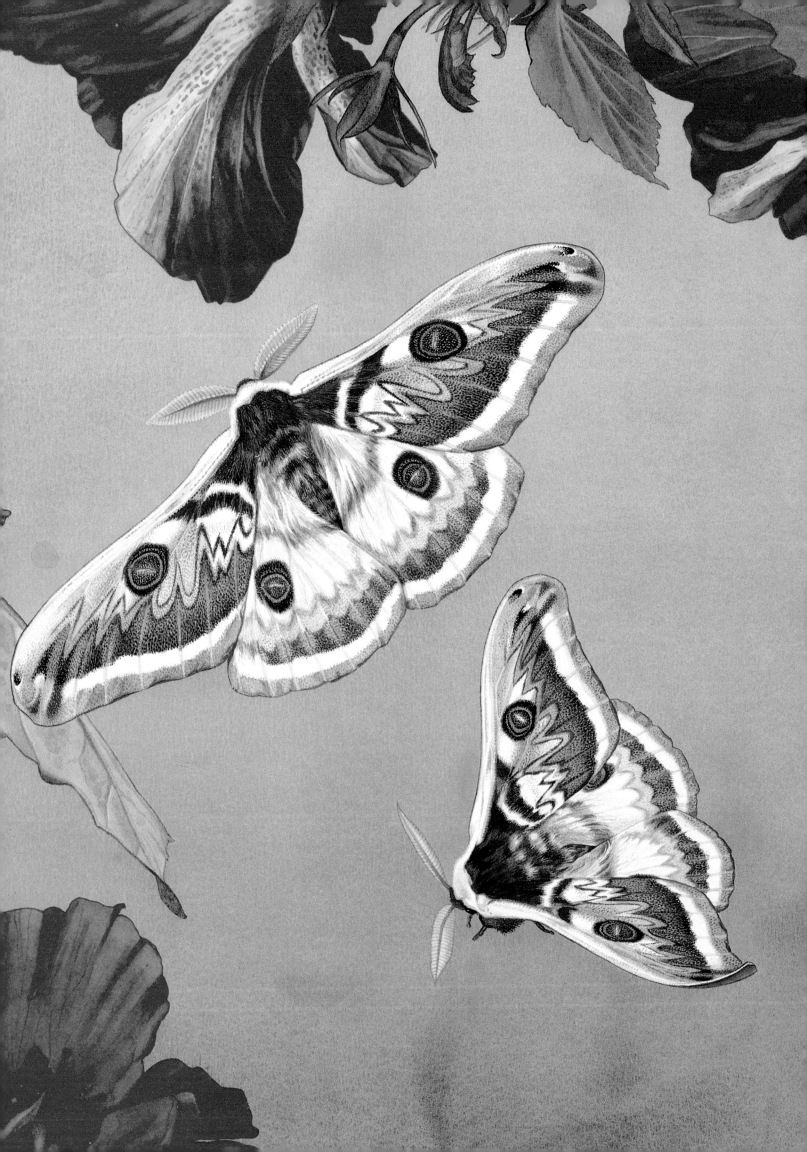

Contents

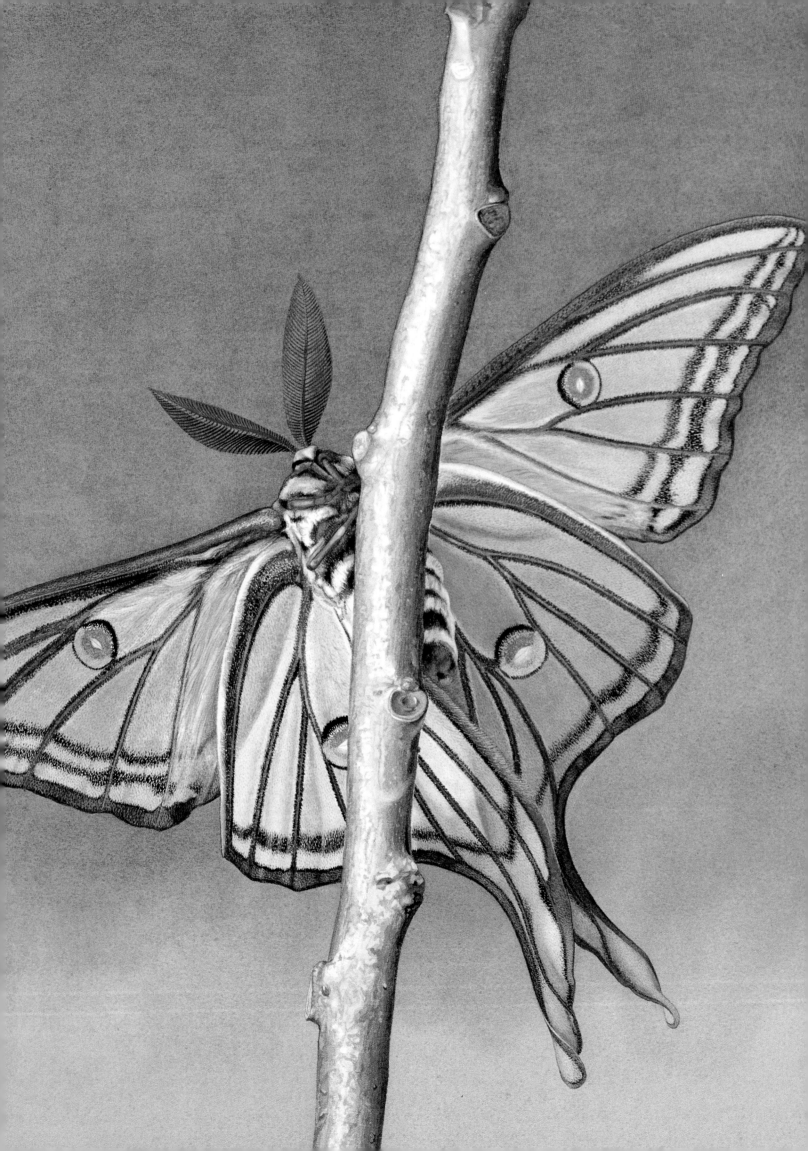

Acknowledgments

So many people over so many years, some now deceased and missed, have arranged exhibitions, given me specimens and cocoons, encouraged my painting, and provided essential aid in innumerable other ways, that it is impossible to name them all. I know that I cannot help but overlook some whose assistance and kindness I could not have done without. You know who you are, and if your name does not appear here please regard that omission as what it is — a failure of memory and not of gratitude and lasting appreciation.

My deepest thanks to Nancy Adams, Karl Alexander, Bob Ault, William Beebe, Barbara Beville, David Bigelow, Agnes Rand Bradley, John Brodsky, Petey Cerf, Florence Connolly, Rod Crawford, Ranice Crosby, Walter Ferguson, Joyce Gloeckler, Jim Gray, Len Hart, Edward Hayes, Richard Hesterberg, Mary Ann Hudson, Phil Humphrey, Daniel Janzen, D. P. Kaye, Otto Kernberg, Paulina Kernberg, James Langstaff, Charles Lacaillade, Mel Levy, J. P. McDonald, Marie McSwiggen, Brenda Meder, William Miller, Molly Monica, Brian Morris, Lawrence O'Reilly, Dorcas Hager Padget, Richard Peigler, David and Kate Pierson, Abe and Anne Rabinowitz, Brett Ratcliff, Lisa Rebori, Mark Schmidt, Paul Schulz, Leroy Simon, Steve Stone, Tom Swearingen, Edwin Way Teale, Kate Torrey, Gloria Vanderbilt, Edwina Walls, Mike Weissmann, William Wisner, Kirby Wolfe, and Fred Woodward.

My odd passion for painting moths would have come to nothing without the endless support of my family over many years — support from my parents, Ellen Langstaff Cody and Joseph Edward Cody, and from my brother Edwin and my four sisters, Eileen, Evelyn, Genevieve, and Ellen, all of whom have constituted an always dependable cheering section ever since their older brother was a teenager. I love them for it. They were essential to me.

Nor can my children be left out, as one's offspring are often as much an inspiration to their parent as the other way around. My daughters Loren and Andrea and my son Graham certainly fit this description. Moreover, they have always enjoyed my work and encouraged me by their enthusiasm.

Most important of all was, and is, my wife, Dorothy Casto Cody. In every way she has fostered my interests devotedly, steadily, and selflessly, with understanding and love. A great blessing descended on the moths and me the day she came into my life.

I want to extend a special thank-you to Moore Tours of Hays, Kansas, for underwriting part of the expense of publishing this book. Without this subvention it would have been all but impossible.

John Cody 1989

Foreword

I admired moths of the family Saturniidae long before I began to study them from a scientific viewpoint. A glass case filled with pinned saturniid moths, whether in a specimen cabinet or on the wall, cannot elicit any response but admiration. However, seeing these moths live, in their natural resting positions, is a much greater pleasure. I prove this to myself time and again in the museum setting in which I work: if I show a pinned moth, I get the expected response; if I show a live one, I get a much stronger response. Most of us will never have the opportunity to see most of the giant moths alive, but John Cody brings them to life for us nonetheless. He captures their intrinsic beauty in both color and pose. That is to say, his ability to combine anatomically accurate postures with colorful and balanced compositions results in an art that appeals to everyone, regardless of his or her background or sophistication. Each person who views Cody's paintings will admire them for a different suite of reasons and tastes. When I acquire a saturniid for study, I may be excited about the scientific questions it may answer or the value of adding a species not yet represented in the museum collection, but all such emotions are secondary to the pure and simple beauty of the specimen itself. To a susceptible person, the impact of a saturniid is lasting. I enjoy yellow roses and fried chicken immensely, yet I do not remember when I saw my first yellow rose or when I ate fried chicken for the first time. I do, however, remember my first luna moth, my first polyphemus moth, and my first cynthia moth.

Saturniidae are large and robust, usually colorful and attractively patterned, and docile enough to remain motionless as they cling to a branch or curtain. But the main feature of their appeal is that they are *velvety*, with wings like rich carpets and tufted legs attached to soft furry bodies, undoubtedly reaching the same deep human instinct we observe when a child holds a teddy bear. If soft and furry creatures have the advantage when it comes to choosing the focus of our conservation efforts, then the saturniids should be winners. None of my or anyone else's scientific publications on saturniids will ever reach the general public in any forum, but Dr. Cody's paintings have been doing so for years. We can only hope that his art will continue to bring widespread awareness and cause the average person to care about loss of tropical rainforests and to take time to observe the beauty in their own backyards (and some fine large saturniids do live in many backyards in North America).

Having studied saturniid moths for more than twenty-five years, I have a comprehensive knowledge of the literature on these insects. Books devoted solely to these magnificent moths and articles about them in scientific journals, both historical and current and in numerous languages, purport to show their splendor in paintings or photographs. In fact, saturniids have infrequently been painted. The art of Maria Sibylla Merian (1647–1717), for example, which includes several saturniids from Surinam, is often cited as representing the

acme of entomological painting and is much praised by modern writers. Yet I see her paintings as crude, inaccurate, and not at all lifelike. Except for the photographs of living saturniids by Kirby Wolfe and Leroy Simon, nothing I have seen approaches the lifelikeness of Cody's exquisite compositions. Indeed, until Cody, no insect artist had come up to the standard of Pierre Joseph Redouté in flower painting, or John James Audubon in bird art. Moreover, Cody's paintings are accurate from the scientific viewpoint. The moths rest upon, or fly past, tropical plants that are plausible backgrounds consistent with what exists in their natural habitats. Colors used by Cody for backgrounds and plants are selected to enhance the moth subjects. Although anecdotal, the narrative essays he has written here for each painting are full of exact scientific information. This book will serve a very diverse audience indeed.

Though never before taken with full seriousness as subjects for art, the Saturniidae are an obvious choice for any artist who favors natural history. How easy it would be for Cody to expand his artwork to include other highly colorful creatures such as sphinx moths and tiger moths (families Sphingidae and Arctiidae) or butterflies. Or birds. Yet he remains loyal to this one family of moths, so as not to dilute his mission. He is not content to sit at home in western Kansas studying dried specimens. He travels routinely to distant regions—New Guinea, Peru, Madagascar, Ecuador, Borneo, China, to name just a few of the places he has visited in recent years—and captures and photographs the moths in their native lands. Seeing the moths in nature not only adds a dimension of authenticity to his art but also gives him a solid grasp of the issues pertaining to loss of tropical habitat around the world. He hopes that by helping us to admire saturniid moths, he can make us want to save them from extinction. We hear that word "extinction" increasingly, but not, one hopes, to the point where we have become desensitized to all that it implies.

Saturniid moths have long been esteemed in many human cultures. Tarahumara Indians in the mountains of western Mexico make dance rattles from the cocoons of several saturniids; these rattles have special significance, because the Tarahumara believe that butterflies and moths are human souls reincarnated. The ceanothus silkmoth (*Hyalophora euryalus*) was associated with much power among Indians of central and northern California before their cultures were assaulted. This association is exemplified by the legend of the moth woman among the Maidu tribe, and by hand rattles made from its cocoons and used by shamans of the Miwok, Pomo, Yokuts, Maidu, Wintun, Yuki, and Mono tribes to cure sickness and in ceremonial dances. In southern Africa, Zulu and Swazi people still use cocoons of the African moon moth (*Argema mimosae*) to make dance rattles. The ancient Aztecs of Mexico believed the orizaba silkmoth (*Rothschildia orizaba*) to be the incarnation of Itzpapálotl, the evil goddess of human sacrifice and war, because the transparent, pointed markings on its wings resemble flint daggers. In ancient and modern times in Japan, China, and particularly India, the large cocoons of several saturniid moths have been used to produce wild silk fabrics. Many caterpillars of Saturniidae are eaten in Africa, South America, and New Guinea today, as are those of the pandora moth, which are still eaten by Paiute Indians in California. Over 125 postage stamps have been issued depicting Saturniidae, mainly by countries in Africa and Europe. Recognizable Saturniidae are sometimes seen in the art of China, Europe, and Indonesia.

Many readers of this book will not have an entomological background. The following paragraphs are offered in hopes that these readers will gain a deeper appreciation of the complex lives of these beautiful creatures and thereby enjoy Cody's art to a greater degree. At my museum I receive calls from the public each year asking about saturniid moths they have found; in Denver it is usually a cecropia or a polyphemus moth. I tell them various things, like what kind of trees the caterpillars feed on ("Yes, I have that tree here in my yard!"). The fact that surprises people more than any other is that the moths do not feed. They live only a few days, perhaps a week, on energy stored when they were caterpillars. Their mouthparts are underdeveloped, so they are unable to eat or drink. Most other kinds of moths and virtually all butterflies feed on nectar in flowers, providing an energy-rich source of carbohydrate that will prolong their adult lives by several weeks. Not with the saturniids: after emergence from their cocoons, the only goal of the males is to find females and mate, the only goal of the females is, after mating, to locate the appropriate hostplants on which to glue their eggs. Both parents die several days before the eggs hatch, so from an anthropomorphic viewpoint, all saturniids are orphans at birth. Care of offspring by parents is rare among insects, mainly occurring among bees and wasps. Putting the eggs onto the correct food that the caterpillars will eat is the mother moth's last—and only—act of parental care. It may not seem significant, but what chance would the tiny caterpillars have of crawling to the right tree or shrub if she had dropped her eggs in the grass? Considering the abundance of ants and spiders on the ground, one can appreciate that there would be almost no chance whatsoever.

Saturniidae are a family of moths comprising over 1,500 species, of which less than one hundred live in North America and only half a dozen in Europe. The majority fly in the tropics, which is where diversity of insects, birds, and plants is the greatest. Although there are several saturniids in Siberia, and the emperor moth (*Saturnia pavonia*) ranges to the North Cape of Norway, we know of none ranging into northern Canada or Alaska. Likewise, none are known from Cuba, Hawaii, Antarctica, Greenland, or the South Pacific. But saturniids are a conspicuous part of the insect fauna that arrives at artificial lights in many areas of the tropics and some regions of the lower forty-eight states. People in North America do not have to travel to Africa or South America to see large, exquisite moths.

Their habitats vary considerably. Saturniid populations flourish in the hardwood forests of eastern North America, the pine forests of the Southeast, and the coniferous forests of the Rocky Mountains and the Northwest. In the Great Plains, they are likely to be few and far between, in fencerows amid seas of agriculture and along streams and rivers where trees dominate. Several interesting ones fly in the chaparral communities of California. The deserts of the Southwest are home to numerous species, several of which are illustrated in this book. More surprisingly, a few species thrive in the urban environment, apparently better than they would in the countryside. When I visited Mexico City years ago, I found many cocoons and larvae of the orizaba silkmoth and the calleta silkmoth (*Eupackardia calleta*) on the pepper trees (*Schinus molle*), and cocoons of *Automeris cecrops* on the dwarf poplar trees along streets and in a park. I found a cocoon of the atlas moth (*Attacus atlas*) in the middle of the city of Bogor, on the island of Java. I have not been able so far to find out whether the ailanthus silkmoth

(*Samia cynthia*) lives mainly in cities in its native China, but in areas where it has been introduced, it lives *only* in cities—for example, Paris, Vienna, New York, Philadelphia, and Boston.

Despite the fact that some saturniids do well in cities, the chief threat to their populations is the sort of "development" performed by the chainsaw and bulldozer. As more land is urbanized or converted to agriculture, less habitat remains to support populations of the saturniids. Another way that human activity interferes with their survival is as follows. Many natural habitats are maintained by fire, such as the scrub oak areas of the Southeast and Northeast, the chaparral in California, and the moors of heath and heather in the British Isles. Without periodic natural fires, these places change into habitats that are no longer suitable for the saturniids they once supported. Nobody living in the scrub areas of California or Florida wants his home to burn, but such persons often fail to understand that the beauty that surrounds them is the result of fires. The British love their heathlands because they provide breathtaking spring flowers; and, assuming that these heaths are natural and original, they demand that all fires be extinguished. But centuries ago, many of these regions of Britain were oak forests, which were largely cut to build ships for the Royal Navy. Without fires, the moors will grow into birch forests. The emperor moth, Britain's only saturniid, depends on the heath and heather for its caterpillars to feed, and its range and abundance have likely *increased* in Britain in recent centuries because of human alteration of the habitats.

In the tropical rainforests, however, fires are not beneficial, and we cannot expect saturniids of these habitats to become urban dwellers or to thrive among areas devoted to agriculture. Extinctions are inevitable. No saturniid is known to have become extinct, but many are rapidly becoming endangered, especially in the tropics. I have seen abundant forest on Java, Sumatra, Borneo, Sumba, Sumbawa, and other Indonesian islands, but most of it is secondary forest. Some researchers believe that certain saturniid moths require primary (original) rainforest for their continued existence. Many of the regions where some of the biggest and most famous saturniids occur—Madagascar, the Himalayas, southeastern Brazil—are now severely impacted by deforestation.

Flying over the Great Smoky Mountains National Park, which straddles the North Carolina/Tennessee border, I see thousands of acres of habitat that is presumably safe from logging. However, the main threat to that area now is probably acid rain, a by-product of air pollution. If trees there begin to die, so will millions of caterpillars that would otherwise metamorphose into some of our finest saturniids: the regal moth, imperial moth, polyphemus moth, luna moth, and promethea moth, all illustrated on the pages of this book. Thus, we see that air pollution as well as deforestation can lead to loss of valuable habitat. Every plea to save habitat for the spotted owl, the giant panda, or the Bengal tiger is also a plea to save that same habitat for countless beautiful moths and butterflies.

Now that I have discussed the healthy and suffering habitats of the Saturniidae, I will move toward the life cycles they carry out within those habitats. Tropical saturniids may have a single generation per year but more often have two to four. These flight times of the adult and feeding times of the larvae are often synchronized with the wet and dry seasons. In the temperate regions—areas with four recognizable seasons—most saturniids have one or two generations

per year. Exceptions do occur, of course. In the Deep South, the luna moth has fully three broods annually; the first moths are seen as early as February and March. In the far North it will have strictly one brood per year. In most areas in between, we may expect to see luna moths in April and May and again in July or August. The spring fliers have spent the winter in their cocoons. The summer fliers spend only ten to fifteen days in their cocoons, and their offspring must have sufficient time to complete the egg and caterpillar stage, which usually takes about five or six weeks, before the first frosts in September or October. Others, like the cecropia moth, Glover's silkmoth, and the ceanothus silkmoth, all shown in this book and all belonging to the genus *Hyalophora*, have strictly one generation per year, although some researchers suspect that Glover's silkmoths in southern Arizona and western Mexico may have two broods per year. Either way, the cocoon is the stage that overwinters. The regal moth usually has only one generation per year, even in the Gulf states, so the adults do not fly until July or August, emerging from pupae that rested in the ground all winter and spring. Most of the big saturniids of Europe and Asia have one generation per year, but some in China have two.

Species like the magnificent buckmoth (*Hemileuca magnifica*), from the high plateaus of southern Colorado and northern New Mexico, have one generation every two years. This two-year life cycle is necessary because the short summers at the high altitudes do not allow enough time for a full generation. These moths (many species of *Hemileuca* and *Coloradia* in North America) spend the first winter as an egg or young larva and the second winter below ground as a pupa. Some hold over in the pupal stage an extra year or more, so genetic exchange does occur between the even-year and odd-year broods.

Oviposition (the word we entomologists use to mean the laying of eggs by a female insect) by saturniid moths is usually done on the types of trees or shrubs that will provide appropriate nutrition for their caterpillars to mature. This selection is done by smell, and the female moth in flight presumably flits from plant to plant, laying eggs only on the one or few types that are correct. The association between the insects and their host plants may reflect a relationship that goes back millions of years. For example, the green and yellow moon moths (the genera *Actias*, *Argema*, *Graëllsia*), examples of which are all depicted on the pages in this book, favor plants in the myrtle, witch-hazel, cashew, and ebony families. This is true of virtually every moon moth, from the luna moth of the forests of eastern North America, to the Malaysian moon moth of tropical Asia, to the African moon moth of the savannas of Africa. We believe that the stained glass moth (*Graëllsia isabellae*) is an exception that shifted to pine trees as its host when ice ages in Europe pushed it southward and exterminated its ancestral host trees. Since pines are copious producers of resin (exemplified by the amber jewelry we see from the Baltic region—fossilized resin from ancient pines), and so are the trees in the plant families mentioned above, this fact supports the hypothesis. Most caterpillars of Saturniidae feed on the leaves of trees and shrubs. None are borers into stems or wood or fruits, and almost none feed on grasses or herbs such as wildflowers. The eggs are glued onto the stems or leaves by the female when she lays them. Eggs are usually laid in masses, so that later we find small battalions of sibling caterpillars living in groups. The eggs normally hatch in a week or two, depending on the species and the temperatures.

The caterpillar chews its way out of the egg shell. It has a well-defined head capsule, on which we can easily see its chewing mouthparts. It is almost blind. The body has three segments behind the head; each of these segments, which together are called the "thorax," has a tiny pair of true legs. Behind the thorax are about ten segments of abdomen, half of which have a pair of fleshy false legs, called "prolegs." These legs have little hooklike claws used to hang on to a leaf or branch, even in the strongest wind. The larva's only mission is to eat and grow. Although caterpillars appear to be very soft, they do have an external skeleton and must stop feeding periodically to molt. Molting usually happens four to six times before a caterpillar is full-grown. It spins a silken pad on a twig, attaches its legs, and remains motionless for about two days. The old "skin" splits and the larva pulls itself out, shaking off the hard head capsule. A larger caterpillar hardens for a few hours and is then ready to feed and stretch its new outer covering to the limit again.

Saturniid larvae are remarkable in their diversity of form, color, and ornamentation. Some are smooth and green, like a tomato hornworm (which is not a saturniid but the larva of a sphinx moth), and these rely on escaping their enemies by camouflage. They usually rest on the undersides of leaves to stay out of sight of wasps or the sharp eyes of birds. Others mimic seedpods on their host plants. Protective form and coloration like mimicry and camouflage must often be accompanied with protective behavior such as remaining motionless during the day, feeding at night. It is not enough to look like a leaf or seedpod; the caterpillar must also act like one—that is, must be still for hours on end. The big caterpillars often betray their presence by the defoliation they cause, or the droppings we see on the sand or sidewalk below. You can prove this to yourself by stripping off leaves on a branch in summer and then watching for paper wasps or yellow jackets to hover around it seeking caterpillars.

Some caterpillars of the Saturniidae are armed from head to tail with stinging spines, resembling a cactus crawling along the branch. Examples of this category are all of the species of *Automeris* and *Hemileuca*, several of which Cody brings to us in his art. Yet the big spiny caterpillar in his painting of the hickory-horned devil is not in this group. It is harmless. Other saturniid larvae have no camouflage, but instead are very easy to see when they are resting and feeding on their host plants. This is because they obtain toxic substances from the plant and are therefore poisonous to predators like birds, monkeys, or rodents. Their coloration thus serves to warn predators away; scientists call it "aposematic coloration." Here we always see contrast like black-and-white, or black spots or stripes on a background of red, orange, or yellow. Well-known examples are skunks, coral snakes, poison-arrow frogs, wasps, bees, and monarch butterflies and their caterpillars. These animals *want* to be detected, and they rely on their coloration to prevent attacks. Many saturniids follow this pattern. The black-and-white larva of the roseate emperor (*Eochroa trimeni*) from southern Africa is a good example. Perhaps the bright colors of the adult moth indicate that the poisons of the caterpillar are carried into the adult stage. However, bright colors may not always be a sign of poisonous properties. For example, the brilliant yellow colors of many Saturniidae are for camouflage, to simulate yellow (dying) leaves.

Winter is a period when no leaves are available for food for larvae, except for ones that eat pine, for example. Moreover, most moths and caterpillars cannot survive freezing temperatures. Some saturniids overwinter in the egg stage, which therefore has a duration of several months. Adults of these species usually fly between late summer and early winter. However, the majority of saturniid species in temperate zones spend the winter in the pupal stage, in one of two ways. The first type is a naked pupa lying in a cell under the ground. After it has finished feeding and reached full size, the larva burrows into the ground, hollows out a small chamber, sheds its larval skin, and becomes a pupa. Most other moths that are not saturniids also pupate in this manner. The second type involves construction of a cocoon. A cocoon is a silken covering produced from the larva's silk glands to protect it during the pupal stage. Production of silk by a caterpillar is called "spinning," probably in allusion to production of thread on a spinning wheel. Cocoons may hang from twigs high in trees, be attached lengthwise along sides of twigs, spun among leaves, or affixed flat against a tree trunk or rock. When hanging, the caterpillar often reinforces the petiole of the leaf with silk so that it will not fall to the ground when the other leaves drop in the autumn. This silk band is called a peduncle. Cocoons hanging on trees are believed to be safe from ground rodents but perhaps more in danger from birds, which can eat the pupae within. However, the dead leaf or leaves in which the cocoon is wrapped may offer some camouflage, and the cocoon may swing when a bird pecks at it. An example of this type of cocoon is that of the promethea moth. Other cocoons spend the winter on the ground among dead leaves. The larva may spin its cocoon in the tree among green leaves, which then falls to the ground in autumn. Or it may descend the tree and spin its cocoon among dead leaves. Overwintering cocoons of the luna moth are always in leaf litter below the host plants on which the caterpillars fed. Cocoons of the polyphemus moth are sometimes spun in trees with or without a peduncle, or the larva may descend the tree and spin on the ground. So its cocoons can be found either hanging in the host tree or in leaf litter or dead grass below the tree. When descending the tree, polyphemus caterpillars always make their cocoons within a foot of the main stem or trunk of the tree, among dead leaves or against the trunk or a board.

Emergences of the moths from the pupae or cocoons are triggered by external stimuli. Longer days or warmer temperatures in spring are main factors. Autumn fliers respond to shorter days and cooler temperatures. A pupa of a luna moth has a clear "window" on its head to allow the brain to detect day-length. In cells deep underground, light may not be present and temperatures may not vary much, so an internal clock may be in operation. Sometimes moths emerge from pupae in our rearing cages at the time coinciding with the flight time in nature, regardless of the conditions we offer—proof of their remarkable internal timekeeping. Sometimes, especially in desert species, wetting pupae or cocoons stimulates moths to emerge.

The pupa is a rather helpless creature. It can move only its abdomen; it does this by twisting the segments, which are telescoped within one another. On the surface of the pupa, which varies from chestnut brown to almost black, features of the future moth are visible: imprints of compound eyes, antennae, wings, legs, and abdominal segments. Pupae within cocoons

have a rounded tail end. Those that occur below ground have a spike on the tail end called a cremaster, used to push the pupa up to the surface when the moth is ready to emerge.

The tissues of the caterpillar break down into a liquid from which those of the moth are formed. Upon emergence, the moth will break open the pupal shell to molt one last time, and then it will crawl to a support to spread its wings. It will never grow any larger. A moth that has just emerged from its cocoon has legs and antennae and body that are full-sized. The wings' colors and patterns are usually recognizable, but the wings themselves are tiny flaps; some authors say they resemble gill slits on a tadpole or a fish. The moth rushes frantically to climb up a nearby tree trunk or plant, then its wings expand and hang down. This must be accomplished within minutes, or the wings will harden completely or partially in the unexpanded state, and a moth that is unable to fly has little chance to mate and lay eggs. Many authors say the moths emerge wet and must let their wings dry, but the moths are usually dry when they emerge and simply need to expand the wings, which then harden, not "dry." We know that exoskeletons of insects and other arthropods can harden under water—this happens every time a crab or dragonfly nymph molts—so it makes no sense to refer to the hardening of wings of a newly molted moth as "drying."

The colors on the wings of the adult moths result from thousands of tiny scales, which under a microscope look like shingles or palm thatch on a roof. If the scales are rubbed off, the wings appear as transparent as those of a dragonfly or a bee. Even the "fur" on the bodies of the moths is actually elongated scales. Much has been written in many languages pertaining to the ecological significance of the countless features of color and pattern on the wings of Saturniidae. Much is obvious, and much is conjecture. Most is difficult to prove or to even test. Many of the wing markings that provide the great aesthetic appeal to the artist also appeal to the ecologist from a scientific perspective. Look at the paintings in this book that show moths with large eyespots on their hind wings. Notice that in each case, the forewings look like bark on a tree or dead leaves. When the moth rests by day, its forewings cover its hind wings. Suppose now a curious bird pecks at a resting moth because it looks like a potential meal. The moth immediately lifts up the forewings, causing two large, glaring "eyes" to open. Whether birds retreat in alarm or peck at the eyespot, we must assume that this defense is very effective. Otherwise, why would hundreds of different species of moths around the world have this general pattern? Incidentally, if the bird pecks at the eyespot, a large portion of the hind wing may be torn out, yet the damaged moth can fly and live out its brief life successfully. If the bird seizes the body of the moth, on the other hand, there will be minimal chance for the moth to survive. Virtually every one of the colors and patterns that we see on the wings of the moth is there for a reason, albeit unknown to us—to protect it from enemies, or simply reflecting some pattern fixed in the moth's evolutionary history and possibly no longer of protective significance.

The colors and patterns on the wings are not, however, used in mate location or recognition, as is often the case with birds and butterflies. Saturniidae locate their mates based on the sense of smell, usually in total darkness. The females emerge from their cocoons or pupae with a full load of eggs, which in most species is at least two or three hundred. They are usu-

ally not inclined to fly until they have attracted a mate, have mated, and then have lightened their load by laying some eggs, often on the same tree on which they themselves fed as larvae. As a female lays batches of eggs on trees, her abdomen gets smaller and she becomes lighter, so she can fly farther and farther. This dispersal is beneficial in that it spreads genetic variability, reducing chances of inbreeding in the populations of the moths.

But to return to the topic of mate location, the female protrudes, at her tail end, a soft gland that emits a scent. This odor is called a "pheromone," the name entomologists use for the chemicals that insects emit to influence each other's behavior. In the insect world, most communication is done chemically. For example, ants lay down a trail pheromone to keep each other on a single path. Bees and wasps emit an alarm pheromone when an intruder threatens their nest, immediately alerting all members of the colony of the problem. The saturniid females use a sex pheromone to attract males. Each moth species has a unique chemical or mixture of chemicals. Sometimes males of closely related species are attracted to a female. If two or more species having the same pheromone fly in the same location, the potential of hybrid matings is usually avoided by each species flying at a different time of day or a different season. The male moth can often detect a single molecule of the pheromone in the air, whereas even if the pheromone were densely permeating the air of a closed room, our noses could not detect it. The males fly in the direction of the wind. When they detect pheromone, they turn sharply at a right angle, with an even chance of going the right or wrong way. If the correct way is initially chosen, they continue to zigzag into the ever-smaller plume of pheromone until they reach the female. Experiments have shown that males can locate females kilometers away. Often, many males will reach a female, but she will mate with only one. The mating behavior usually takes place early in the night, but for some moths, like the promethea moth or the magnificent buckmoth, it occurs during the day. The males fly in bright daylight and may mimic butterflies or display warning coloration. Once moths are paired, their mating will last from half an hour to more than twenty hours, depending on the species. After mating, a male will seek another female, but a female will seek trees on which to lay her eggs. As I indicated above, the moths never feed or drink, and they die within a few days.

I have known John Cody personally for eight years. Fortunately for me, the wheat fields of eastern Colorado and western Kansas, although seemingly endless, form no barrier to our visits. Certainly, saturniid moths provide a basic common ground for our cooperation and friendship, but we always find many other unrelated topics for thought-provoking discussions. I am delighted to accept the invitation to write this foreword, mainly as an opportunity to document my certainty of the permanent significance of his work for all of us who hold the highest veneration for these moths. Saturniids have been good for John Cody, and if his work contributes toward a widespread appreciation and desire to conserve them, as I believe it will, then he has been good for them.

Richard S. Peigler, Ph.D.
Denver Museum of Natural History

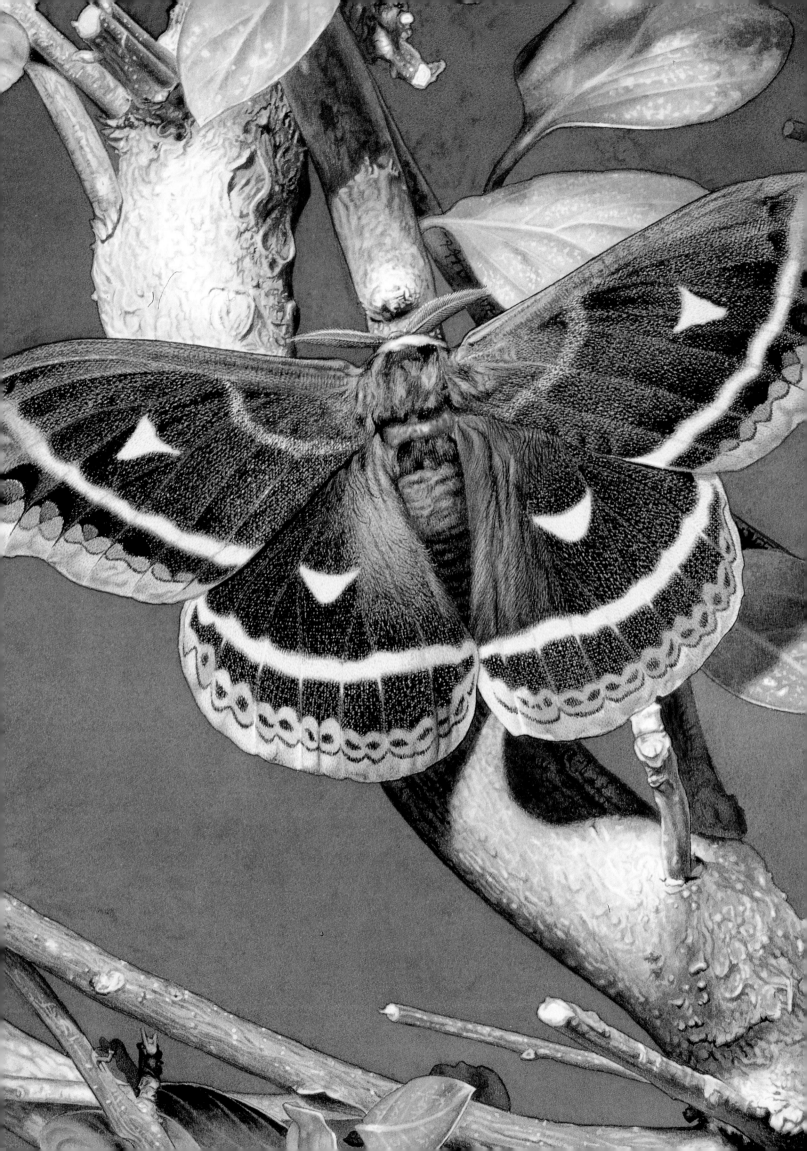

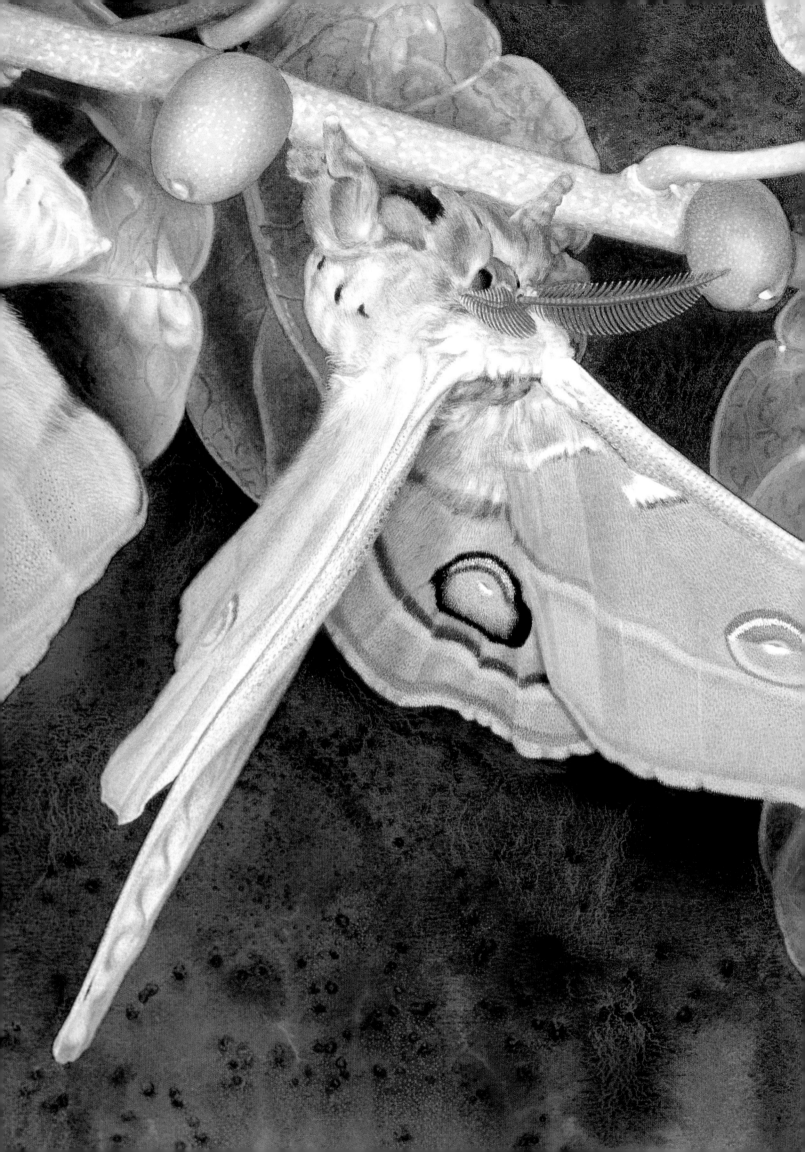

Introduction

Insects, with the exception of butterflies, are not often chosen as the focus of artistic attention. Moths, in particular, have never held a high place in public esteem, and the preponderance of artists stick with what is esteemed. Hence the rarity of moth depictions. As with many entrenched attitudes, the Bible set the tone. Centuries ago it made the moth a symbol of loss and decay, lumping it with thieves and rust. Given this long-standing reputation, why would anyone spend a lifetime painting such pariahs? Whatever the answer, moths were the sitters for every portrait in this book, and there is not a butterfly among them. This naturally raises a question about the artist: how come?

My field is not entomology but psychiatry. I had a course in entomology in college, taught by a brilliant teacher, Charles William Lacaillade, but that is the extent of my formal training in that science. Except for the silkmoths, I was not otherwise fascinated with insects.

I never went to art school, either—at least, not as a regular student. I loved the art of past centuries, but, with certain exceptions, I rarely thrilled over the work of my contemporaries. I never admired Pablo Picasso; I did not want to paint like Willem de Kooning, Jackson Pollock, or Robert Motherwell. From my earliest years, though, from before I entered the first grade, I wanted to make likenesses, in pencil or crayon, of the silkmoths that I knew, especially the cecropia. I thought them the acme of beauty.

Most medical school graduates who enter specialty training in psychiatry, whether or not they have personal problems, hope to learn to understand themselves better, along with understanding other people. During my training, and in the many subsequent years in which I practiced psychiatry, I did to some extent achieve those goals. I learned much about myself, about how I came to have my quirks and hangups. But I never gained any "depth knowledge" as to why, all my life, I have painted moths.

Nobody knows why ducks and skunks and other mammals, right after they are born, accept as their mothers the first thing that moves. My niece often has a live barn owl on her shoulder. She fed it as a tiny hatchling, and now that it is a mature bird, it will hardly let her out of its sight. This is "imprinting," a word that covers a lot of ignorance. Freud said that psychoanalysis could not explain why and how artists make art. Perhaps, somewhere along the line, they are imprinted.

The enduring impulse to paint moths, for one who must make a living, is embarrassing and inconvenient. It is like having a barn owl on one's shoulder.

When I was twenty I did not realize this. I was familiar with the flower paintings of Redouté, having been deeply impressed by an exhibition of them at the Frick Gallery. I knew that French aristocrats had provided him with an income for life on the condition that he keep doing what he did better than anyone else. I was encouraged also by the experience of

Audubon, another artist I deeply admired. I knew he had a tough time at the outset. Along the way he found enthusiastic engravers, publishers, and patrons and went on to acclaim and enough money to prevent starvation.

If Redouté could do it with flowers, and Audubon with birds, I thought, why not John Cody with moths? At the time, I did not consider that people have always known and loved flowers and birds. But what moths do they know by name? Only the clothes moths and gypsy moths.

I was realistic about my abilities, I believe. I knew I could not paint as well as Redouté and Audubon, but I knew that their skills matured as they did. In Los Angeles there is a still life in oils by Audubon that is so atrocious as to be an inspiration to all struggling artists. If I persisted in my moth painting—and there never was any doubt in my mind about that—I thought I would eventually be able to paint moths as well as anyone ever had.

By my twenties I had done a little research in that area of art that I had come to think of as my special preserve. I concluded, with the thrill that seizes all pioneers, that nobody had ever devoted himself seriously to the painting of moths! There had been a number of painters who concentrated on butterflies. One was the Englishman Benjamin Wilkes, whose books and colored plates appeared in the 1740s. Another painter I discovered was the English generalist Dru Drury, whose paintings of a wide variety of insects, including butterflies and moths, appeared in his book "Illustrations of Natural History" (1770). The most widely acclaimed natural history painter I learned of was Maria Sybilla Merian (b. 1647 in Germany), who published *Insects of Surinam*. Even today experts declare her plates "magnificent."

I scrutinized them, searching for the magnificence. The insects looked stiff, as though preserved specimens had somehow blown out of their cabinets and sailed around still mounted on their pins. The bodies had a generic look. With just a touch here and there they could easily have passed for those of wasps or grasshoppers.

I was immensely encouraged. If the experts thought those plates admirable, they might find some merit in mine. My own drawings seemed to me more lifelike than Merian's.

By the time I reached college I had acquired some facility with watercolor. It became and remained my favorite medium. In Good Shepherd grade school in Brooklyn I had taken occasional after-class lessons at fifty cents each from Catherine Quinn, our one-hour-a-week art teacher. Miss Quinn, a thin, quick, nervous woman who had an aversion to insects, tried unsuccessfully to steer me away from moths. When I think back to those depression times, I realize that fifty cents represented a real investment on my parents' part.

At about age ten, I started as a "wildlife painter." I was much ahead of my time: my first watercolor featured a wolf, now a ubiquitous subject. I had never seen one in the flesh, alive or stuffed. I depicted it at sunset—a many-splendored thing—under an erupting volcano surrounded by palm trees. Head thrown back, he howled at the riotous sky, for which I do not blame him. When my mother put him in a gold frame placed on an end table, I was overwhelmed. It was as though I were branded permanently with the letter *A*—for "artist." There he stayed for some time until one day he vanished forever without a trace, the mysterious way of things when my mother had enough of them. But by then I had moved on to moths, so I did not mind, and her initial enthusiastic approval had been a great stimulus.

As late as age five, I was innocent of moths. Until my first encounter with one, I thought the most beautiful thing I had ever seen was a perfect circle colored yellow. It was on the cover of a book in a store window. I suspect it was a mathematics book, perhaps geometry. I pleaded with my parents to buy it for me, and I felt I could not survive without it. Considering the year—1930—it would be surprising if my parents had had a spare penny to throw away. They ignored my tears and begging and tried to explain that the book's subject matter was unsuitable to my five-year-old intellect. But I continued to long for it and ran to that store window every chance I got. I can recall vividly peering at that so absolute thing, my face pressed to the glass. The perfection was not only in the roundness but also in the black outline encompassing the yellow, and the way the yellow was so exquisitely contained. It was years before it occurred to me that that flawless thing was the product of some draftsman's hand.

No eclipse dimmed the miracle of that yellow circle until the day a cecropia moth took me by surprise. But before I get to that, I must say something about giant silkmoths, of which the cecropia is one.

THE GIANT SILKMOTHS

Classification is always a confusing area to nonspecialists. Entomologists have named the family to which these moths belong Saturniidae, part of a superfamily named Bombycoidea. The family also has three subfamilies: Ceratocampinae, Hemileucinae, and Saturniinae. These subfamilies are divided into tribes. Consider the plight of the luna moth, one of the loveliest of our American saturniids. It is placed in the family Saturniidae, the subfamily Saturniinae, and the tribe Saturniini! To make matters worse, nobody knows how to pronounce these names.

When entomologists try to pronounce "saturniidae," "saturniinae," and "saturniini" distinguishably, one hears plenty of "sats" and a lot of "knees" or "neighs." Roman Catholic Church Latin, for example, is pronounced as though it were Italian. My own Latin is medically derived and therefore the most bastardly of all. I call these moths "suh-TURN-ids," and in all the "saturn" words I put the accent on the "turn," not troubling about the double *i*. As some eminent entomologists do the same, I do not feel on shaky ground. So suh-TURN-ids it is.

Furthermore, the names and classification are under incessant revision. Today's names are likely to be out of vogue next year, and back in again the following. One of the reasons for the popularity of revising nomenclature and reorganizing taxonomy seems clear: it is work that can be done by day in the office. Studying the live insects in their habitats is night work conducted in heat and humidity, amid mosquitoes. Saturniids are mostly creatures of the jungle. Many lepidopterists who do not go to jungles do observe the insects firsthand, however, by raising the exotic caterpillars in screened-in enclosures in their gardens.

As insect families go, the Saturniidae family is a small one, comprising, according to recent estimates, around 1,500 to 1,600 species. Of all butterflies and moths, known collectively as

the Lepidoptera, Saturniidae contains the largest, most impressive specimens. There exist a few huge butterflies, notably the female birdwings of New Guinea, eastern Indonesia, and northern Australia, but the atlas moth and hercules moth—both saturniids—surpass them.

Moths undeservedly have a bad reputation. I often give talks on the subject at schools, from first grade on up. It is second nature for me, as a psychiatrist, to begin by asking for associations: "What is the first thing that pops into your minds when I say the word 'moth'?" The answer is always the same, embodying the idea of destruction, especially in reference to clothes. I allow dismay to register on my face. "Suppose," I propose to the students, "I had just returned from Mars after giving a talk to the inhabitants. Imagine I had asked these Martians, what is the first thing that pops into your minds when I say 'human being,' and all they could come up with was 'war'? Would that strike you as fair? Well, that's what you're doing to the moths." I remind them that for over four thousand years moths have *made* more clothes for the human race than they have ever destroyed.

This brings me to the salient characteristic of the saturniids. They are the silkmoths. (*Bombyx mori*, the commercial silkmoth, is, ironically, not one of them.) Cocoons from various species come in many colors and textures. *Bombyx mori*'s is like a cream-colored or golden spool of thread, and, spool-like, it unreels readily. It is in this easy unreeling that it differs most from saturniid cocoons, which vary greatly in density and in the quantity of silk they contain. Like the three little pigs, not all saturniid caterpillars build equally sturdy houses. The cecropia builds a tough, double-walled cocoon capable of keeping out wind, rain, and cold (though not the occasional predator in the form of a hungry bird). In contrast, the io moth, another American species, builds such a flimsy and papery cocoon that the pupa—the stage between the caterpillar and the adult moth—often falls out! Despite this, the io must be a favorite of nature. Unfair as it seems, the io consistently outnumbers that conscientious master builder, the cecropia, now rare and getting rarer (though there are still pockets of abundance, such as the suburbs of Denver).

It is a bit misleading to refer to all the Saturniidae as silkmoths. Many species have lost the ability to secrete silk, and many non-saturniids, including a couple of atypical sphinx moths, spin silk cocoons. Those saturniid caterpillars that do not undergo their metamorphosis in a silken chamber adopt the ascetic alternative of burrowing into the ground and hollowing out a cell for themselves.

Nothing about the saturniids—not their size, their beauty, their silk-making, their metamorphosis, or the sad dwindling of their numbers worldwide—impresses young audiences quite like another fact: these moths do not eat or drink. They cannot, because they have no mouths, and no functioning digestive systems at all.

This bit of news strikes teenagers as a horror beyond comprehension. That hunger and thirst and a constant search for food may keep most creatures from enjoying life never occurs to them. Emily Dickinson speaks of herself as a child "with food's necessity upon me—like a claw." The saturniids are almost unique in being free of that claw.

The question of what moths are good for is a frequent one. Perhaps one should ask what flowers are good for. The two questions are comparable. The adult moth is the efflorescence

of the species' life cycle. It bears the burden of beauty as an adjunct to its reproductive functions. Its purpose, therefore, is the same as the blossom's for the plant—that is, to reproduce the species. The comparison with flowers is not far-fetched. Besides being both beautiful and reproductive, the moths also resemble flowers in that they are short-lived. Indeed, there are many flowers—orchids, for instance—that last much longer. The moths emerge from their transformation chambers full of energy stored in the form of readily burnable fats. The supply lasts precisely long enough for them to provide for another generation. This means, for the male, the finding of a mate, and for the female, the finding of suitable foodplants for her caterpillars. On these plants she lays her eggs. Unburdened with the need for nourishment, saturniids have but a single focus: sex. For this purpose they are not reluctant to squander their energy, and they live as though there were no tomorrow. And for them there mostly isn't. Their maximum span of life is a week. During that time they fulfill nature's purpose to perpetuate itself. *That's* what they are good for.

I am surprised that these short, passionate lives do not strike people as romantic.

There is much more to be said about the saturniids, but I am not the one to say it. Those interested in the scientific fine points should consult the publications of bona fide entomologists.[*]

[*] See, for example, Seitz and Gaede, *Macrolepidoptera of the World*; Michener, "Saturniidae of the Western Hemisphere"; Lemaire, "Les Attacidae américains"; Peigler, "Attacus"; Stone, "Foodplants of World Saturniidae"; and Wolfe, *Copaxa of Mexico*.

MY "IMPRINTING"

All I have ever really cared about is the *beauty* of saturniids. In the eyes of trained researchers, this is wholly subjective and not amenable to scientific inquiry. When they find that I ignore any insect that is not beautiful, no matter how fascinating otherwise, they are scandalized. But that's an artist rather than a scientist at work. There are even some saturniids, though not many, that I am not eager to paint. If I was "imprinted," it was magnificence of form, color, and texture that made the impression—which brings me back to my encounter with the successor to the yellow circle. What I have to say in reviving that incident applies to practically all saturniids.

The moth, dust or less for some six decades now, is as alive in my memory as if I had met it yesterday. We lived then in a large apartment house called Flagg Court in the Bay Ridge section of Brooklyn, near Fort Hamilton. These many-storied buildings were new then, and the maple trees that lined the adjacent streets cannot have been there long. The diameters of their trunks did not exceed four or five inches. One day in May, close to my fifth birthday, I saw a patch of color on one of the trunks, just a little above my eye level.

At first I took it for a butterfly. The wings were shaped like that and had similar colorful, symmetrical markings. But certain discrepancies gave me pause and made me cautious. First of all, it was enormous, far larger than the tiger swallowtails that, until now, were the largest butterflies I had ever seen. It also had a different kind of body—big, plump, covered with fur like a kitten, but softer-looking—not at all like the skinny, crusty, bug-bodies of butterflies. I saw that it had a red fur cape across its back and red circles down its sides and that these markings were surrounded by snowy white fur. From behind its head came two large dark

"feathers" that projected forward. I thought of a moose head that I had seen at one of the beer joints my father frequented. "This butterfly has antlers!" I thought in awe.

As I observed it, I crept closer, holding my breath, slowly and very carefully, so as not to scare it off. I had done the same with butterflies many times. Experience had taught me that the closest you could get was almost always a couple of feet, then they would fly away. So I stopped at two feet, my eyes fixed on this wholly new creature. It moved its wings peculiarly. The front wings resembled a huge, expanded cape on the animal's "shoulders." Gently and rhythmically it "shrugged," raising the wings, bringing them backward over its back, and then settling them flat again. It repeated this mesmerizing motion over and over in the calmest way until my eyes glazed over. I realized that my nearness was not making it nervous, and I sensed that I might get even closer. I crept forward again until finally my nose was less than a foot away.

I think it was at that point that the full beauty of the moth overwhelmed me. I did not, of course, have the words to describe what I saw and felt. I certainly would not have been able to explain it to anyone. Beauty, as a concept, has yet to dawn in the five-year-old-mind. What I saw was a tapestry of the richest fabrics and shades. Having the experience without the vocabulary, I saw ermine, velvet, brocade, and embroidery all intricately worked together into a marvelous design. I marveled at how substantial the wings were, how unpapery, how soft and textured their surface. I saw the short, plump, fur-covered legs, more like those of a mammal than of an insect, and of such a red! And on top of it all, the moth, like all members of its genus, smelled like fresh peanut butter! I had seen perfection.

Fear mixed with my admiration.

The creature stood its ground! It refused to fly. It did not budge, no matter how close I got. Was it brave, I wondered, because it knew it could defend itself by biting or stinging? It could not, of course—it was totally harmless and vulnerable—but it looked dauntless. I wanted to feel the soft fur but decided I had pushed my luck far enough. I didn't dare touch it, not knowing what it might do. I just looked at it worshipfully for minute after minute—a very long time in a child's view of time. They were powerful minutes. They have colored all my remaining years.

My parents called me away and took me somewhere with them. All I could think about was this apparition and my eagerness to get back to it and admire it some more. I do not remember where we went. It seemed that we were away an endless time. As soon as we got back home, I rushed to the tree. Some older boys were gathered around. Fragments of wings were blowing here and there on the sidewalk. They had beaten the creature to pieces with sticks. The furred body lay crushed on the sidewalk, demolished by the stamp of a foot. Nothing of beauty remained. Beauty, I learned, was a passing thing. I was certain that the boys had destroyed the only creature of its kind in existence. I thought I would never see another one as long as I lived. I went to bed mourning.

Now the minitragedy is happening all over again, but on a global scale. Wherever one goes—Borneo, India, the Amazon, and especially our own East Coast—the story is the same. The big moths are vanishing. One doesn't see their cocoons on the trees anymore. They do not come to the lights the way they used to. Young people in Brooklyn say they have never seen a cecropia. Old people say they haven't seen one in years.

It is not boys with sticks to blame. Today's threat is more insidious and subtle—in fact, nobody knows exactly what it is, which makes it more disturbing. Is it acid rain? Or too much man-made light at night, so-called light pollution?—for moths are notoriously vulnerable to light. Deforestation has much to do with it, as no creature can survive without its habitat, and moths are mostly jungle creatures. What about pesticides, or the greenhouse effect? Did viral experiments conducted a couple of decades ago against the gypsy moth go awry and spread a deadly plague to the harmless saturniids?

I am ahead of my story. I did not begin painting moths to draw attention to their dwindling numbers, although that has increased my motivation in recent years. At the start I just wanted others to see how wonderful they are.

THE AUDUBON OF MOTHS

Beginning at about age nine or so and into my twenties, I seem in retrospect to have been crossing a stream, on the far side of which was my goal of becoming "the Audubon of Moths." A whole series of loving people miraculously appeared just when I needed them, like rocks forming a way across the water. At the near shore were my parents. Then came my uncle, Edward Hayes. He got me my first cecropia cocoon by repeatedly throwing a broom from three stories up at a cocoon-laden sycamore twig until it finally snapped and fell to the areaway below. Next was (literally) the girl next door, Agnes Rand, who knew a lot about moths and showed me how to find the cocoons of a number of species. Agnes liked to draw and paint, and together we drew the moths in pencil and even occasionally tinted them with watercolor.

My first formal exhibition took place in 1941, while I was attending James Madison High School. At this time the cecropias and other silkmoths were abundant. Florence Connolly, one of my art teachers, saw my pencil drawings and, to my astonishment, praised them warmly; her words brought embarrassing tears to my eyes. She took them home and matted them. I learned then what wonders mats did for drawings: when she showed me the result of her efforts, they were so enhanced I could hardly believe they were mine. The exhibition filled both sides of a long hall. One of my deepest regrets is that I was too inarticulate and unassured to adequately thank this extraordinarily kind, but queenly and somewhat forbidding woman.

I did not begin seriously to paint moths in watercolor until after my father enrolled me at St. John's University, then on Lewis Avenue in Brooklyn. It was there that I took my only class in entomology. With Charles Lacaillade's prodigious encouragement, I began the series that

I have continued to the present day. My first work showed a polyphemus moth from the underside and its cocoon. Not an ambitious painting, but not a bad one either, it resembled a primitive Audubon. By my senior year in 1947 I had enough paintings (each framed through the extraordinary generosity of Dr. Lacaillade) for an exhibition in the university's library. A couple of years later, at the prompting of Edwin Way Teale (whom I met at meetings of the New York Entomological Society, which I had joined), the American Museum of Natural History presented a one-man show of my work.

During the next few years I had a number of similar exhibitions at various colleges and at Baltimore's Enoch Pratt Library and the Welch Library at Johns Hopkins. Each exhibition led to others, and I was developing a modest renown among people interested in scientific illustration. But no opportunities for me to make a living painting moths arose.

I could not live at my father's expense indefinitely. In desperation, I wrote to Georgia O'Keeffe, who I innocently thought might be a kindred spirit because of her flower and bone paintings, and asked if she would take a look at my work and advise me. O'Keeffe, who did not know me, replied with a gracious handwritten letter suggesting that I contact Dorothy Miller at the Museum of Modern Art in New York. I never followed her advice. I knew that my art was not in any sense "modern" or likely to interest anyone in that austere organization.

Dr. Lacaillade now came to my assistance again. He brought my paintings to the attention of Ranice Birch (now Crosby), director of the Department of Art as Applied to Medicine at Johns Hopkins. I was accepted as a student there and became a medical illustrator. Besides providing me with a marketable skill, this training also greatly improved my moth paintings. Also, as a result of my studies I was accepted as staff artist to William Beebe on an expedition to the jungles of Trinidad, where Dr. Beebe, under the auspices of the New York Zoological Society, had established a field research station named "Simla." But even this job, thrilling to me as it was, did not lead to further moth painting opportunities. It did, however, convince me that the tropics were filled with fine moths. The following year I was doing medical illustrating at the medical center in Little Rock, where, five years later, I enrolled in medical school. I got my M.D. in 1960, and after an internship in Boston, I went to Topeka, Kansas, for three years of psychiatric training at the Menninger School of Psychiatry. I happily practiced that most artlike of medical specialties until I retired in 1986 to concentrate on painting moths.

In the meantime, I wrote biographies of Emily Dickinson and Richard Wagner and, with coauthor Ranice Crosby (my former medical illustration professor), a biography of Max Brödel, founder of Hopkins's medical art department. I also published books on foreshortening and surface anatomy. Work on these projects served as a kind of break from the intense emotional realm of psychiatry and the intense visual realm of painting moths.

Psychiatry, as an essentially word-oriented profession, proved over the years a much better counterbalance to moth painting than medical illustration had been. After a week of depicting hearts and livers I felt depleted of the "libido" required for painting, and my weekend moths suffered. But after a week talking and listening to staff and patients, I was more than ready for the silence of paint and brush.

I was as fortunate in finding the woman I married as in choosing psychiatry as my field.

Her name was Dorothy Casto, and she was a resident in pediatrics when I met her. Besides her countless virtues as a wife and as a mother to our three children, and her all-out enthusiasm in support of my moth painting, even her ailments were helpful. Television gave her migraines. Thus, we never owned a television set; we have never had a TV in our home. Naturally, our children, when they were young, felt uniquely deprived. At first I felt a little deprived too, as TV mesmerized me. But on looking back, I realize that I missed nothing of importance and, moreover, had a lot of time for painting and writing and other creative projects—time that many people lacked because of television.

Dot and I felt obliged to offer the children some compensation for what seemed to them a serious omission. So in exchange for their acceptance of our not having a TV, we promised to let them explore the wonders of the world firsthand. We promised to take them on unusual trips to exotic places—Borneo, New Guinea, the Brazilian Amazon, and other equally remote and adventurous areas. At first dubiously, they considered the idea, and we were soon off to Africa. After that, we heard no complaints. They have their own homes now—all equipped with TVs, of course—but none of them complain that they had an impoverished childhood. They still, however, haven't the faintest idea who left what to Beaver.

My reputation as a moth painter, just budding during my early twenties, withered and died with my move to Little Rock and entrance into the medical profession. I continued to find or buy cocoons from dealers and frequently raised moths from the caterpillars that happened my way. I also managed from time to time to turn out a painting, and I continued to polish my technique. I also had occasional exhibitions here and there. But there was no continuity or follow-up. By the 1980s I had become better known as a writer and psychiatrist than as an artist. When I retired at age sixty-one I decided to change that and see if I could revive my earlier career where it had died some forty years before.

My first break came when Gloria Vanderbilt kindly brought my work to the attention of *Audubon* magazine, who then published an article of mine on the saturniids, along with reproductions of eleven of my paintings. Since then, a few dozen articles on my work have appeared in other periodicals—*International Wildlife*, *Defenders*, the German *Ein Herz für Tiere*, and others.

A couple of these articles came to the attention of Barbara Beville in Gatlinburg, Tennessee, in the Great Smoky Mountains. She telephoned me, and the eventual result was a partnership and the establishment of the John Cody Gallery in Gatlinburg for the sale of limited-edition prints. Numerous requests for exhibitions of my work followed the articles. After a series of shows in both art and natural history museums, I was encouraged enough to approach the goal of my most ambitious dreams.

Canada's great wildlife artist Robert Bateman was having an exhibition of his paintings at the Smithsonian Institution in Washington, D.C. I thought, if a Canadian, why not a native son? I called the Smithsonian and got an appointment with a member of the exhibitions committee, packed my portfolio immediately, and headed for Washington. My impression was that the interview did not go well and that my work had failed to make an impression. I returned to my home in Kansas.

The Smithsonian evidently moves with glacial speed. I heard nothing from them for over a year. Only by a roundabout rumor did I hear that they were seriously considering exhibiting my work. I called them. Yes, it was true. They would mount a one-man exhibition of my moths. This took place from January to June of 1990. It was held in the Rotunda Gallery in the National Museum of Natural History.

THE PAINTINGS

A final word about media and goals. The paintings that follow are done in transparent watercolors; all white areas are simply the color of the paper showing through. I work either from live moths (which I prefer, for this gives me their living postures) or from freshly dead ones, before their subtle colors have a chance to fade. All but one or two of the paintings are done on Arches cold-pressed paper. All paintings are of "imperial" size—that is, twenty-two by thirty inches.

In a sense, my paintings are didactic. I want to inform the public not only that saturniids do exist but also that they are worth looking at. Recently, I started to hope even to reach the "boys with the sticks" and persuade them it would be desirable to let up a little. My aim was never to teach entomological science. I felt no urge to depict entire life cycles—egg, larva, pupa, adult, together with the foodplants. My highest goal was to produce not scientific illustrations crammed with facts but works of art using moths as subject matter. I sensed that people could only be made aware of moths in a positive sense the same way I had become aware of them—through their beauty. Furthermore, I had long observed the curious fact that people will look closely at something an artist has taken pains to paint faithfully when they will not give more than a passing glance to the thing itself, which in many cases is more beautiful and interesting. It is as though they say to themselves, "As someone bothered to paint it, it may be worth looking at." All the scientific information in the world will not, I believe, cause the public to care at all that the great moths are vanishing. First they must be convinced that the moths are something worth saving.

Years ago, Walter Ferguson, Israel's foremost wildlife artist and a close friend of mine from high school days, fished a fine moth out of a swimming pool, where a gust had blown it. He showed it to a woman friend of his parents. She shrank back in revulsion, screaming in her Brooklyn accent and with heavy emphasis on the *t*, "Who needs iT!"

The ultimate purpose of my paintings is to respond to that quasi-question. Along with the panda, snow leopard, lemur, and all the other oppressed and crowded-out examples of nature's craftsmanship, the saturniid, by its beauty, has the capacity to bring joy to members of all future human generations. Though perhaps a minority at any one time, this cannot help but add up over centuries to an enormous multitude. Therefore, to the question "Who needs it?" I respond for those yet-to-be-born children and adults. I answer, pleadingly, "*We* need it."

Plates and Commentaries

PLATE I

Cynthia Moth, *Samia cynthia*, 1951

Collection of Ellen M. Cody

Size:
Up to 150 mm.
Range:
Originally eastern Asia; now established in the eastern United States and in Europe

This is a nostalgic painting for me. I was twenty-five when I made it. Though only I may recognize the fact, it shows the influence of Brancusi on a young artist. I had in mind the sculpture that looks like a soaring, curved, silvery exclamation point. The upper moth still gives me the same feeling as that masterpiece.

My mother liked it, so I gave it to her, and now, at age ninety-eight, she still gazes at it on her living room wall, though now through eyes dimmed despite cataract surgery.

I owe a great deal to her from the standpoint of both art and moth interests. Long before grade school I knew the names of all the common flowers and could draw them—after a fashion. On request, she would draw a flower for me. Her style was entirely left-brain. For instance, she would sketch four valentine hearts with their points together, and that would be a dogwood. An oval with three points at the top would be a tulip. At the bottom she would letter in the flower's name. I would then copy the picture and name, color it with crayons, and be fanatically careful to stay within the lines. So I learned motor control plus my flowers, letters, and colors as though they were all the same thing.

By the time I was thirteen, she had cheerfully turned our front room over to me for the raising of caterpillars. In our crowded house (I had five younger siblings) there was simply no other space. On every available surface, jars of water stood sprouting bouquets of leaves crawling with larvae. I had to keep clean newspapers under them to collect the droppings. This "sun porch" was a many-windowed room through which people entered our house, and to the average eye it must have appeared an unholy mess. Though a neat, pretty home was always important to my mother, she bore up under the embarrassment without complaint.

With the goal of producing a book, I began keeping a daily record of my caterpillars, complete with drawings of every stage and position. She encouraged me, but I lacked the necessary organizing ability then, and she was disappointed when, after many months, my efforts trailed off into nothingness.

The only place to paint was at the dining room table. By the time I was eighteen or so, the table was regularly covered with paints, brushes, branches, moths, and all my other art paraphernalia. Once I started painting, I could not seem to stop. My mother would delay and delay dinner as long as she could, while I kept pleading, "Just ten more minutes, just ten more minutes." I do not know how my parents, brother, and sisters put up with me.

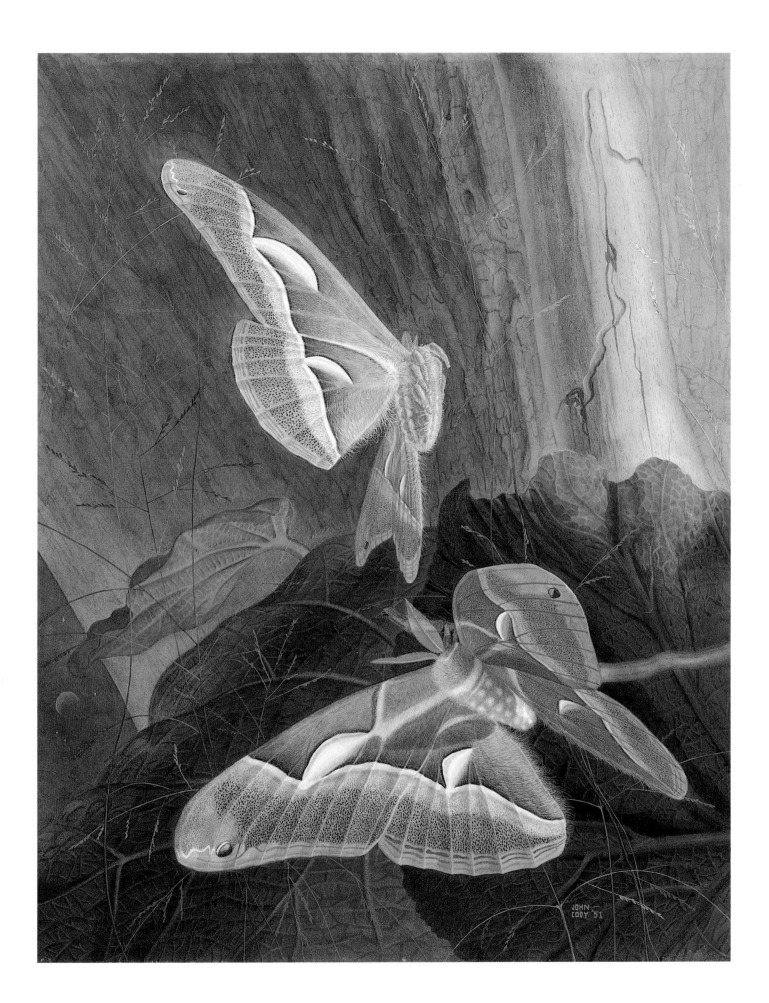

PLATE 2

Luna Moth, *Actias luna*, 1952

Collection of the artist

Size:
120 mm.
Range:
*Eastern
North America*

This 1952 painting was done during my "Matisse period." It is hard to say that now without a smile on my face.

Visually aware people cannot grow up without being influenced by their century's art. Though I was not powerfully attracted to most of it, something made me keep looking. What drove me was the experience, just often enough repeated, of having the scales suddenly fall from my eyes. A work at first repellent would, on continued exposure, take on a previously unperceived charm.

The depthless designs of Matisse worked that way with me. Slowly I found myself developing admiration for the colors and patterns, the decorative quality of his paintings. For a time I tried, mostly unsuccessfully, to adapt his aesthetic to my own paintings.

I ran into difficulties of visual contradiction and incongruity. The actual, living appearance of my moths was of prime importance to me. I was unwilling to sacrifice that for anything. Relatively small as moths are, when painted faithfully they require a certain minimal depth, a definite—if shallow—space. The absolute flatness of Matisse's designs and his bright, arbitrary color did not accord well with this requirement. But for a considerable period I struggled to reconcile the two.

This painting is probably the least unsuccessful product of those efforts. Here, I placed advancing colors—deep reds and oranges—*behind* retreating ones—pale blues and greens—to produce an almost depthless decoration. The price of flat design is, of course, a loss of realism. In the end I could not reconcile myself to this loss. Blake observed that one cannot know what enough is until one knows what too much is. I had learned what too much is—compression that was too flat, color that was too arbitrary. I had become completely conscious of the limit beyond which it was best for my purposes not to go.

I have always striven for decorative qualities, but I never again painted quite so unrealistically. Maximal decorativeness and maximal naturalism can very rarely be combined. Most frequently, each quality must accommodate to the other and be modified toward an unconflicted common ground. All good realistic painting is located between those extremes. On behalf of my moths I have tried, since my "Matisse period," for the elusive, precise balance that to my eye is optimally enhancing.

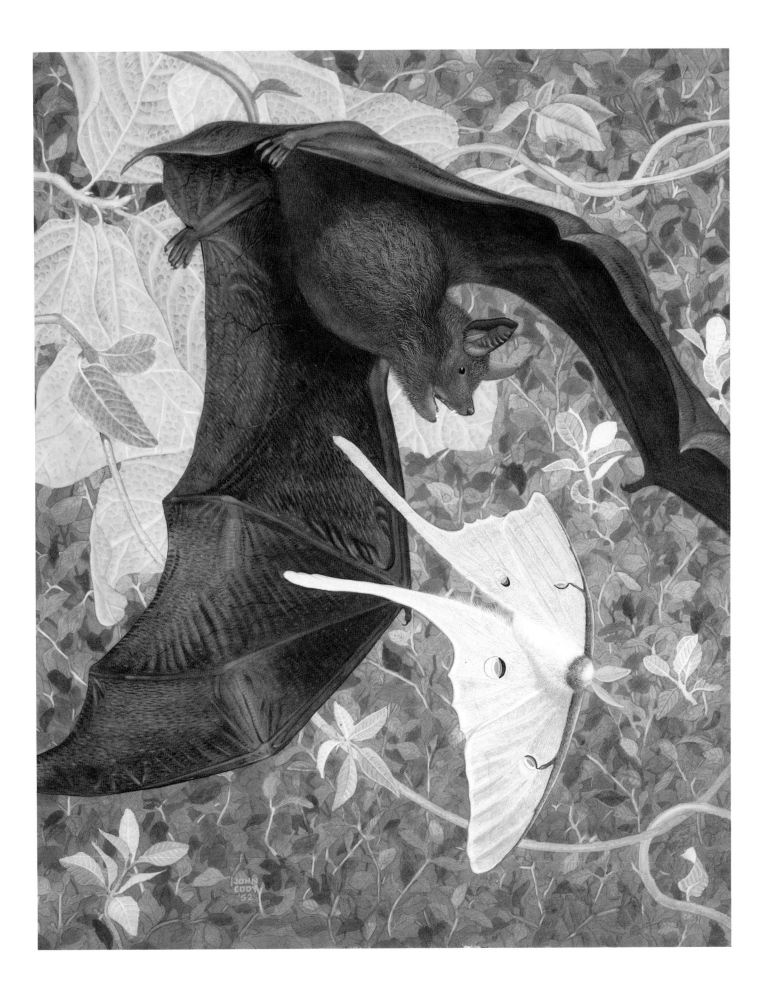

PLATE 3

Luna Moth, *Actias luna*, 1959

Collection of Dr. Dorothy C. Cody

Size:

120 mm.

Range:

Eastern

North America

Another of my innumerable early luna paintings, this one from 1959, when I was in medical school. My continuing efforts to avoid too much depth are obvious here. By filling in all would-be negative shapes with positive ones in an infinity of small details, I tried to avoid those "holes" that vitiate two-dimensional design. The method more or less achieved its purpose, but at the cost of "busyness." Commentators on so-called naive art speak of a *horror vacui.*

Pale moths are harder to paint than dark ones. The watercolor medium is inherently one of dark over light and not the other way around. One starts with the paper's white surface, and every stroke of the brush darkens the picture, no matter the color. Producing an image is a process of darkening.

Pale moths such as the luna owe their opulence of texture to tiny, flaxen details—details that are light over dark. These consist of innumerable fine hairs and minute dots in immense numbers. In reality, these hairs and dots are the scales that make moths "scale-wings"—that is, *lepidoptera.* Such minuscule structures stand out as pale forms against a slightly darker ground. How to get that effect in a dark-over-light medium is the challenge of watercolor. What seems really to be needed is a light-over-dark medium, just the opposite of watercolor.

There are plenty of such media: oil paints, acrylics, gouache, tempera, pastels, and others. All allow light-over-dark, because all are opaque. But none has the purity and brilliance of transparent watercolor or lends itself as well to microscopic minuteness of detail.

Someday, someone will invent pale, opaque pigments that dry with exactly the same finish and surface look as other watercolors. Presently, such pigments do not exist. All opaque paints produce a hard, flat, somewhat glossy surface. This is unlike the rich matte surface of watercolors, which, being transparent, do not obscure the underlying complex, lovely texture of the paper. This difference in finish, to my mind, spoils the unity of the painted surface: the opaque areas stand out from the rest somewhat like a rash.

Watercolorists have devised expedients for getting around the problem of light-over-dark areas. Dark areas can be scratched out with a knife, selectively flooded with water and blotted, lightened with an electric eraser, or bleached with Clorox. All these methods are rough on the paper and difficult to control, especially with small, precise detail. Until the perfect paint comes along I'll probably continue to paint lunas and continue to be dissatisfied with the results.

16

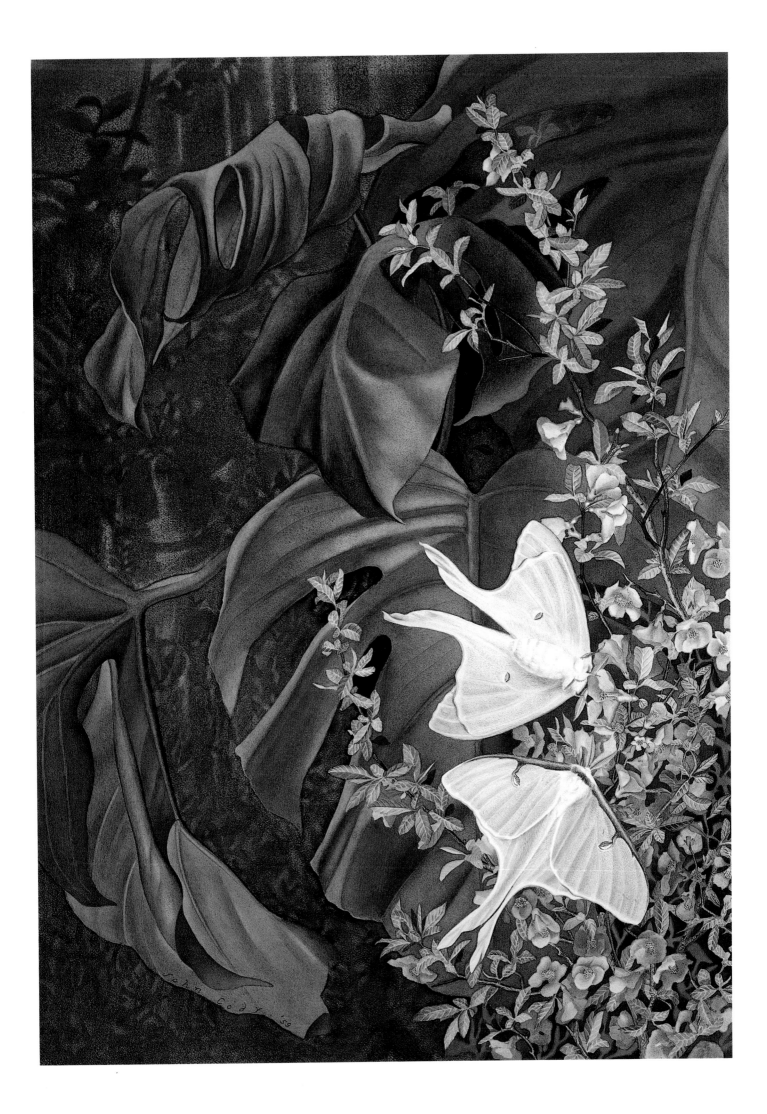

PLATE 4

Luna Moth, *Actias luna*, 1981

Collection of Mr. and Mrs. Joseph Russell

Size:

120 mm.

Range:

Eastern

North America

For about fifteen of the first thirty years of my life I searched for the luna moth the way Don Quixote searched for Dulcinea. I had virtually memorized a charming little book by Ellen Robertson Miller. In one chapter the author discovers her mother asleep on a porch in a rocking chair. In her hand is "a great green moth . . . quivering from fear." Descriptions of the luna in this book, and in a couple by Gene Stratton Porter, increased my longing to see one almost to the point of obsession.

The books invariably referred to the luna as a "common" species. Everywhere, people told me of seeing one flying around a streetlamp, or on their screen doors, or fluttering against a windowpane. Somehow, such experiences refused to happen to me. I envied those they did happen to—people who, with regard to moths, could take them or leave them.

I read that luna caterpillars fed on sweetgum, walnut, and hickory, and that the papery cocoons tumbled to the ground when fall winds tore them loose. They were usually found at the bases of these trees, buried in dry leaves. I sifted through tons of crackling leaves and never found a one. I cringed when walking in wooded areas. With every crunch I was sure I had squashed a treasure.

A delicate green moth with maroon legs and a body covered in ermine and with long tails on the hind wings—how improbable that seemed, and how different from the deep, substantial colors of the moths I knew! I tried to conjure by magic what I could not find in life. I copied black and white photographs and colorized the results. Under my hand appeared lunas that evolution had never dreamed of—emerald ones and olive, pea, sap, bottle, jade, cucumber, Nile, and viridian ones. A would-be-helpful neighbor, who had once seen a luna, said, "No dear, more bluish and more yellowish, paler yet deeper."

One windless night when I was thirty I was driving with Dot near Benton, Arkansas. A piece of paper seemed to be blowing peculiarly around a light at a gas station. I all but wrecked the car when I realized what it was. I caught it, my first luna—a female under duress of impending motherhood. She began laying eggs, and soon I was feeding her offspring branches of sweetgum leaves stolen from MacArthur Park. I ended with seventy cocoons—a feast after a long famine. As the moths emerged I admired every one before I turned it loose. They were not emerald, olive, pea, sap, and so forth, nor more bluish or yellowish, nor paler nor deeper. They were, exactly and precisely, luna green.

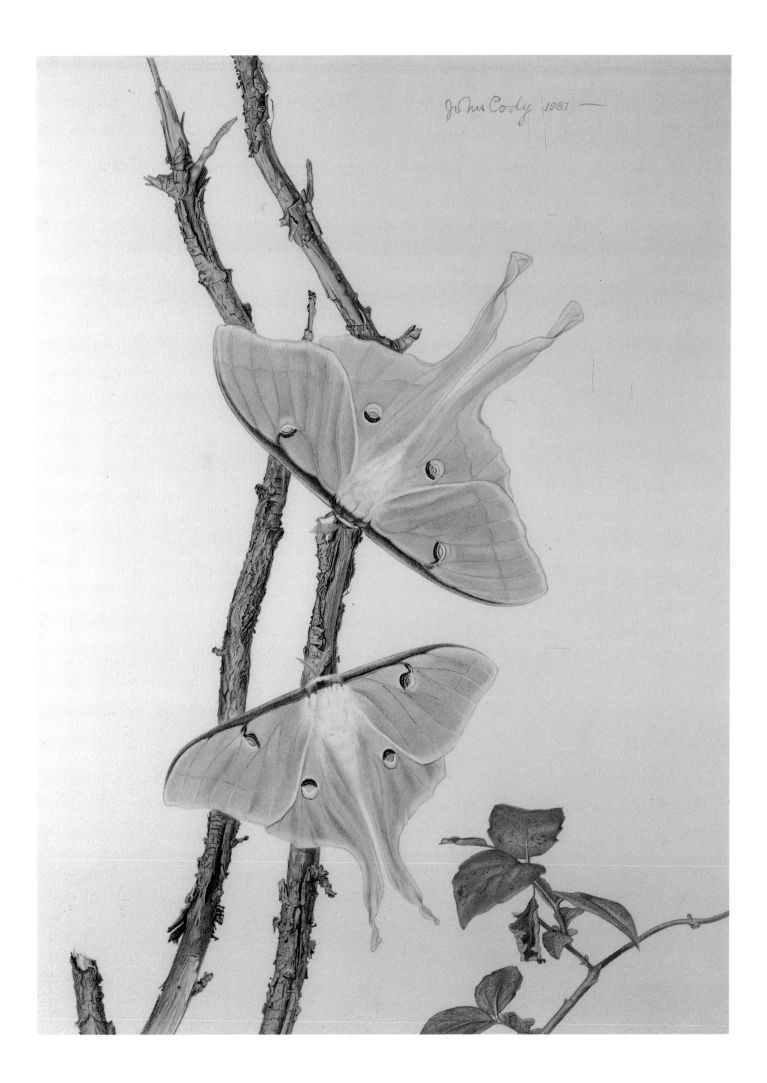

PLATE 5

Atlas Moth, *Attacus atlas*, 1981

Collection of Genevieve F. Cody

Size:
240 mm.
Range:
From India to China, Hong Kong, the East Indies, the tropical Asian mainland, Taiwan, and Indonesia

For years I had seen atlas moths under unsatisfactory conditions. Either they were in museum displays, where they were invariably faded to a drab tan, or they were in gift shops in Riker mounts and sold as "butterfly pictures," in which case they were runty specimens raised in Taiwan, evidently without great care, for such commercial purposes. Written descriptions and photographs of wild specimens indicated that when fresh and matured under ideal conditions, they were magnificently rich and multicolored and huge—up to a foot, wingtip to wingtip. Since my youth I had longed to see one such in the flesh.

My opportunity came not directly from their habitat, the lower Himalayas, but from a less likely spot—Wyoming. To my great joy, Duke Downey, an amateur lepidopterist, sent me a dozen atlas eggs in a letter. He had lined them up side by side in a one-inch bit of clear plastic tubing. I wondered what it is about eggs that they should come by the dozen.

These eggs and I were very lucky. They arrived on the Saturday morning of the Memorial Day weekend. The caterpillars hatched an hour later. If there had been some hitch in delivery, the letter would not have reached me until Tuesday, at which time it would have contained twelve tiny corpses, dead of dehydration.

As it was, they gave me reason to worry. I put them on that old standby, fresh lilac leaves, but they just sniffed them and nibbled at their eggshells. Was I attempting to feed these Asians Big Macs when they hankered for curry tandoori? Afraid they would dry up if they didn't starve first, I sprayed the lilac leaves and covered them with a plastic terrarium dome. All the next day the caterpillars appeared to sulk, and not a single pinhole did I see in the lilac to indicate a tiny bite.

By next morning they had evidently decided to make the best of an uncongenial situation. There they were, all munching away. While they grew to their final size of six inches, I kept them in my bathroom on bouquets of lilac leaves in water-filled plastic milk containers. Because the summer heat of the high plains is desiccating, I kept the bathtub full of steaming hot water to simulate Indian jungle conditions.

Not all of them survived. Of the twelve, I wound up with nine fat cocoons, of which five yielded perfect, enormous moths. They perched quietly and securely on my left index finger as I drove, one-handedly, all over Hays, knocking on the doors of astounded friends, claiming, "Never before in Kansas in the entire history of the world!"

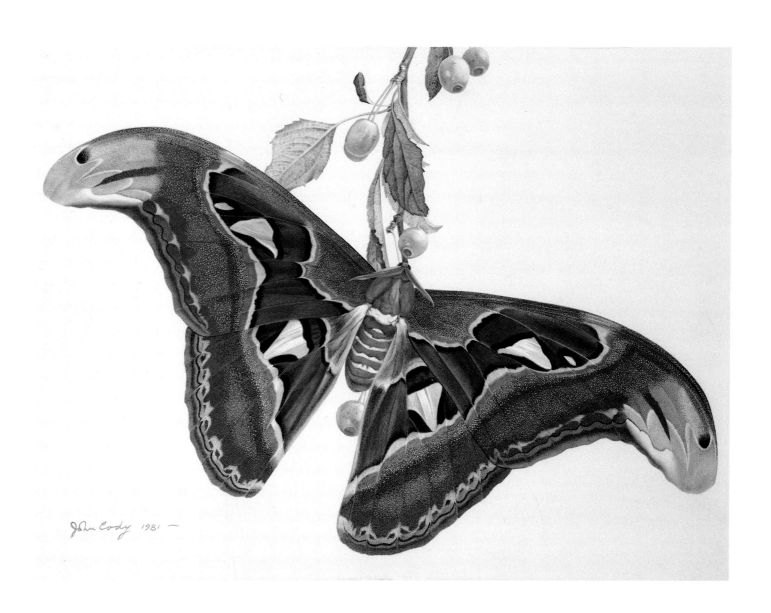

John Cody 1981 —

PLATE 6

Atlas Moth, *Attacus atlas*, 1981

Collection of Andrea Louise Cody

Size:

240 mm.

Range:

From India to
China, Hong Kong,
the East Indies,
the tropical Asian
mainland, Taiwan,
and Indonesia

At the apex of the forewings in many saturniids there is a "snake's head" pattern. This is especially true of the atlas moth. In no other species is this reptilian image so telling. The effect of color and shading is further enhanced in atlas moths because the apex is both produced and hooked, giving the illusion of snakelike flexibility.

Like the great "eyes" on the *Automeris* moths and on the polyphemus, such markings are accepted by most lepidopterists as deterrents to birds and other predators. As far as I can ascertain, however, there is not much research to support this contention, however highly plausible it seems.

Birds are probably not very intelligent, but their vision surpasses ours in acuity. Do they really mistake these paper-thin "snakes" for the real, three-dimensional animal? Or are we being anthropomorphic in thinking so? I have observed English sparrows attacking polyphemus and cecropia moths and showing no sign that the great "eyes" of the one, or the "snake's head" of the other, intimidated them in the least. Then again, scarecrows are effective, and they look less like human beings than the moths look like snakes. In the meantime, I guess I'll believe the theory until a better explanation comes along.

Note the wings-over-back position of the moth in this painting—a position more characteristic of butterflies. Most moths adopt it for a very short period at the beginning of their existence as adults. They do so immediately after emerging from the cocoon, while their wings are only just expanded and still soft. After the wings have hardened, most of them never assume it again. The atlas, however, is an exception. Atlases are frequently found in the posture shown, perhaps as a way of making their great, sail-like wings less vulnerable to the wind.

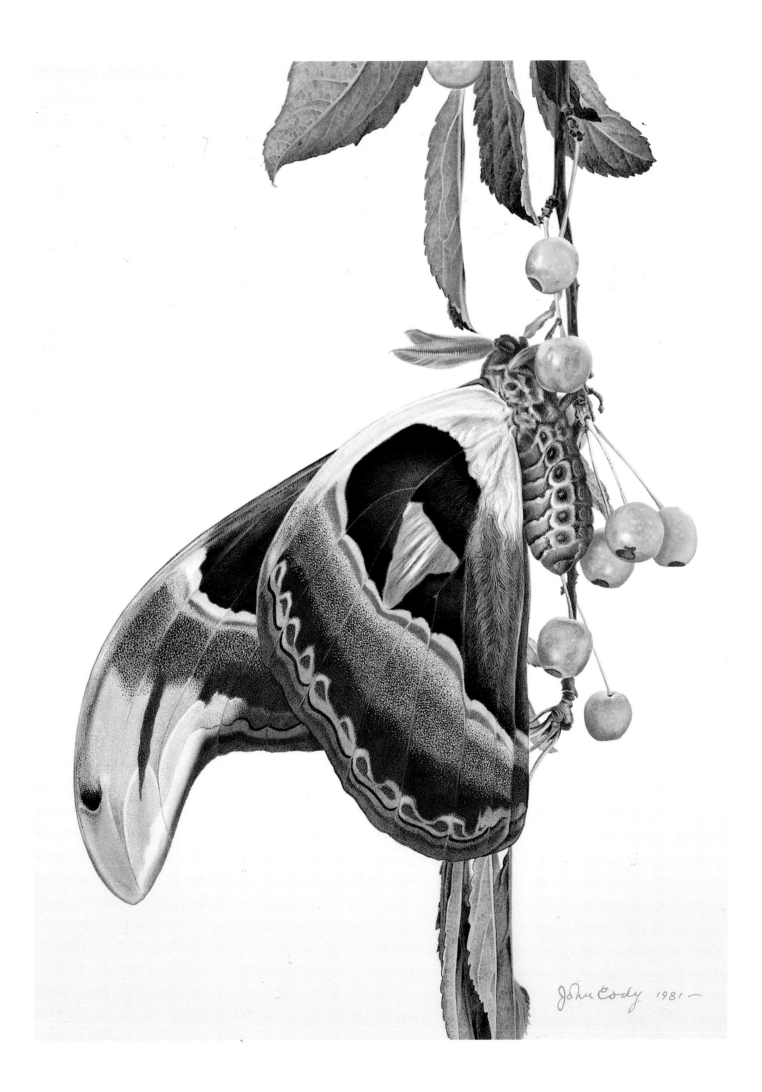

John Cody 1981

PLATE 7

Cecropia Moth, *Hyalophora cecropia*, 1981

Collection of Dr. Graham Cody

Size:
Up to 160 mm.
Range:
North America east of the Rocky Mountains

Though admiring and therefore protective of the adult moths, I was slow as a child to connect the huge cecropia caterpillars with the winged creatures they turned into. In the fall my childhood companions and I would find these impressive blue-green, red- and orange-knobbed larvae crawling here and there, searching for a spot in which to spin their cocoons. Like most saturniid larvae, the cecropia become restless before pupating. When feeding in the trees it is inconspicuous. But when it leaves them to wander, it attracts dangerous attention to itself. Discovery by ten-year-old boys is the worst possible stroke of luck.

I readily took part, though I hate to admit it, in one of the most atrocious of our games. We considered it exciting to place these caterpillars in the middle of busy Brooklyn streets and watch for cars to run over them. As far as I can recall, no car ever did. The caterpillars rarely got away scot-free, however. The first boy to get tired of waiting for the fatal accident expedited things. Down came his foot, dispatching the cecropia in a squishy coup de grace.

In spite of this sadistic fun—duplicated, no doubt, by boys in every cecropia neighborhood—the moths continued to flourish and remained abundant until their mysterious disappearance in the early 1970s. At that time, bigger "feet" than those of ten-year-old boys must have come down on the hapless cecropias.

A possible clue may recently have surfaced. The Associated Press reported on July 20, 1992, that the Agricultural Research Service, headquartered in Fresno, has developed a virus capable of killing "a broader array of insects than the four viral insecticides already approved by the Environmental Protection Agency." Named the "celery looper virus," it infects tomato worms, tobacco budworms, and cotton bollworms, among others. The article, written by Patrick V. Vail, said that the virus "takes over an insect's cell machinery. As the cells churn out millions of copies of virus particles," the caterpillar dies. The body then disintegrates into "an infective liquid that can spread across leaves or dribble on to the ground. An insect chancing upon this deadly goo can restart the cycle." The virus, in Vail's words, is "environmentally friendly"—meaning that it is not known to harm human beings or their pets.

Do we not have as much cotton and as many tomatoes as we need? And bigger tobacco crops—who can fault that? The tomato worm is a sphinx moth. The sphinx family, of worldwide distribution, contains great numbers of beautiful and valuable, and even essential, pollinators. One wonders how warmly this "environmentally friendly" insect AIDS will befriend these close relatives of the apparently doomed tomato worm.

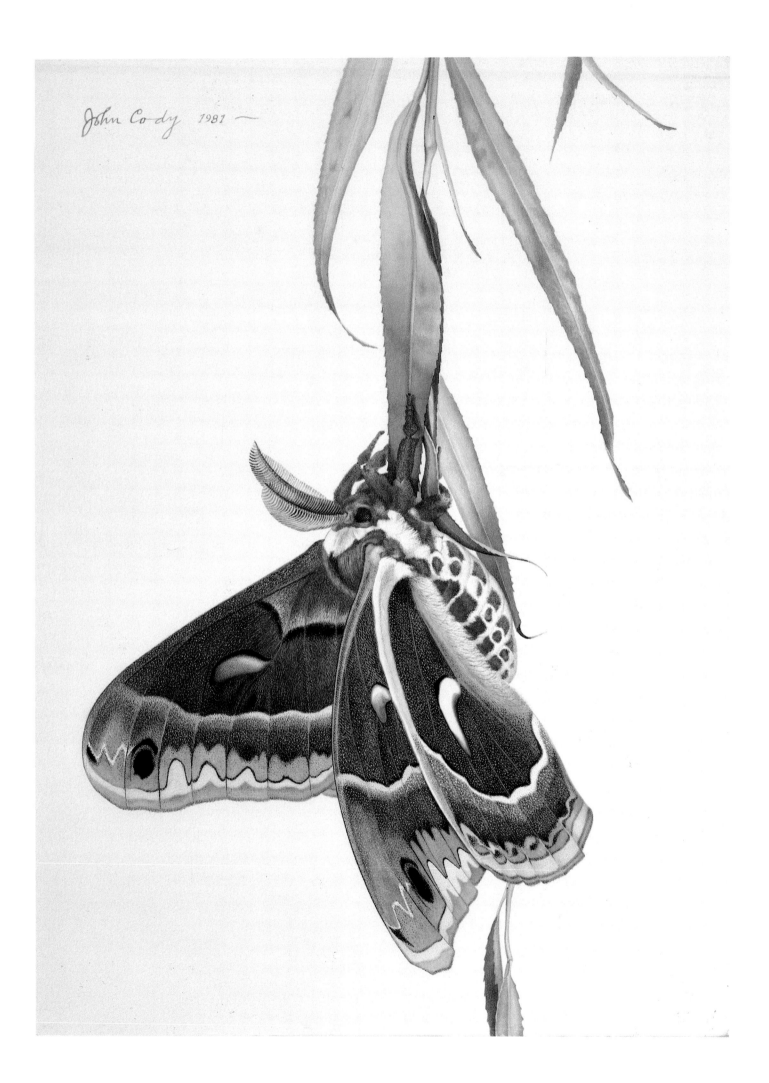

John Cody 1981 ~

John Cody 1981

PLATE 8

Glover's Silkmoth, *Hyalophora gloveri*, 1981

Collection of Mr. and Mrs. Joseph Russell

Size:
100 to 110 mm.
Range:
*Rocky Mountain
area from Canada to
Mexico; most numerous
in Colorado and Utah*

Obviously, Glover's Silkmoth is a close relative of the cecropia. It not only looks like a cecropia, it also exudes the same peanut-butter aroma. The caterpillar, too, is aromatic. Some entomologists think it smells like camphor.

The caterpillar is polyphagous — that is, it will eat almost anything green. It has been found on willow, wild cherry, buffalo berry, alder, currant, and many other trees. It also eats larch, the favorite and almost sole foodplant of its relative, *H. columbia*. Claude Lemaire believes that *gloveri* is a subspecies of columbia. It is perhaps significant that the males of a subspecies of gloveri — specifically, *nokomis* — have genitalia indistinguishable from those of columbia.

The cocoon is attached lengthwise to a twig or branch, as are all *Hyalophora* cocoons. Gloveri, like the three others in the genus, push their way out of the cocoon by main force, using head and "shoulders" as a battering ram.

The process is facilitated by the way the cocoon was constructed. The caterpillar, as though anticipating emergence, prepares an open-ended, narrow tunnel of silk leading from the inner chamber proper, something like the outlet of an igloo. Luna and polyphemus cocoons do not have this feature and are completely enclosed. Unlike the *Hyalophora*, these moths have to secrete a silk-dissolving fluid before they can push through the solid wall of the cocoon. In either case, emergence is like childbirth — not an easy process, and the moth has to exert a great deal of effort to escape. The process of pushing through the silk requires repeated gathering of forces and all-out thrusts and may take several hours. Some moths, exhausted by the effort, give up and die in the cocoon without ever having emerged.

If the moths were well-fed, healthy caterpillars, however, they can be expected to be more than equal to the task. It is patent from the painting that the gloveri depicted were sleek, ample creatures with vigor to spare.

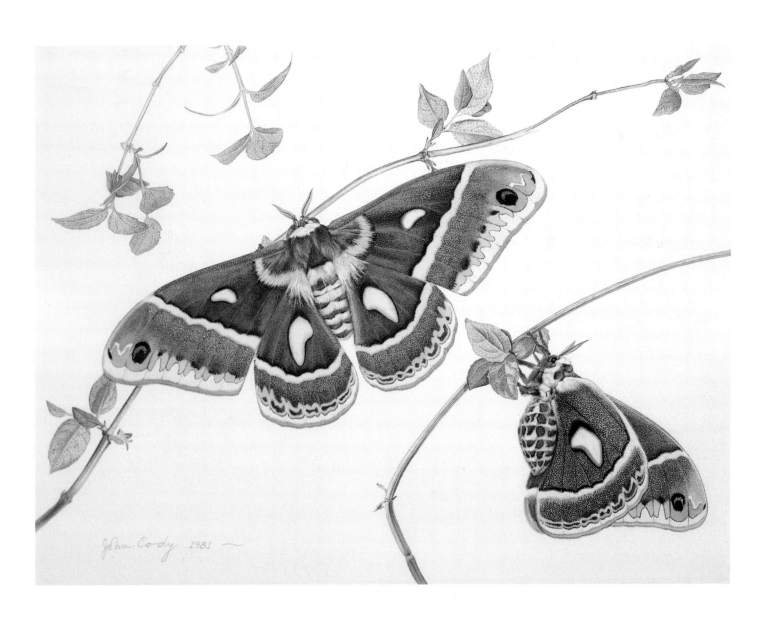

John Cody 1981

PLATE 9

Cynthia Moth, *Samia cynthia*, 1982

Collection of Dr. Graham Cody

Size:

Up to 150 mm.

Range:

Originally eastern Asia; now established in the eastern United States and in Europe

A few years ago, the entomologist Robert Michael Pyle wrote an article titled "Silk Moth of the Railroad Yards," on the cynthia moth. Pyle lamented the decline of butterflies and moths over the last few decades and commented, "But the plight of the giant silk moths, with the exception of the cynthia moth, seems more severe and more pervasive than that of most other moths and butterflies." He attributed the cynthia's apparent success to its adapting to areas so bleak and polluted as to be practically devoid not only of predators but also of most plants other than the cynthia's food tree, the ailanthus. Like the cynthia, Pyle wrote, the ailanthus manages to thrive where little else will grow. Springing up between bricks, bursting through concrete, the ailanthus seems daunted by nothing.

A few years after this article appeared, I tried to verify Pyle's optimistic impression—without success. I searched where he said to search and came away with the conviction that the cynthia was sharing the fate of its cousins. As far as I can judge, these moths are now far less numerous than when I was a boy.

I discovered my first cynthia cocoons at age ten in my Aunt Millie's backyard on Seventy-second Street in Bay Ridge, Brooklyn. An old ailanthus trunk of great girth, and with most of its branches sawed off, stood in the far corner of her garden. On a puny branch, very high, I spotted some dozen cocoons. I had never seen their like before; they looked like prometheas, although bigger and looser. My aunt was dubious and sure they were dead leaves. But as this loving woman would do anything for her nephew, she bullied my Uncle Jimmy up a tall and shaky ladder and he sawed off the branch. Although it was fall, a day later a small but perfect moth emerged, and my aunt looked at me in amazement, as though I had performed magic.

The Asiatic cynthia, along with the ailanthus, was imported into Philadelphia in 1861 in the fruitless hope of making it the basis of an American silk industry. I'll never forget how chagrined and amused I was a few years ago after visiting a remote village in Nepal. There I was ceremoniously given a fine caterpillar I immediately recognized as a saturniid. It promptly spun up, and thinking I had obtained a new and exotic species to paint, I brought it home and guarded it watchfully until it emerged. It turned out to be a cynthia.

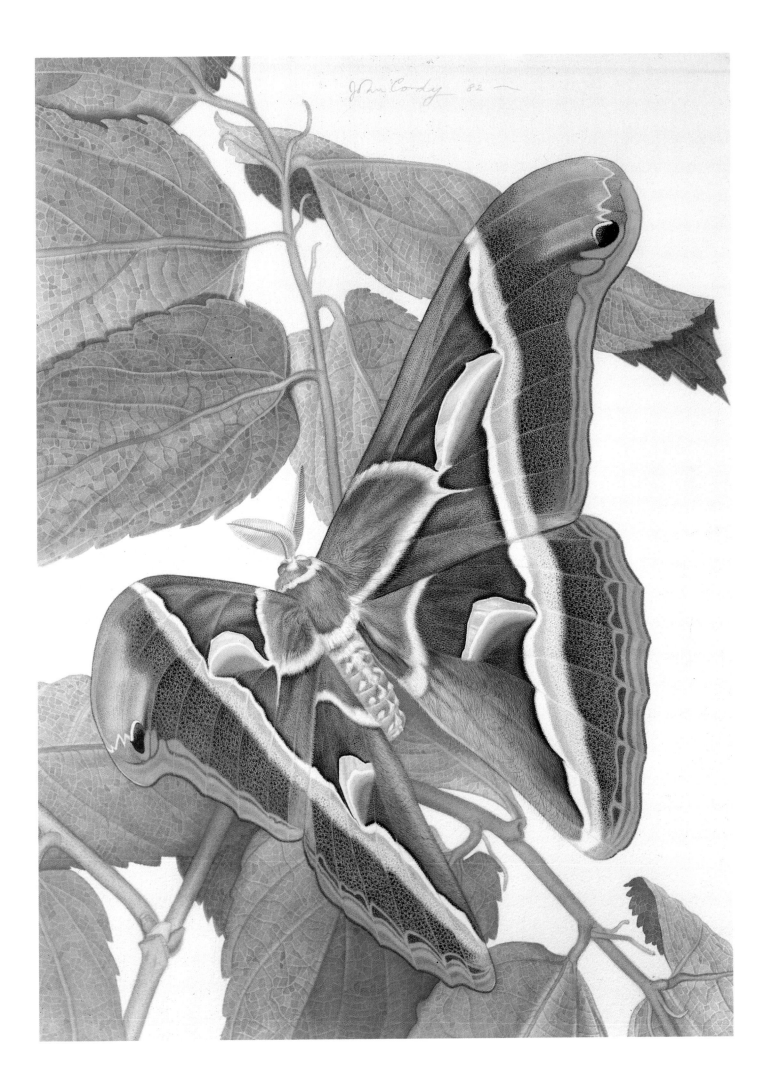

John Cody 82

PLATE 10

Imperial Moth, *Eacles imperialis*, 1982

Collection of Mr. and Mrs. Joseph Russell

Size:

110 to 150 mm.

Range:

Atlantic Seaboard

William Beebe, before he became famous for his deep-sea diving and jungle explorations, was an ornithologist and an expert on the pheasants of the world. He told me once that people were always coming up to him to describe a bird they had seen and asking him to identify it. He said their descriptions always went something like this: "It was dark on top and lighter underneath and it said 'tweet tweet.'" Beebe used to go on to ask, "Did you happen to notice if it laid square eggs and said 'ouch'?"

People do the same with me, though their descriptions usually lack the bird observer's conservativeness. "It was a moth this big," they say, indicating the wing span of a gull, and its color was "chartreuse with red zigzags." When this happens in, say, Wichita, Kansas, I usually reply, "Well, it doesn't sound *exactly* like anything one might expect in Wichita. Perhaps a stray from the tropics blown up by a tornado?" My reply always seems to give satisfaction, even in the best of weather.

Occasionally, the moth in question is later caught. Now it has shrunk to two inches, faded to brown, and lost its zigzags. In spite of such episodes, I always respond to sightings of unusual moths, because one never knows. Years ago in Brooklyn, someone found a moth on his bumper—"five inches across, bright yellow, speckled all over lavender." "No doubt a tropical storm victim," I said. I took my time going to his house, but when I arrived, the moth was still on his car. It *was* five inches across, bright yellow and speckled all over lavender!

It had not been deposited by a storm, however. It was my first imperial moth, a big female. It was on its last legs, so I took it for a model. Shortly after I sketched it, I discovered the pinned carcass devoured by museum beetles and the wings fallen off the body in a pile of moth dust. I was not to see another imperial moth for several decades.

Subspecies range widely from Canada to Argentina, at home in both tropics and temperate zones. It is extremely variable, both in size and in the degree to which the yellow ground is mottled with reddish lavender or brown. Some imperial moths that I have seen in the Amazon area looked exactly like the one I saw in Brooklyn so long ago. Unlike other saturniids, *imperialis* has a possibly functional mouth and may actually be able to sip fluids.

The painting shows four males, three in flight and one in a normal resting position. Except for the polyphemus on a locust pod, this painting seems to me the most like an Audubon of all my moth pictures, though I was not consciously trying to imitate him.

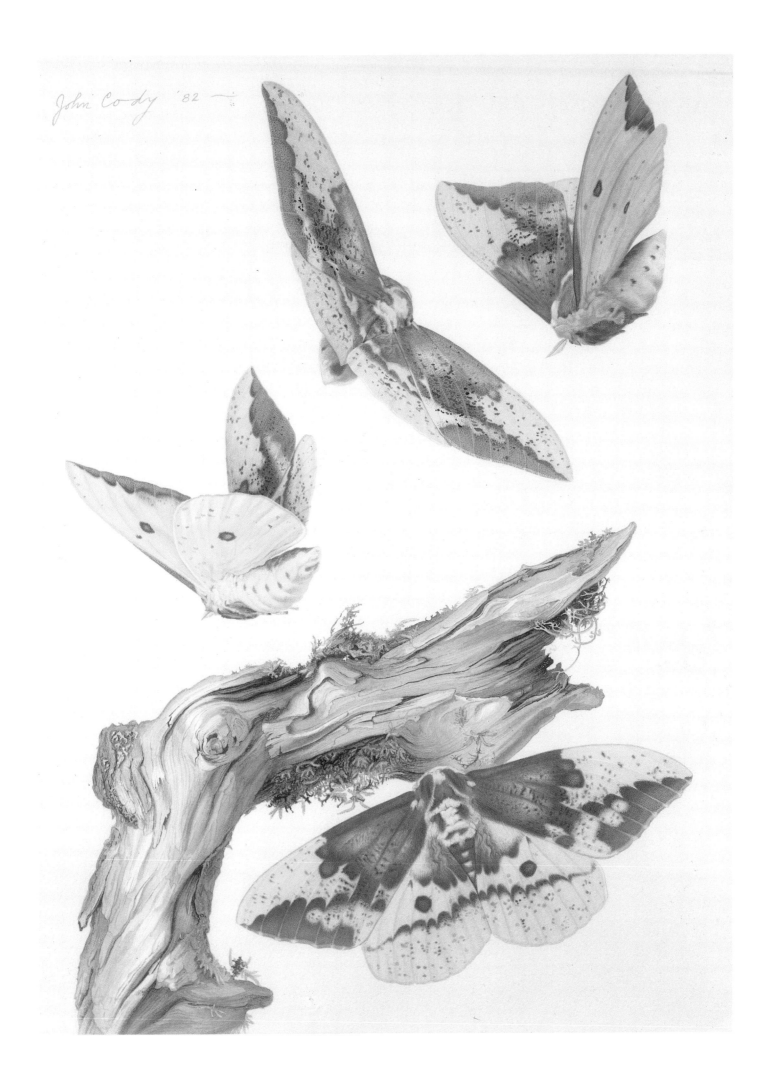

PLATE 11

Argentine Silkmoth, *Rothschildia jacobaeae*, 1982

Collection of Mr. and Mrs. Mark Shaiken

Size:

100 mm.

Range:

*Northern Argentina
and southern Brazil*

As a psychiatrist fascinated with moths, it was natural for me to think in terms of their "intel-ligence." My former coworkers, the psychologists, routinely gave IQ tests as part of patient evaluations. In handling moths—posing them, photographing them, offering them mates, removing obstacles to their freedom, and so forth—I came away feeling that some seemed cooperative and alert, others just the opposite. I knew, for example, that whenever I worked with a polyphemus moth I would have trouble. "Beautiful but dumb" seemed to sum it up.

Entomologists study macro-behavior. They less often note the small differences in micro-behavior. I refer here to differences in what might be called "temperament," that style of going about their business that is peculiar to each species. As I rated moths informally, I developed an entirely arbitrary and unscientific criterion of "intelligence." For me, the less self-destructive the species, the higher the IQ. By this yardstick some moths are definitely smarter than others.

I became systematic. For my own amusement, I began rating the moths on a 10-point scale. The very brightest I encountered received an IQ of 9.5. I did not assign any 10.0s because sometime in the future I might meet one smarter than any I presently knew.

I started by examining those that had died a natural death. Saturniids, which neither eat nor drink, do not last long. Because I never release exotic species (the first commandment for amateur lepidopterists), those I did not need for my collection of models lived out their brief span in my studio. Some, after death, were found to be presentable enough to be mounted on pins and made a part of the collection. Obviously, they had taken care of themselves—that is, had not self-destructed. The remains of other species, by contrast, were a sad sight, their wings in shreds. Some were hardly distinguishable from sphagnum moss and deteriorated tea bags.

Rothschildia jacobaeae is my genius (IQ 9.5). When jacobaeae is handled, it causes no fuss. It never get hysterical like, say, the Japanese oak silkmoth (IQ 5.0), which flies frantically from window to window. Jacobaeae, unlike the io (IQ 4.5), never races along the tops of things, legs going a mile a minute, wings flapping over its back, only to end up hunkered down and all messed up in the dust bunnies under the couch. And it would never think of behaving like the gorgeous polyphemus, which is, I hate to say it, a moron (IQ 0.5). When it is so much as gently noticed, the polyphemus leaps without a moment's thought into self-destructive ado. It lets go its perch, folds up all its legs under itself, and drops like a stone, regardless of what is below. There it lies doing an endless series of flip-flops until the tips of its wings abrade away. Jacobaeae clings sensibly to one's finger, allows itself to be transferred from twig to twig with poise and patience, poses prettily, and, aware that it is nocturnal, never hurries to go any-where while the sun is shining.

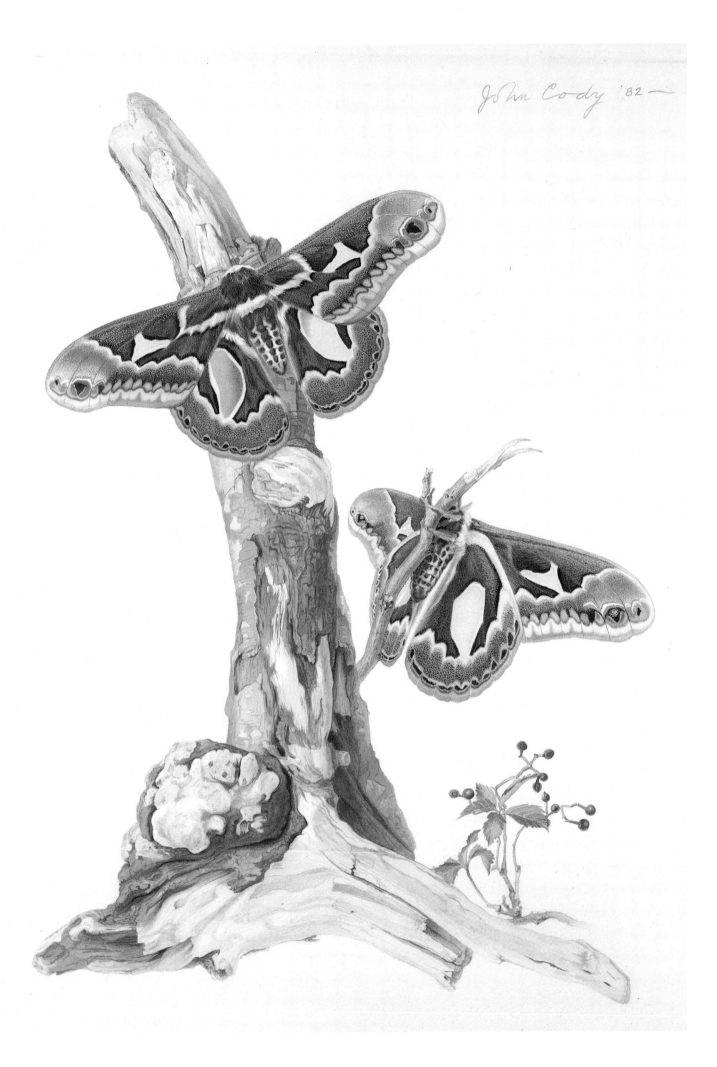

PLATE 12

Cecropia Moth, *Hyalophora cecropia*, 1983

Collection of Dr. Graham Cody

Size:
160 mm.
Range:
*North America east of
the Rocky Mountains*

"He turned paper into air and set birds free in it." This poetic remark was made by an admirer of Audubon. When I read it as a young artist, I hardly dared admit that I deeply longed to do the same for moths. Though fearfully aware that such miracles are mostly unrepeatable, I nevertheless struggled to paint moths the way they looked to me most beautiful—as if they were still flying about freely, or had just alighted on a painted stem.

Before Audubon, the time-honored method was to draw and paint from stuffed birds. A similar practice obtained for butterflies. (Moths were rarely painted at all.) Likenesses were taken from specimens on pins spread in the scientifically prescribed "anatomical position."

The term is derived from the study of human anatomy. A man in the anatomical position looks straight ahead with arms stiffly extended, palms facing forward, feet flat on the floor. The position is a useful scientific orienting and ordering device, but it is not natural. No human being is ever likely to spontaneously assume this stiff, artificial, and somewhat uncomfortable attitude.

The same is true of butterflies and moths. Mounted specimens in collections follow a convention contrived and standardized centuries ago. The insect is skewered on a pin with its wings flattened to the horizontal. The forewings are brought forward until their lower edges form 90-degree angles with the long axis of the body. The hind wings are slid forward under the forewings until three-fourths of their leading edges are covered. The insect is allowed to dry until it is permanently set, then it is put in a cabinet with other specimens all mounted in identical positions.

Century after century, almost all paintings of lepidoptera have combined, in a quaint, charming, but highly artificial way, lively naturalistic settings with obviously dead, mounted specimens. Though I have observed living moths and butterflies for many years, I still cannot say that they never, under any circumstances, assume the anatomical position. But if they do, it must be extremely rarely, and for a fleeting instant only. What is dead certain, however, is that not a single species ever assumes the position at rest.

There is little truth or nature, therefore, in the ubiquitous paintings and photographs that one sees, even in entomology books, showing a flower on which is perched a butterfly or moth in the anatomical position. One knows at once that the insect is a corpse. Frequently one sees antique watercolors in which a whole cloud of these stiff butterflies is shown supposedly hovering around a bouquet. Such a scene would look as strange to another butterfly as a gathering of men and women at a reception, all standing around with their arms stiff and their palms facing forward, would look to us.

The upper moth in this painting is as close as I've ever allowed myself to get to the anatomical position.

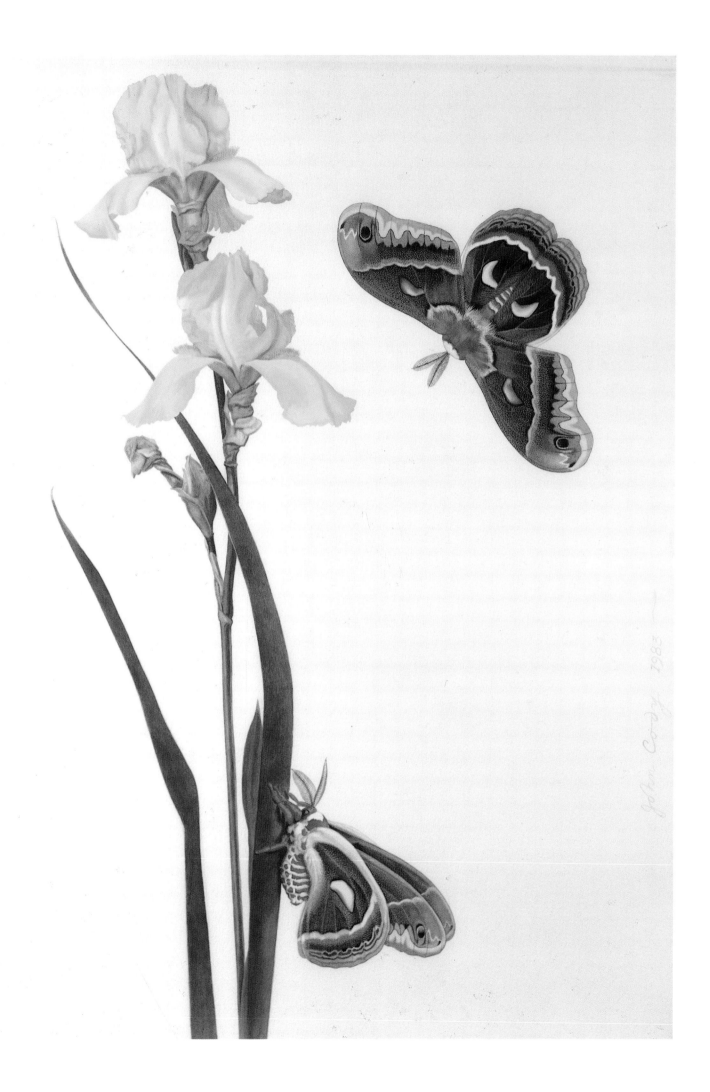

John Cody 1983

PLATE 13

Chinese Moon Moth, *Actias sinensis*, 1983

Collection of Mr. and Mrs. Mark Shaiken

Size:
100 to 110 mm.
Range:
China

I have not been able to find out much about this moth, and what I have read is confusing. Brian Gardiner, in "A Silkmoth Rearer's Handbook," seems to regard it as simply another form of *Actias selene*, the Indian moon moth. Not being an entomologist myself, I am reluctant to disagree with the experts, but it exceeds my powers of self-persuasion to believe that moths so very different as *A. sinensis* and *A. selene* can be the same species. Perhaps the matter will be settled when Brian Morris of England completes his book on the moon moths of the world.

Another name for *Actias sinensis* is the eminently appropriate *Actias heterogyna*—"heterogyna" meaning, of course, "different female." The only two specimens I have seen alive happened to be of different sexes and, indeed, the female was so different from the male that even *they* could be mistaken for different species. The male is a deep yellow flushed with green and decorated lavishly with lavender. The female is a clear, pale turquoise with almost no markings. Neither one to my eye greatly resembles *A. selene* in either color or form. In *A. selene*, moreover, male and female are much alike. The pair of Chinese moon moths I had and painted emerged from cocoons sent to me by one of the country's best moth photographers—Leroy Simon, of Leesburg, Florida.

The caterpillars will feed on sweetgum and camphor trees, but whether these trees are their preferred foodplant in the wild, I do not know.

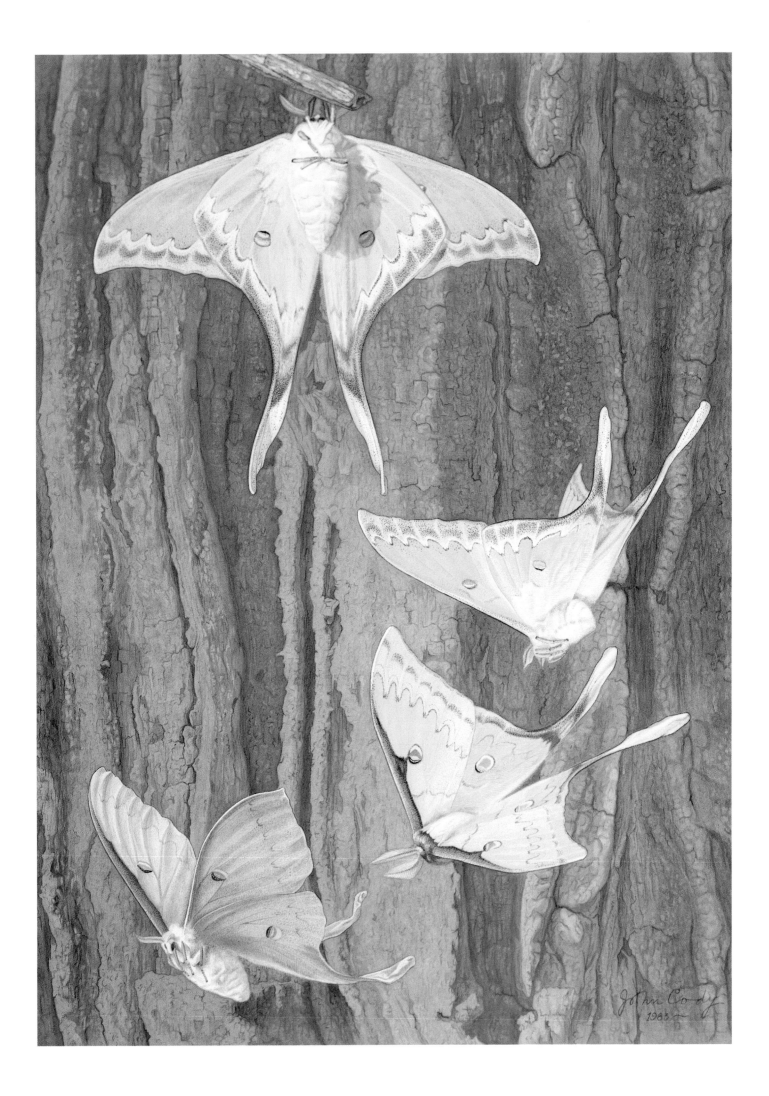

PLATE 14

Comet Moth, *Argema mittrei,* 1983

Collection of Mr. and Mrs. Mark Shaiken

Size:
Up to 170 mm.
Range:
Madagascar

The comet moth, like the stained glass moth, is one that I never expected to see alive. In "Butterflies and Moths," published in 1955, Alfred Werner wrote, "Dr. Diehl . . . , Medical Inspector in Madagascar, has sent many live cocoons to collectors, and although moths have emerged from them, it has not yet proved possible to breed them in Europe." Almost fifteen years later, in "Moths and How to Rear Them," Paul Villiard was only a little less discouraging. "Probably the rarest moth known," he wrote. Cocoons were "very costly," and the preferred foodplant was "anybody's guess."

But there was a ray of hope. Someone sent Villiard two dozen *mittrei* eggs. One of the caterpillars was accidentally drowned. Twenty-two starved to death rather than take a single bite of any of the forty-four kinds of leaves he offered them. As though in revenge, Villiard served the last remaining larva a zesty salad: poison ivy, poison laurel, and poison parsnip. How did the infant mittrei fare on this vibrant mix? The perverse little beast ate it and flourished!

Since then, rearers and mittrei have managed on more conservative tidbits—pepper tree, dwarf sumac, even walnut. Still, cocoons continued scarce. Then one day a small parcel came from a British friend, Brian Morris. Thinking I would appreciate it more than anyone and would make good use of it, Brian had sent his one cocoon to me. Pupae are prone to disaster—sudden chills, dehydration, molds, parasites, etc. This precious one was a *responsibility!* It reminded me of the raw egg teenagers in sex education classes are made to carry around constantly for a week. This is supposed to give them a notion of what it is like to have on their hands the full-time care of a baby.

The mittrei cocoon was beautiful. Large as a hen's egg, it was a silvery meshwork with a luster as brilliant as the polished metal itself. I moved my cocoon box, a two-foot-square wood frame with windowscreen sides and top, to our bathroom. Then, as I did when I was raising atlas moths, I humidified the room to jungle conditions by keeping the tub full of hot water, to the point that the walls sweated. When I actually experienced the Madagascar jungle a few years later I found it drier and *far* more comfortable.

Many times a day I looked through the screen for signs of life. One morning, against a drab background of brown and gray cocoons, Mithras, the solar deity himself, seemed to have materialized and risen beyond the screen in the form of a great golden shape. Breathless, as at a miracle, I coaxed the moth to my hand; he completely covered it with his huge wings. Later, photographing him in my studio, I watched him fly leisurely around me twice before alighting on the skylight. With his long, supple tails and majestically beating wings, he was a wonder to behold.

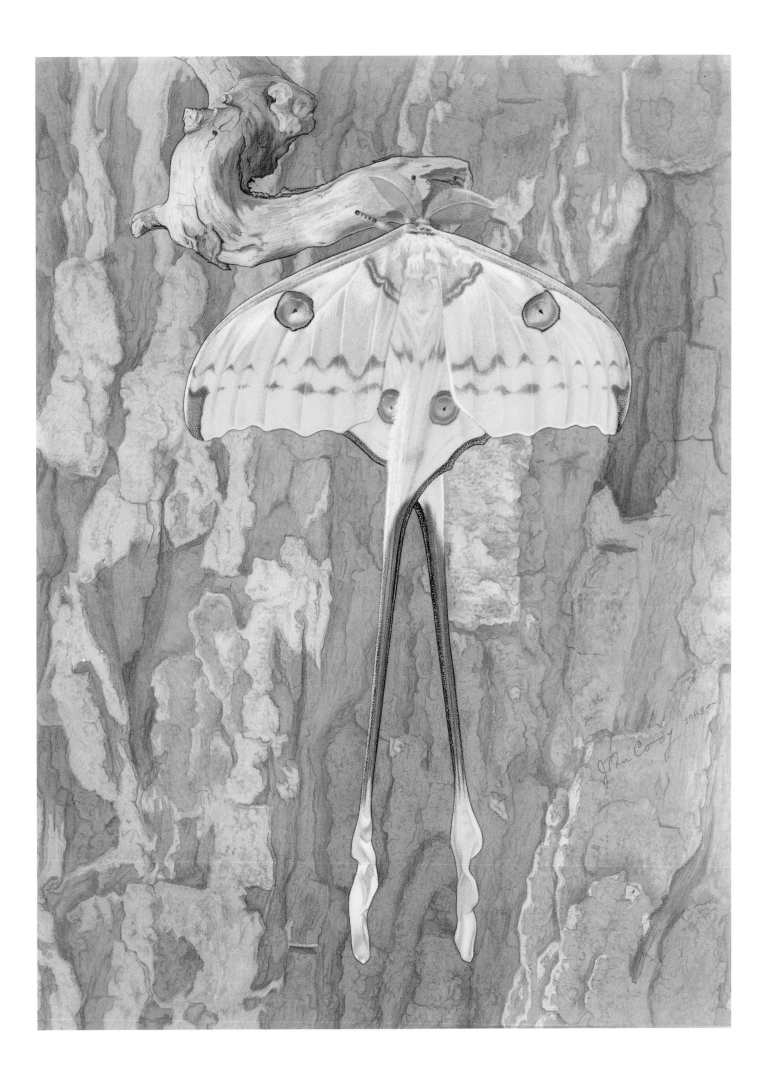

PLATE 15

Golden Emperor Moth, *Loepa katinka*, 1983

Collection of Dr. Dorothy C. Cody

Size:
90 to 100 mm.
Range:
China, northern India

Cocoons of the golden emperor moth were given to me by a British friend, Len Hart, when I visited him in South Shields. In "Moths and How to Rear Them," Paul Villiard says that they are always available from dealers in Europe and often from breeders in the United States. Probably this is because they are easy to rear, provided one has a high tolerance for frustration.

The caterpillars, which feed on Virginia creeper and grape, have certain annoying habits. When even minimally disturbed, they let go of their perch and fall to the ground or to the bottom of the breeding cage. This makes it hard to transfer them to fresh leaves and increases the risk of injury to the larvae. A common way of transferring caterpillars is to cut out with scissors the portion of leaf the caterpillar is sitting on and pin it to the bouquet of fresh leaves. This way the caterpillar itself can move to the fresh food when it is hungry, thereby avoiding possibly damaging handling by the rearer. Obviously, this does not work with *katinka*, which must be coaxed onto the new leaves, and this takes time and patience.

Another troublesome behavior is katinka's propensity to escape and wander. After falling, it proceeds to get away through any escape hole—seemingly, the smaller and more inconspicuous the better. Once gone, it is hard to find again: these caterpillars really travel.

They have one more uningratiating tic. If disturbed, but not enough so as to cause them to fall off their twigs, they secrete a fluid and, tucking down their heads, blow a big bubble. By the time they are moths, however, they have put all these juvenile tricks behind them and are models of decorum.

Like Rorschach blots, caterpillars and moths are often the objects of projection by entomologists. To Gardiner, katinka larvae in profile look like tiny snakes, and, seen from above, like hairy rodents. Villiard does not mention snakes; to him they resemble French poodles, clipped.

In my painting, I used the Thoreau quotation as an experiment for compositional purposes, but it seemed appropriate, too. Thoreau, though he undoubtedly never saw a Chinese emperor, was a devoted student of Oriental wisdom and philosophy, and I did not think he would disclaim the linkage.

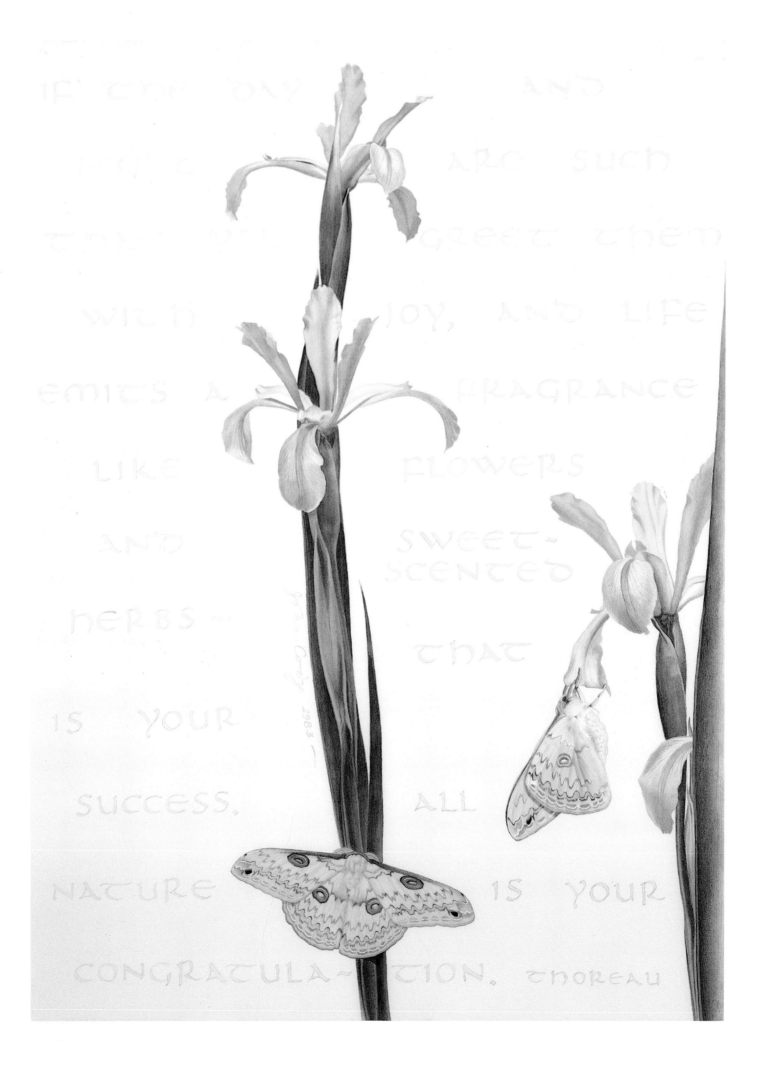

PLATE 16

Chestnut Emperor Moth, *Melanocera menippe*, 1983

Collection of Mr. and Mrs. Mark Shaiken

Size:
110 to 130 mm.
Range:
*Central and
East Africa*

Structurally and physiologically the species is a saturniid, and "saturniid" signifies, roughly, "silkmoth." Yet *menippe* is one of those silkmoths that does not spin silk. In having this peculiarity it has plenty of company. Over half of all saturniids produce no silk, or only minute amounts. Instead, when they are fully mature larvae and ready for transformation, they burrow into the ground. An amazing instinct. Here they are, leading an airy life up in the trees ever since hatching from their eggs, and somehow they know how to dig into the earth and make an underground cell for themselves. But then, spinning a cocoon without having been taught seems no less remarkable.

The chestnut emperors pictured emerged from pupae sent via England by Len Hart. I have not been able to find out much about them except that they were raised on oak. The larvae also eat fig, bird's eye bush, and kanchan. They are deep red in color and covered with pointed spines arising from black patches. The word "chestnut" in the name refers to the color of the moth, not to the diet of the larva. Having made these few comments, I have conveyed all I know about this species.

I can, however, use its Latin name as a springboard for saying something about the difference between moths and butterflies. Note in the painting that the moths' antennae are very dark. "Melanocera" means "black horn"—"melano" being "black," and "cera" being "horn." "Black horn" refers, of course, to this species' antennae.

The suffix "-cera" appears again in the classification of moths and butterflies. Under Lepidoptera (signifying wings that are covered with minute scales, the bearers of color and pattern) one finds Rhopalocera, or butterflies, and Heterocera, the moths. The prefix "rhopalo" means "club"; so butterflies are the "clubhorns," meaning that a butterfly's antennae end in a swelled-out area, such as a caveman's club. Any lepidopteran whose threadlike antennae ends in a rounded enlargement is a butterfly.

"Heterocera" means, roughly, "any other kind of horn." "Hetero" means "different"— that is, different from the clubhorn of butterflies. So, a moth may have antennae like tiny feathers, or like threads tapering to a point, or a combination of the two, or any of a number of other configurations. All one has to keep in mind, however, is the clubbed antennae of the butterfly. If the creature under examination does not possess that, then one can confidently call it a moth.

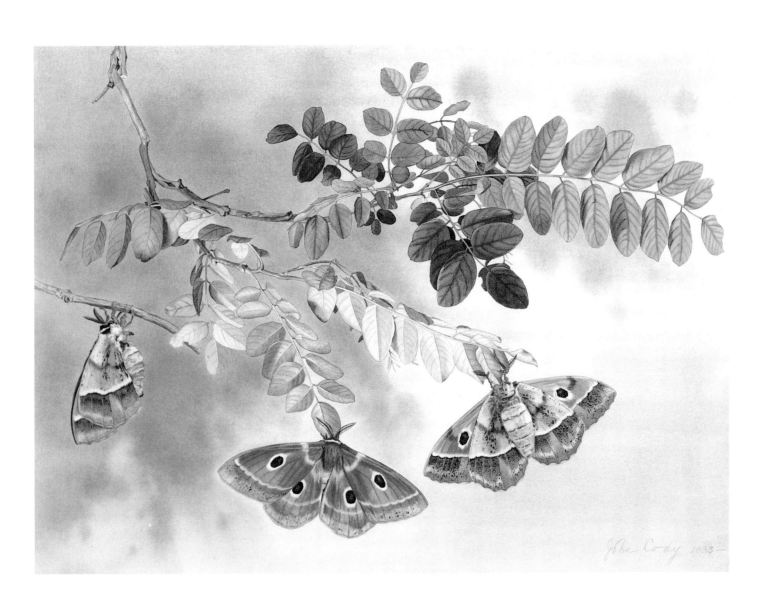

PLATE 17

Polyphemus Moth, *Antheraea polyphemus*, 1983

Collection of Dr. Graham Cody

Size:
Up to 150 mm.
Range:
*The United States
(lower forty-eight),
Canada, and Mexico;
absent from western
Nevada, Utah,
northern Arizona, and
far eastern California*

No moth has antennae that are more impressive and elegant than those of the male polyphemus, the subject of this painting. The stained glass moth of Spain (*Graëllsia isabellae*) has larger antennae than polyphemus in proportion to its size, but in absolute dimensions their antennae are about the same. In both species they resemble perfectly symmetrical twin plumes or ferns. They are the sense organs that detect the pheromones given off by the "calling" female.

Most male and female saturniids will mate on different nights with other partners. It is not clear what this accomplishes, if anything, for as a rule all eggs are fertilized at the first copulation. Moths with the same parents somehow recognize each other and usually will not mate, revealing the presence of some in-built mechanism that prevents inbreeding.

Moths of one species do not often mate with those of another, for each variety has different, species-specific pheromones. Sometimes, however, a male is misled into pairing with a female of a different species because she happens to be in close proximity to one of his own. There is evidence that as males get within a few meters of females they cease relying solely on pheromones and switch over to visual identification of the female. I have seen male moths in the vicinity of a female fly to their own shadows when these are roughly the size and shape of the female. Typically, they bounce off the shadowed surface a few times, realize their error, and try another tack. It seems likely that in poor light one female may look much like another and, in the presence of the right pheromones, the male may choose the wrong individual.

Hybridization rarely occurs in nature when saturniid species overlap geographically. But species from different continents brought into contact by humans will often mate readily with each other and even produce offspring. It seems probable that pheromonal differences have evolved locally to keep adjacent species separate. Such a barrier would not, however, be necessary between moths that under natural conditions would never come in contact with each other.

The polyphemus in the painting is shown on last year's locust pod.

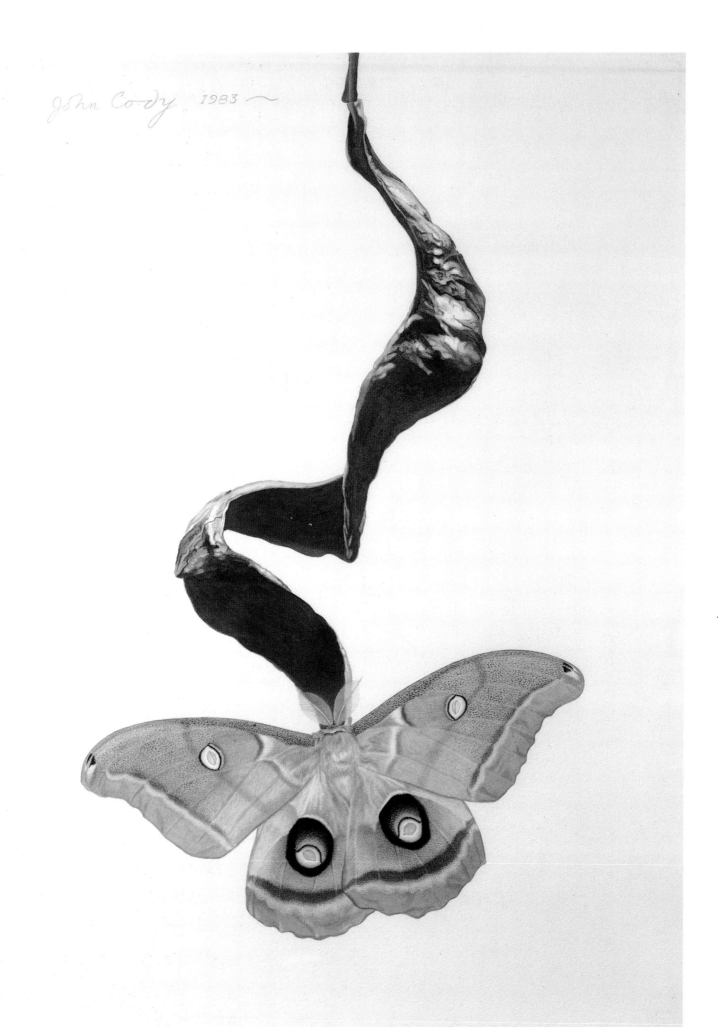

PLATE 18

Malaysian Moon Moth, *Actias maenas*, 1983

Collection of Dr. Graham Cody

Size:
Male 115 mm.;
female 140 mm.
Range:
India to southern China
down to Java

The female *maenas* is so unlike the male that early naturalists thought them different species. They called the male *Actias leto*. He is a large moth—five inches across, with four-inch-long slender tails on the hind wings. His mate, however, is much larger, with broader wings and tails like fluted ribbons. The male is a vivid greenish yellow with purple-brown mottling. The female's coloring is more uniform and subdued. She looks like an enormous luna.

Of all moths, the female maenas is the favorite moth of my wife, Dot. I chanced to be away from Kansas when my maenas moths emerged from their cocoons, all at the same time. It happened that they were all females, some eight or ten of them. It looked as though a cluster of orchid plants had burst into bloom in the cocoon box, producing a bouquet of huge, pale green flowers. Overwhelmed as much by the spectacle as by the responsibility of deciding what to do about it, Dot took the plunge. At this point she also decided that these were the loveliest moths she had ever seen.

It was an embarrassment of riches. There was no question of turning any loose, of course: a central tenet in the code of every lepidopterist holds that no species is ever released in an alien country. No matter how unlikely that the insect in question could survive to become a pest, freeing exotic creatures is reprehensible and illegal.

When I returned to Kansas, I found all the moths carefully preserved. They reposed in covered food bowls, having been put in the freezing compartment of the refrigerator. This killed them painlessly and without evoking frenzied fluttering, and every moth was in perfect condition. Any one of them would serve as a fine model for a painting. In time the freezer became our standard repository for moths that were not immediately needed.

The freezer's capacity to preserve them in full beauty is many-sided. The cold prevents the protein molecules responsible for coloration from breaking down. The darkness protects these organic pigments from the fading effects of light. It also shuts out museum beetles and discourages mold and other moth-destroying entities. And as a method of euthanizing, it is superior to that onetime standby, cyanide, and other such noxious fumes. Besides their dangerousness to human beings, all of these poisons cause an initial period of wing-battering excitation. Cold is also superior to the injection of substances into the thorax with a syringe. This involves grabbing the moth between thumb and index finger, which carries a great risk of damage. Cold at once induces dormancy, and dormancy eases gently into death.

Compared with these advantages, the drawbacks are minor. Once, in serving lunch to house guests, Dot put out a covered bowl. One of the visitors opened it and green ruffled wings popped up. "Oops, wrong salad," said Dot, whisking it away. "I'm saving that for later."

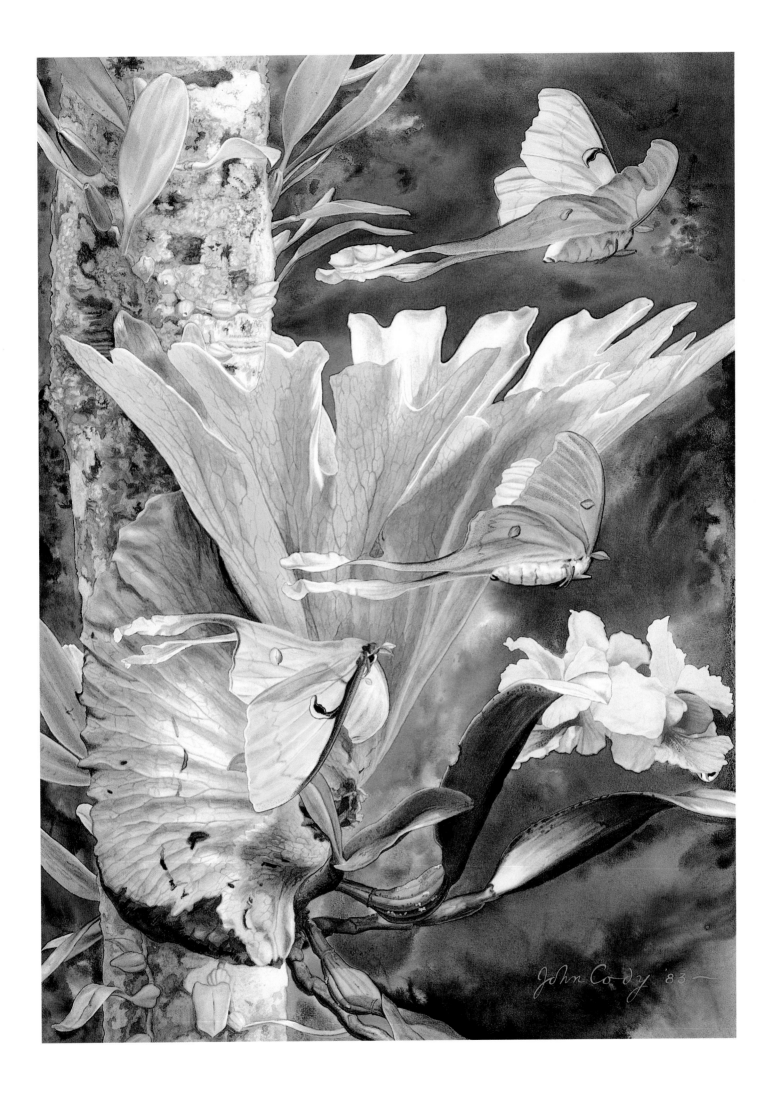

John Cody '83

PLATE 19

Indian Moon Moth, *Actias selene*, 1983

Collection of Mr. and Mrs. Joseph Russell

Size:

120 to 140 mm.

Range:

India and adjacent countries

This moth surpasses our luna in size, coloration, and elegance of shape. It is widely distributed throughout Asia, and local forms vary widely from each other in size, length of tail, and degree of pink in their coloration. The typical Indian form is pictured here.

Once a breeder of these moths gets a culture going, he or she can continue it indefinitely, one generation following another without pause regardless of season, provided a suitable foodplant is always available. A favorite, the rhododendron, happens to be evergreen, and in Seattle, for example, is edible year-round, staying succulent throughout the relatively mild winter. These leaves will nourish caterpillars to perfection, provided they are brought indoors and sprayed with tepid water from time to time. A mature caterpillar, at a length of 120 millimeters, is impressive.

My one effort to raise this species in Kansas (where winters can be extremely severe) was fraught with anxiety. I received the eggs unexpectedly in midfall and from the start feared that I might run out of leaves before the larvae spun their cocoons. In lieu of rhododendron, which, because it requires an acid soil, does not grow in Kansas, I fed the caterpillars on black walnut, on which they did well. But by mid-October, the walnut leaves were turning yellow, and it was evident that the half-grown larvae did not like them that way. In desperation, I gathered as many branches as I could find with leaves that were still green, and refrigerated them in hopes of delaying the withdrawal of chlorophyll. Soon all the trees had gone completely yellow, and after a severe storm with high winds, they were left almost bare.

I reluctantly but mercilessly thinned out my brood, keeping only the furthest-along and most robust caterpillars. Even so, the refrigerated leaves proved inadequate. They came loose of their branches and were limp and faded. Two of the caterpillars, as though sensing calamity, prematurely spun up a couple of sorry-looking cocoons from which no moths ever emerged. The rest all withered away of starvation. This was one of my saddest experiences with moths.

On the other hand, *Actias selene* once gave me an amusing one. When I leave home for visits I often take along with me any special cocoons that I think are likely soon to hatch. Once an Indian moon moth, a large, perfect male, emerged in the car just before I arrived at my brother's house near Albany, New York. As I was taking the moth into the house it flew off my finger and landed high in a pine tree beyond all hope of recapture. Afterward, a quite unbelievable story appeared in the local paper. A woman reported a "gigantic luna" on her screen. Not only was it huge, but "it had pink tails"! "Oh, sure," I can hear the local entomologists saying in disbelief.

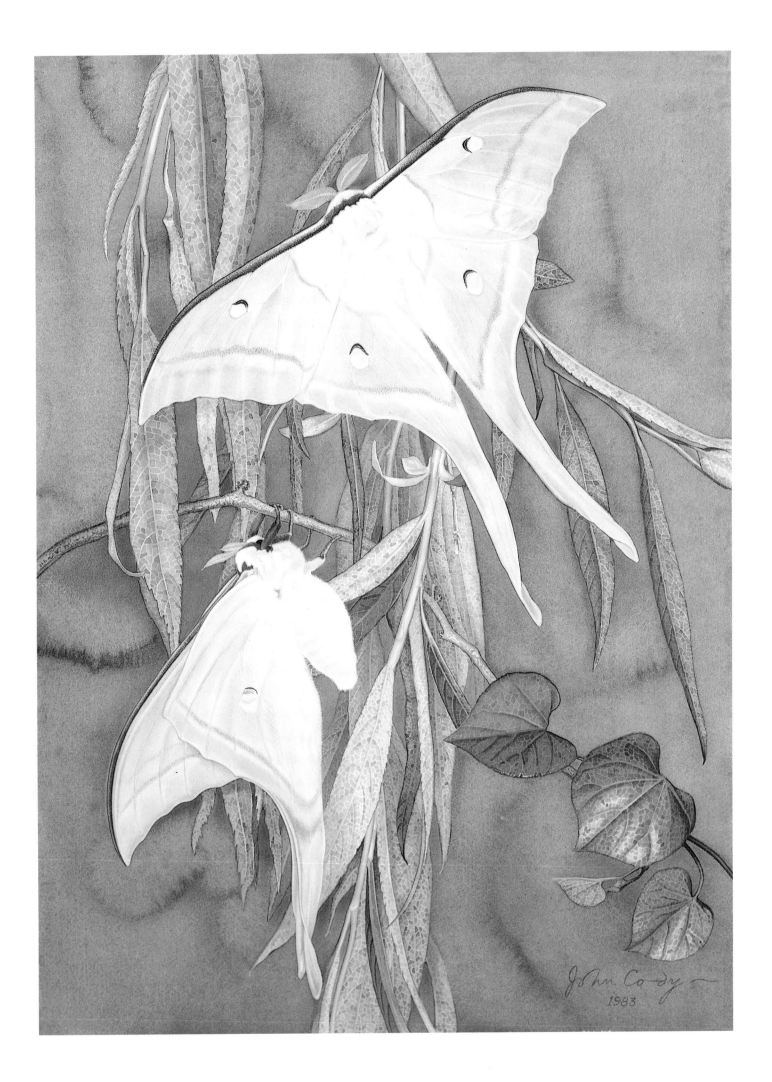

PLATE 20

Eriogyna pyretorum, 1984

Collection of Mr. and Mrs. Joseph Russell

Size:
60 to 110 mm.
Range:
North India,
South China, and
Hong Kong

Most saturniid caterpillars are solitary, and it is rare to find many on one tree or bush. Large and impressive as most of them are, it is to their advantage not to be found close together, which would make them conspicuous and vulnerable to birds. Having discovered one, the birds would continue their predation with avian persistence until all were eaten. Widely scattered throughout a grove and existing separately, the caterpillars have a better chance of finding themselves in a shadowed, out-of-the-way, and undetected corner.

The *pyretorum* larvae are an exception to the rule, and their gregarious behavior and loud colors fairly cry out for attention. Swarms may be found on one gum tree (*Liquidambar formosana*). When mature, they leave the tree and roam all over looking for a place to pupate. Their remarkable coloring—alternating lines of canary yellow and bright turquoise—make them so conspicuous as to suggest that they are aposematic, therefore distasteful to eat. But this seems not to be the case: according to Richard Peigler, the people of Hainan, a Chinese island on the Bay of Tonkin south of mainland China and east of Vietnam, fry and eat them. Perhaps frying improves their flavor.

Before eating them, however, the Chinese and later the Japanese, on occupied Taiwan, exploited pyretorum in another, rather bizarre way. Knocking the larvae out of the gum trees with bamboo poles, they gathered them up and removed their silk glands. After soaking them in vinegar, the Japanese then washed them and stretched the liquid silk to a length of two meters, at which point it hardened into a substantial filament of great tensile strength. First-rate fishing lines are said to have been made in this way.

I have been unable to determine from the literature if the moth is nocturnal or a day-flier. Certainly, the ones that emerged in my studio were more active by day than any saturniid I know except for the promethea, which is a day-flier. In any case, the males are very lively. The female is said by Gardiner to be "inert," and he suggests that she is uninterested in sex and reluctant to use her pheromones.

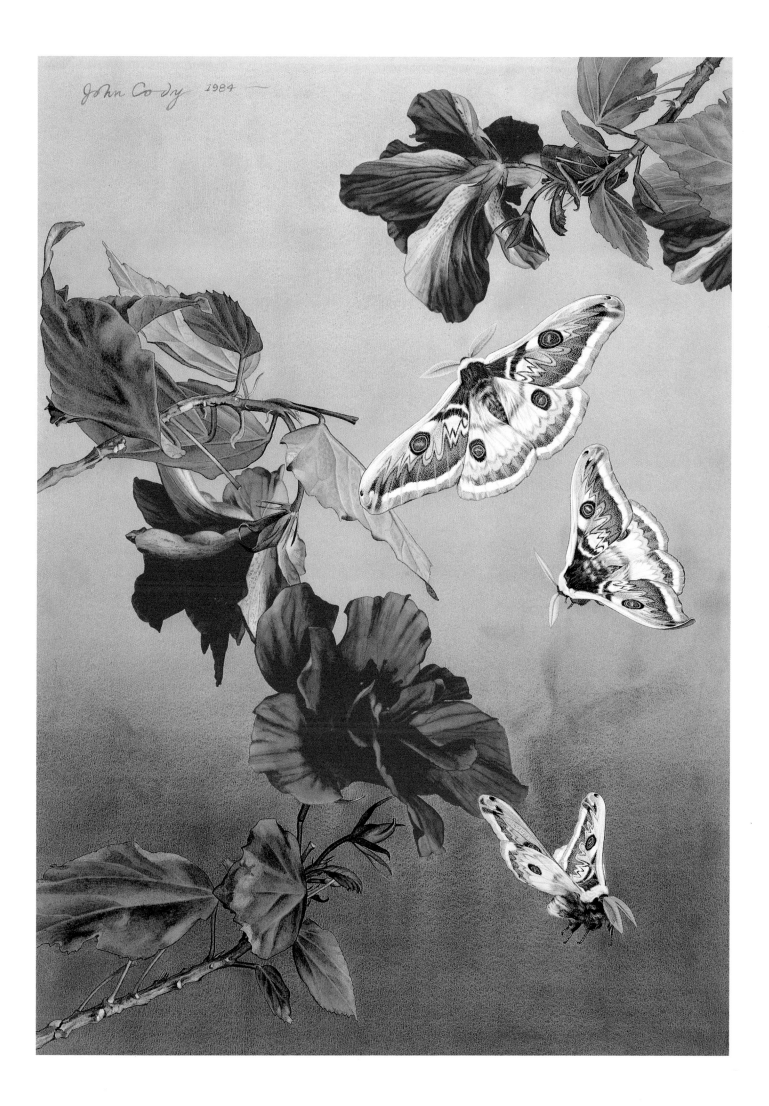

PLATE 21

Io Moth, *Automeris io*, 1984

Collection of Mr. and Mrs. Joseph Russell

Size:
*Male 75 mm.;
female 90 mm.*
Range:
*Eastern half of the
United States; also,
Colorado, Utah, and
New Mexico*

Human type O blood has been called the "universal donor" because in an emergency it can be transfused to anyone. By analogy, wild cherry and lilac are referred to facetiously by lepidopterists as "universal donor" plants because the larvae of so many exotic moths will accept them as substitutes when native foodplants are unavailable. A very large number of American species also will consume wild cherry and lilac for want of something more definitive. As lilac does well in the drought-ridden, alkaline soil of Kansas, where I live, I have used it to raise quite a few domestic and foreign saturniids.

Not surprisingly, then, I first found caterpillars of the io moth on lilac. Later I discovered that the io, unlike the preponderance of tropical saturniids, is not a fussy gourmet. The larvae of many exotic moths will starve to death, though offered literally dozens of species of plants, if they cannot have the one or two favorites available to them on their native soil. By comparison, the io is a pragmatic survivor. It will eat practically anything in preference to starving to death.

Once, during my adolescence, I had a shoebox full of io caterpillars; I kept them in my bedroom and fed them wild cherry leaves. My parents took us kids off somewhere one weekend, and I forgot to see that my ios had enough food to last them. When I returned, I found them fat and contented. They had eaten every wild cherry leaf down to the stems. Then, when these ran out, they had proceeded to eat the newspaper with which I had lined the box. I doubt they got much nourishment from that, but at least they stayed occupied and filled their stomachs until I returned with some real food.

On another occasion I discovered, the hard way, something about io caterpillars that was new to me. I woke up one night with a burning, prickling back. I was lying flat on one of my ios, escaped from the shoebox! Unlike the much-maligned hickory horn devil, io caterpillars —pretty as they are, with their red-and-white stripes and bright green spine clusters—really *are* urticating, or itch-producing. They are tough, too. Even lying on one did not bother the caterpillar half as much as it bothered me, and it went on to normal mothhood.

Note in the painting the moth's sexual dimorphism, a fairly common phenomenon among moths and butterflies. In contrast to the bird world, female moths are not uncommonly larger and more beautifully colored than their mates. Here, the male ios are smaller and canary yellow, the females larger and a rich blend of purplish browns. In some parts of the country the males are darker and more like the females.

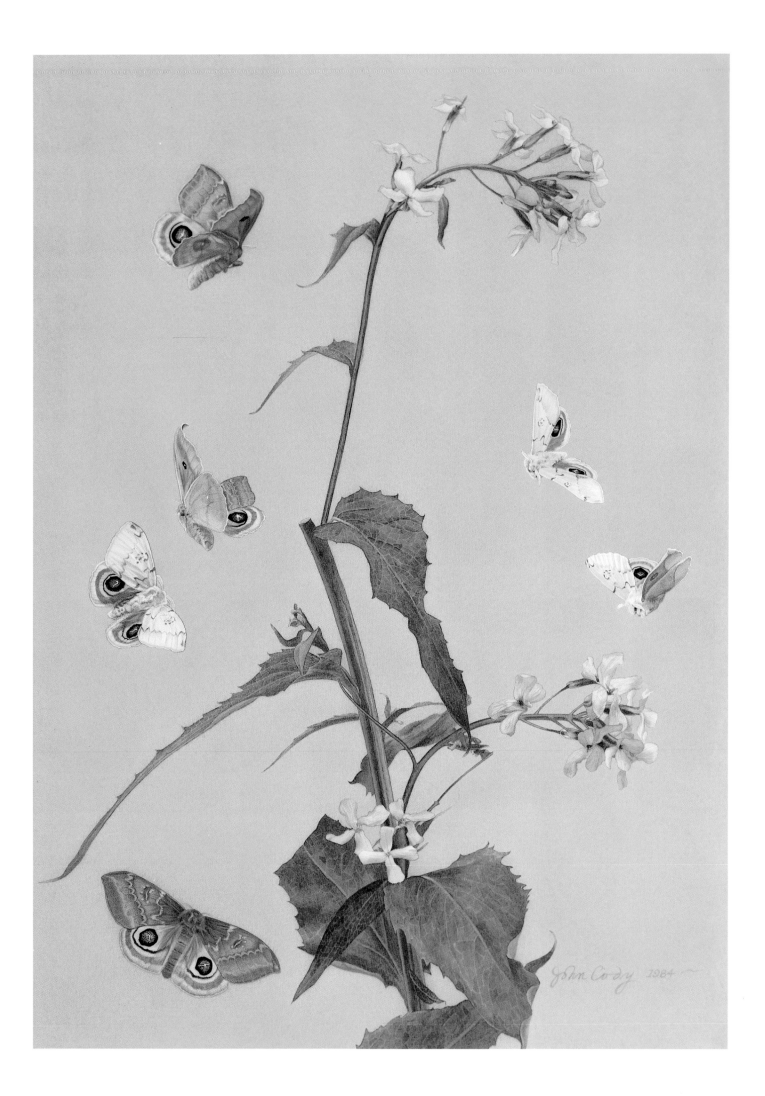

PLATE 22

Malaysian Moon Moth, *Actias maenas*, 1984

Collection of Mr. and Mrs. Mark Shaiken

Size:
Male 115 mm.
Range:
*India to southern China
down to Java*

It is easier to keep making paintings of these magnificent moths than to find new facts to write about them. Therefore, I'll confine myself here to saying something about how this atypical painting was made.

As the moths come from Java, it seemed appropriate that the basic painting medium here also be "java"—that is, coffee and coffee grounds. I believe that Jerry Hodge, the eminent medical artist from Ann Arbor, invented the technique, and I learned it from him.

First, a detailed drawing in pencil of the moth and branch were done on a sheet of Arches cold-pressed (somewhat roughly textured) watercolor paper. Then, Winsor & Newton art masking fluid was brushed over the whole area covered by the moth and branch. This fluid is pale yellow and consists of liquid latex dissolved in an ammonia solution. (It is death on brushes!) It dries in minutes and protects the virgin whiteness of the paper underneath, no matter what kind of colored matter is splashed over the surface.

The next step was to drop sopping coffee grounds here and there in blobs, and sprinkle them in patches, over the negative space around the protected subjects. Then, strong coffee itself was splashed onto selected areas. After that the painting was left severely alone overnight until everything on the surface was bone dry. The next day, the coffee grounds were thoroughly brushed off, leaving only the stained and mottled surface.

There are oils in coffee. These, in varying concentrations, had soaked into the paper in a random way, forming a delicate and reticulated, but still latent pattern. To bring out this pattern, I then went over the surface heavily with sanguine Conté crayon, vigorously working it into the surface with a large, stiff-bristled brush. Then I removed all of the Conté dust with a chamois. The ability of the paper to retain the crayon varied according to the amount of oil present: the heavier the clumps of coffee grounds, the more oil.

The combination of coffee stain and sanguine crayon produced a soft brownish mauve color that was infinitely varied and highly textured over the entire negative space. All that was left was to peel off the dry masking fluid and paint with watercolors the resulting white silhouette.

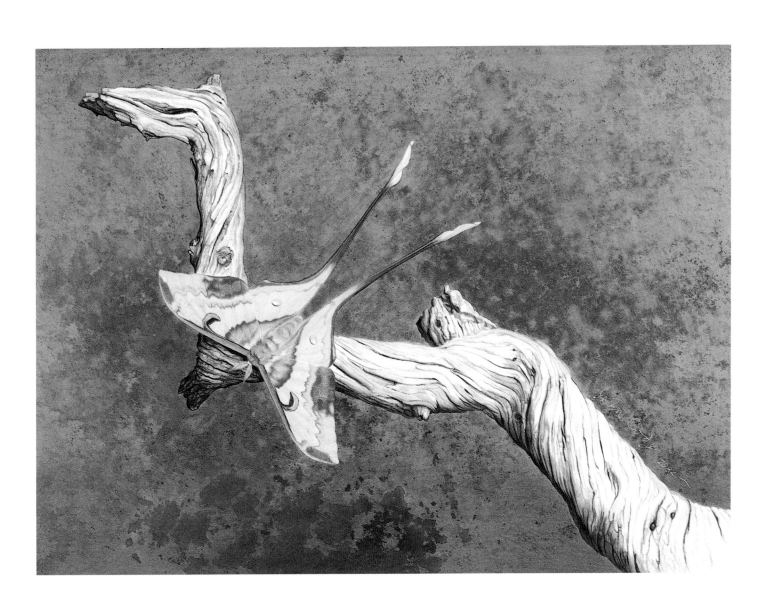

PLATE 23

Promethea Moth, *Callosamia promethea*, 1984

Collection of Dr. Graham Cody

Size:
90 to 110 mm.
Range:
Eastern United States and Canada

Entomologists of the nineteenth century and earlier had classical educations and were well-versed in Latin, Greek, ancient literature, and mythology. To them we owe the impressive names bestowed on so many of the saturniids. Furthermore, it testifies to the high esteem in which they held these great moths that they gave them the names of gods and Titans, mythical kings and queens.

Examples abound. Saturniids are named after such Greek deities as Selene and Cynthia (both moon goddesses), Apollo, Atlas, Cecrops, Erebus, Hecate, Hermes, Iris, Pluto, and Thespis. Then there are names derived from the Greek kings, queens, heroes, and other grand personages, such as Andromeda, Cressida, Electra, Euphrosene, Hercules, Io, Jason, Laocoön, Leda, Medea, Nausicaä, Pandora, Penelope, Polyphemus, Semiramis, and the maenads (*maenas*). Roman gods and goddesses used as namesakes include Luna, Aurora, Janus, Juno, Maia, and Romulus. When they ran out of Greek and Roman names, the collectors turned to figures from an assortment of other cultures. Some instances are Cleopatra, Osiris, Helene (the Simonian gnostic mother goddess), Jehovah, and Mithras (the Persians' solar deity, embodied in the word *mittrei*). Then, depleted of proper names, they resorted to adjectival superlatives: *illustris*, *splendens*, *imperator*, *imperialis*, *majestalis*, and *magnifica*.

Even the name "saturniid" itself is complimentary, derived from the name of the Greek god Saturn, whose reign, the Saturnian Age, was the Golden Age. Given that most such names are multiply determined, it is probable that the ringed planet entered into the choice also: many of these moths have circles and multiple rings as part of their patterns, especially on the hind wings.

The promethea moth is named after the Greek Titan who, after stealing fire from the gods, bestowed it on mankind, along with the arts. Though the nearly black male is anything but fiery in color (the female is a little more so), the name is not inappropriate. Fiery in disposition, it is an easily excited moth and a rapid flier, squandering its energy as though it were inexhaustible. Moreover, it flies in sunlight in the heat of day.

As a boy, I would tie a soft string around the thorax of a female and tether her to a twig to watch the males come. The female would emit her pheromones at once, "calling" the males, and soon they would be surrounding her little domain in clouds, zigzagging in a frenzy. The instant she accepted one of the males, the others would be gone, as though her pheromones were turned off by a switch.

Promethea cocoons are tightly woven, long and slender. I used to find them by the hundred on wild cherry. I wish it were still like that.

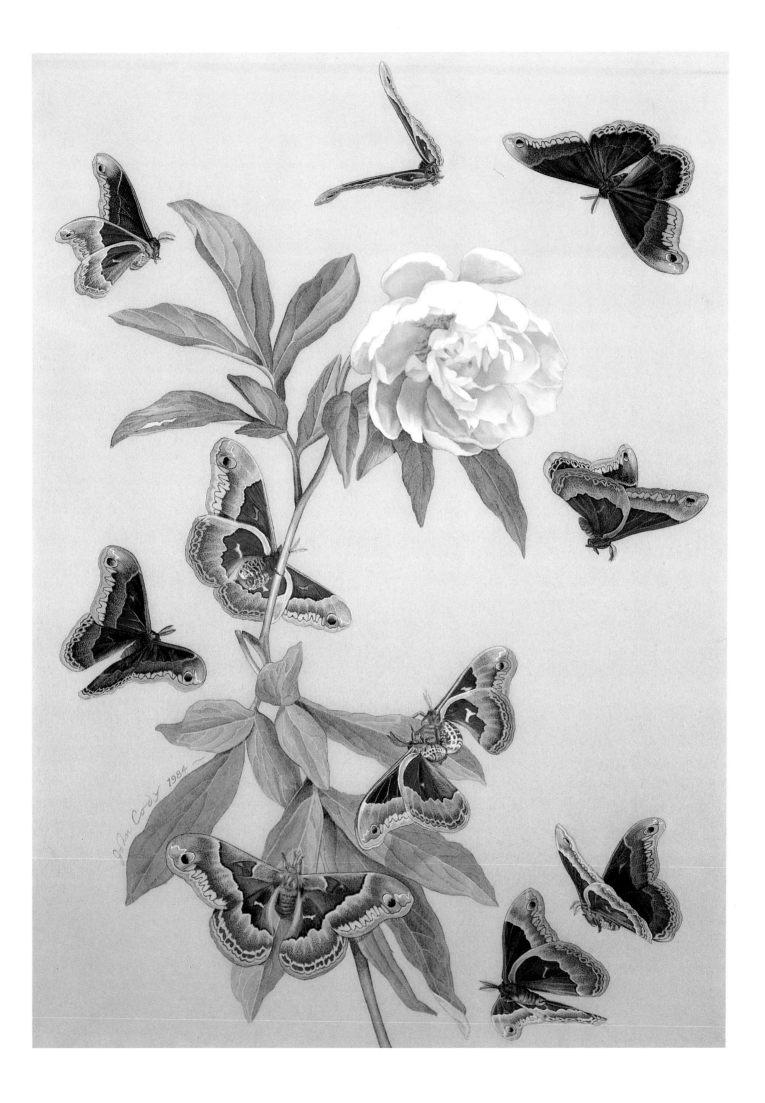

PLATE 24

Sunset Moth, *Chrysiridia madagascariensis*, 1985

Collection of Mr. and Mrs. Joseph Russell

Size:
110 mm.
Range:
Madagascar

A strict entomologist might reasonably say that the sunset moth has no legitimate business being in a book on saturniids. I have included it for two reasons. Because it is not a saturniid or silkmoth, it dramatizes by default the characteristics of those moths. And second, because of its popularity and beauty, I could not resist painting and including it.

The sunset has threadlike antennae that taper to a point. No silkmoth has such antennae; theirs are plumelike, with side branchings. The sunset has long, thin, rather hairless legs. Silkmoths have short, thick, furry legs. The sunset has a long and rather slender body, sparsely haired. Silkmoths are plump and richly furred. And though it does not show in the painting, the sunset has a tubular tongue through which it obtains nourishment, while saturniids, lacking such an organ, do not feed at all.

The subtle colors in a saturniid wing are the result of pigments deposited in the structure and composed of complex organic proteins. Theoretically, they could be extracted by laboratory methods, so that one might have a dram of, say, cecropia red or luna green with which one could actually paint. (Not being light-fast, however, the colors would quickly fade.) In contrast, the sunset moth's metallic green, gold, orange, and magenta—in fact, all its colors but its black and white—are in a sense not there at all. That is, the prismatic effect comes not from pigments but from structure. Like those in soap bubbles and oil slicks, these colors are due solely to the way the surface splits off and sends light rays back to our eyes.

A few years ago I saw two sunset moths sporting in full sunlight in their native Madagascar. (They are day-fliers, and fast.) Their wings flashed like foil or black opals, sending out blazes of green, red, and other colored light, and resembled the glittering feathers of hummingbirds. It is impossible to paint hues of such intensity. Although watercolors are the most brilliant of paints, they do not come within light years of the moths' scintillations.

I became, faute de mieux, a French pointillist. I dotted in the color using the purest hues— Winsor red next to magenta, Winsor green beside cobalt blue—and sparing tiny white spaces between the dots. Leaving it to the eye to mix the unmodulated pigments, and to the paper's hard whiteness to reflect maximally, I tried to create an illusion of that peerless iridescence. The result is not bad. Just don't hold the moth next to it!

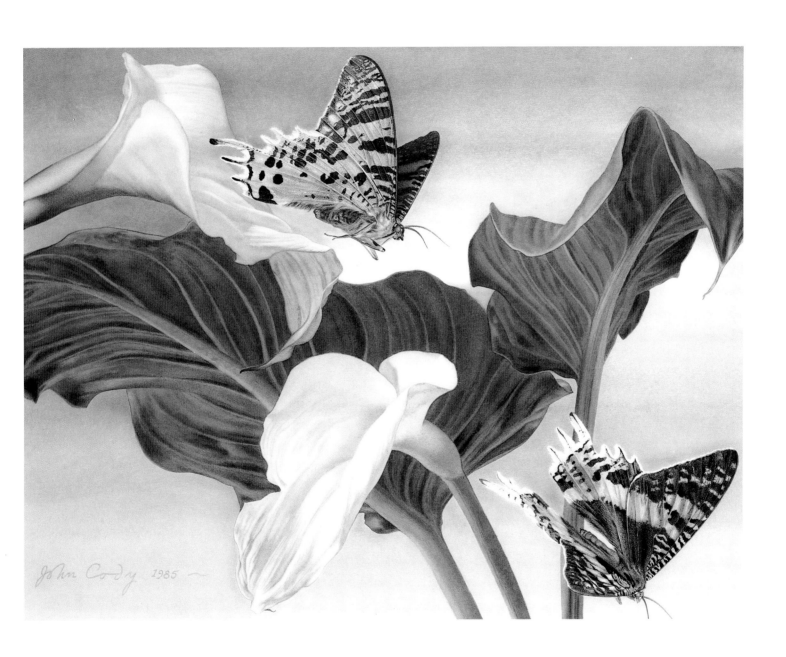

PLATE 25

Australian Silkmoth, *Opodiphthera eucalypti*, 1985

Collection of Gloria Vanderbilt

Size:
110 mm.
Range:
*Australia, Tasmania,
and New Zealand*

Published information about this moth is far from abundant. My own experience is limited to the emerging of moths from a half-dozen cocoons purchased from a dealer. The larva is described as bluish green with orange tubercles, the tubercles on the second, third, and fourth segments having royal blue tops. These caterpillars resemble those of the polyphemus and other moths in the genus *Antheraea*, in which *eucalypti* was formerly placed. In the wild the larva feeds on eucalyptus, in captivity on California pepper tree, olive, sweetgum, and others. The cocoon is remarkably hard.

People frequently ask me why I paint the same moth more than once. There are many reasons for that, but here I want to concentrate on just one. I always try to paint moths as they appear in life, and this often involves poses that, while pleasant and graceful enough in themselves, do not show to best advantage all the features of the species. For example, look at the other painting of *O. eucalypti*. It depicts one moth with wings closed and another with the wings only partially opened—both characteristic attitudes. This painting shows to great advantage the faces and bodies of the moths, but the equally important dorsal surface of the wings is not fully visible. To make up the deficiency required a second painting. Hence this painting, in which the wings are fully open and the entire dorsal surface revealed.

Sometimes, when male and female are very different from each other, and especially if both are very showy, I feel a need to make a separate portrait of each sex. And if the undersurface is of interest, as in the polyphemus, a further painting may be in order. In rare instances I have gotten around this complication by showing a large number of moths in the same painting, as with the promethea moth, in which eleven individuals are shown, and with *H. magnifica*, where seven are portrayed. Of course, I could paint groups of moths for all species, but I believe this would result in a certain compositional monotony.

That there is only one moth shown in this painting serves to dramatize it. The composition is simple, the lighting strong and directional, and the background dark and of a chocolate brown that complements the subject. I believe that adding additional moths would only have detracted from the effect.

O. eucalypti is outstanding for the plushlike, opulent texture of its wings, a quality that is emphasized by its soft, muted coloring.

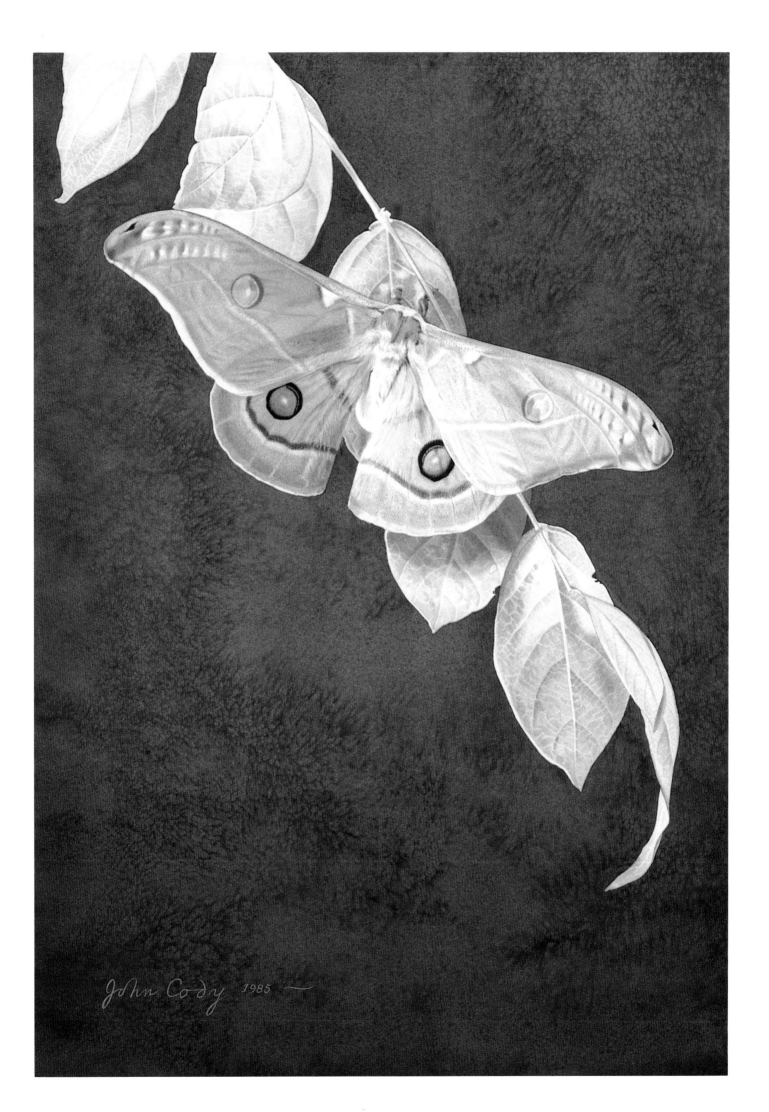

John Cody 1985

PLATE 26

Malaysian Moon Moth, *Actias maenas*, 1986

Collection of Mr. and Mrs. Mark Shaiken

Size:
Male 115 mm.;
female 140 mm.
Range:
India to southern China
down to Java

Forced to name my favorite of all the world's saturniids, I would find the choice difficult, but in the end would doubtless say the male Malaysian moon moth, *Actias maenas*. For size, elegance of shape, and harmony of pattern and coloring, it has no rival. Though some butterflies surpass it in brilliance, not one can claim its beauty of form. The female is altogether different, but breathtaking too. In fact, my wife, Dot, prefers it, citing its subtlety. It is larger than the male. Its color is more subdued—a pale yellowish green, less yellow than the male, with a grayish overcast. It has the most petal-like tails of any moth. They are long, broad, and very ruffled. The tails on the male are much longer, but thinner and without the orchidlike ruffling.

In October 1990, Dot and I went to the Taman Negara Kinabalu in Borneo. This is a national rainforest preserve on the slopes of Mount Kinabalu, near the town of Kota Kinabalu. There we met Fui Lian Tan, a field technician who had been working in the preserve for the past ten years. We wanted to see maenas in its native habitat.

Ms. Tan told us that until 1987 both maenas and atlas moths could be found each morning at the base of almost every light in the preserve. But in that year everything changed. Now the moths are rarely seen.

The area is virgin forest protected by the Malaysian government. As there has been no cutting of trees and no spraying, the disappearance of the moths is all the more puzzling and disturbing. What makes the situation even more alarming is that in 1987 the tree frogs disappeared too.

The Taman Negara, because of its elevation above most of the rest of the country, has a unique flora and fauna, with many species that are found nowhere else. Tree frogs, all of them tiny and many of them with jewel-like coloration, were plentiful, both in individuals and in number of species. They filled the air with their high-pitched nocturnal song, while the great moths, maenas and atlas, flew silently overhead.

If these sudden impoverishments in the Bornean jungle are related to the vanishing American saturniids, then we have a worldwide problem. Let us hope that world leaders will take note. Our planet, once Eden itself, is becoming dangerously toxic to some of its loveliest and most innocent creatures.

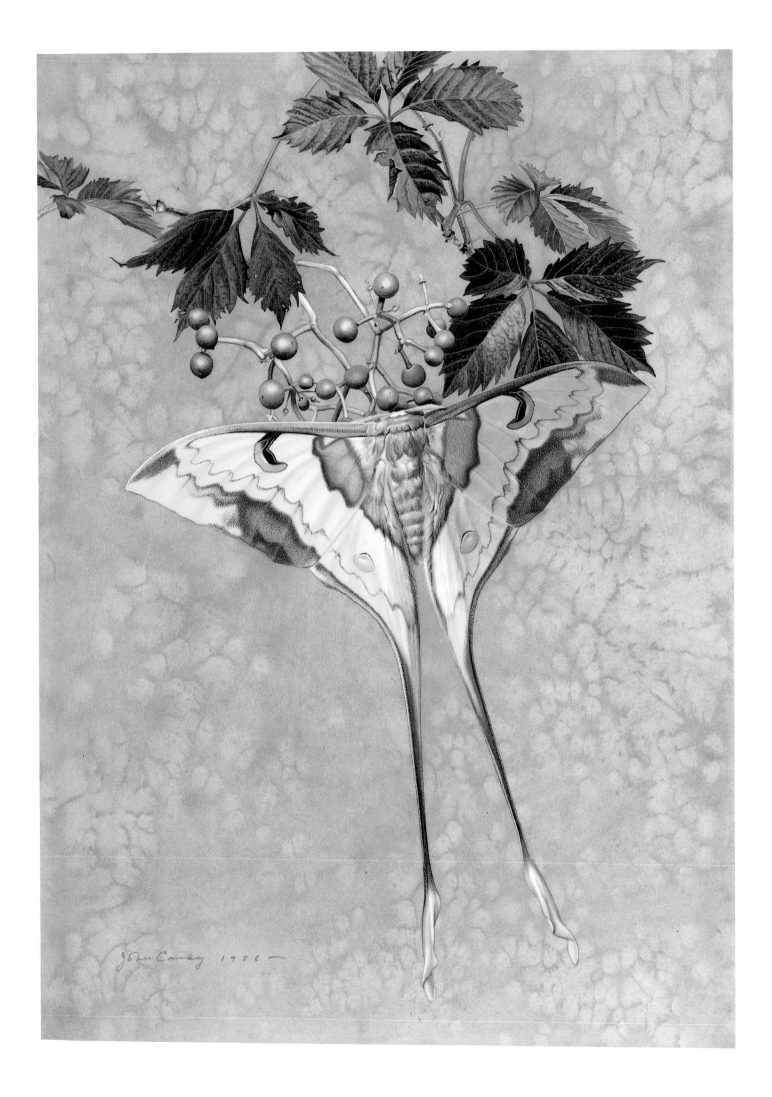

PLATE 27

Malaysian Moon Moth, *Actias maenas*, 1986

Collection of Mr. and Mrs. Joseph Russell

Size:
*Male 115 mm.,
female 140 mm.*
Range:
*India to southern China
down to Java*

Because *A. maenas* is pictured six times in this book, I will say no more about it here. Instead I will focus on my methods of painting it and other moths.

People often ask how I paint my "backgrounds," referring to the area that surrounds the moth and whatever other close-up objects are portrayed, such as branches and flowers. The word "background" has in recent decades gone out of fashion and acquired a pejorative connotation. Instead, art schools speak of "negative shapes," these being the configurations of the spaces between and around objects. For example, the two incomplete squares in the letter *H* are negative shapes; the letter itself is the positive shape. It is important to think in this way because both kinds of areas must be taken into consideration when one is working out the composition of a painting. Negative shapes should be as varied and balanced as positive ones.

Sometimes negative shapes take on the undesirable aspect of "holes" in the design. A strong, integrated surface design is difficult to achieve if there are areas here and there that seem to open on infinite space. I try to avoid the feeling of disunity caused by too much depth in various ways. One way, a favorite of Audubon's, is to leave all negative spaces unpainted and paint only the subject. In this case, the texture and other surface characteristics of the paper cause the background to "come forward" visually, preserving the sense of a relatively flat design.

Another way, the one used in this painting, is to color and texture the negative "background" shapes so that they also "come forward," thereby preserving the effect of two-dimensional integration. Here I used a mixture of sap green and alizarin crimson, painted in very wet and loosely (after covering the subjects with masking fluid). I began with a soup bowl full of each color, concentrated. These I poured simultaneously onto the paper, allowing the contrasting hues to run together. I tilted the paper a couple of times, encouraging a little further mixing in a semicontrolled way. As the paper dried, I shook a salt cellar over the surface, more heavily in some places than others. Then I left the painting alone to dry.

Salt concentrates color in one spot and drives it away from others, thereby creating a reticulated pattern that "advances," establishing the area as a surface and not as a hole into depth. As the colors used—sap green and alizarin crimson—are in themselves advancing hues, they added to the assertiveness of these negative shapes.

64

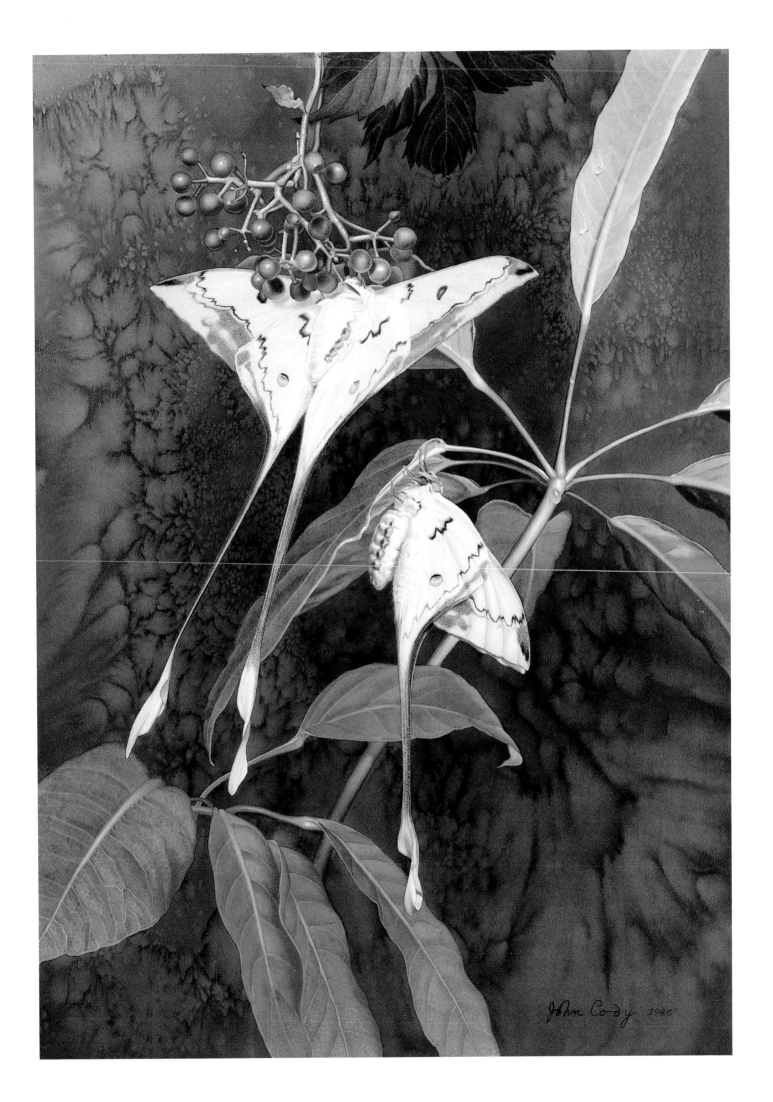

John Cody 1986

PLATE 28

Tusseh Moth, *Antheraea mylitta*, 1986

Collection of Dr. Graham Cody

Size:
150 mm.
Range:
*Central to southern
India and Sri Lanka*

The cocoon of the tusseh moth (also spelled "tasar" or "tussah," meaning "shuttle") is a visually pleasing, decorative object—a large, tan, smooth, perfectly symmetrical oval. A neat cuff of silk attaches it to a stem, and the cocoon hangs from an equally neat ribbon some 100 millimeters long. It is not surprising that ages ago it attracted the attention of human beings who asked themselves what use they could make of these handsome objects. Self-ornamentation probably came first, followed by more ingenious uses. Sericulture (the exploitation of cocoons for fabric production) using these cocoons has been traced back as far as 1590 B.C. Tusseh silk cloth is still made in India today and exported to the United States, Germany, and Japan. According to Richard Peigler, each year this cottage industry attracts hundreds of thousands of dollars to India.

In terms of silk production, one first thinks of the famous mulberry silkworm (*Bombyx mori*). But worldwide, more than twenty-five species of cocoons have been used for the making of fabric. Today, in India, two other "wild" silks besides tusseh are produced. These are *muga* silk, from the fine moth *Antheraea assamensis*, and *eri* silk, from a domesticated version of the cynthia moth, *Samia ricini*. Cloth has been made from the cocoons of the great atlas moth and even, surprisingly enough, from the silk of an atypical butterfly. Butterfly cloth seems to be unique to Mexico. The butterfly is a pierid, a relative of our common white cabbage butterfly.

There are two kinds of silk-yielding cocoons. In one, the silk can be unreeled in a continuous thread, as from a spool. In the other, partly because the caterpillar has impregnated the cocoon with a hardener, the silk must be pulled off the cocoon in wads, which are then spun into thread in the same way that cotton is. The first type, exemplified by the mulberry silkworm, is the more convenient, but excellent cloth can be produced from either kind.

The caterpillar of the tusseh moth is large and impressive and thrives best in extreme humidity. It feeds on tropical oaks and various highly resinous plants. In the United States it can be raised on crape myrtle.

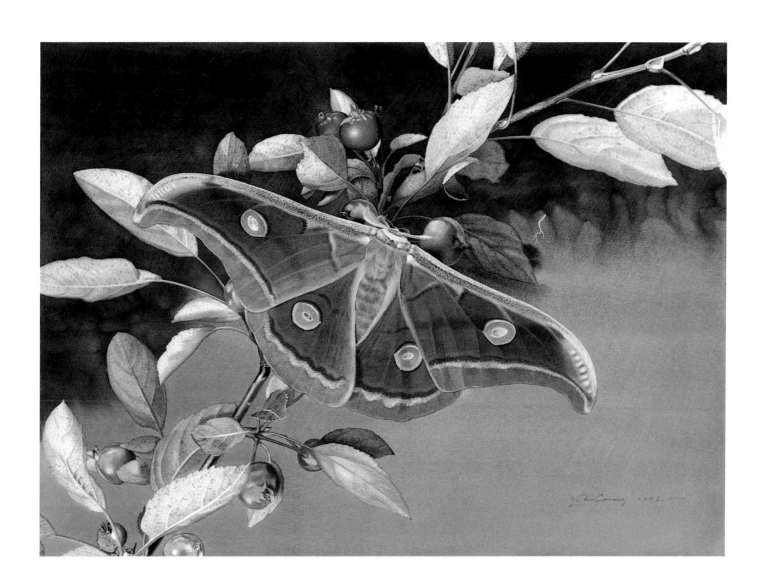

PLATE 29

Malaysian Moon Moth, *Actias maenas*, 1986

Collection of Mr. and Mrs. Joseph Russell

Size:
Female 140 mm.
Range:
*India to southern China
down to Java*

When entomologists are preparing dead moths for collections they put them in the conventional anatomical position and place glass or paper bands over the wings to flatten them. This results in something resembling a pressed flower in a herbarium—convenient, storable, but virtually two-dimensional. One of the glories of the female *maenas* is the attractive twisting and ruffling of the tails. Alive, these appendages appear as fresh and flouncy as orchid petals; dead, they resemble oars. As with orchids, the only way to appreciate their full elegance is to see them in their first bloom.

I once took some live, newly emerged maenas and atlas moths to the Day Hospital to show them to my patients, most of whom suffered from chronic schizophrenia. At least temporarily, the moths jolted these mostly young men and women out of their usual apathy or hostility. I transferred the moths from my fingers to theirs and let them exhibit the moths to the other patients and to the staff. Of course, no one had ever seen such creatures before, much less alive, and most were not even aware that they existed. Eventually overstimulated by so much attention and jostling, the moths took off and flew around the day hall, creating much excitement, until they finally settled down again at the windows.

The patients talked about this experience for weeks afterward. For the duration of their concentration on the moths, the patients were freed from their apathy, depression, and anger. Their negative feelings, focused on themselves, seemed to evaporate as their faculties were directed outward. It made me aware of the importance of novelty and a sense of wonder in the lives of human beings. An earth with no other animals but ourselves would be a realm of apathy alternating with anger. It is essential to mental health, I believe, that we continue to have birds, fish, insects, and all the other creatures that have the faculty of surprising us, fascinating us, and directing our attention, at least from time to time, away from our narcissistic absorption in ourselves.

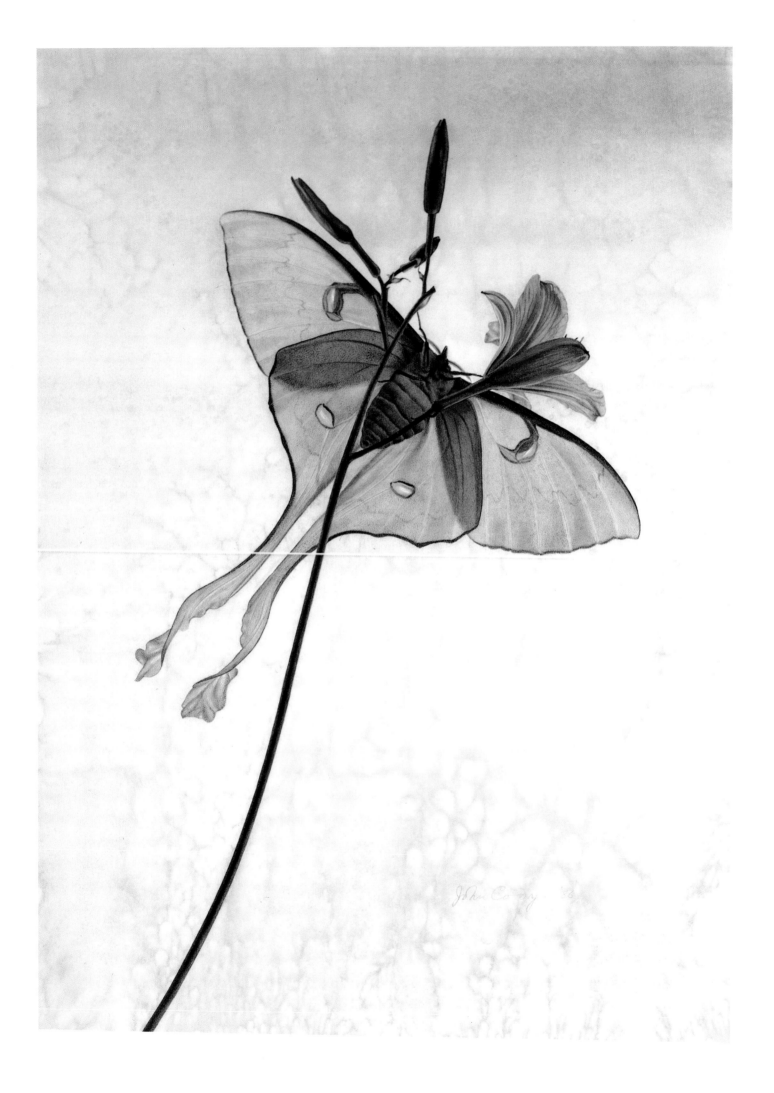

PLATE 30

Rhescyntis hippodamia, 1987

Collection of Mr. and Mrs. Mark Shaiken

Size:
150 to 160 mm.
Range:
Throughout the rainforests of eastern Brazil, along the eastern slopes of the Andes, and along the Amazon to midcontinent

This is a moth about which little is known. According to Claude Lemaire, one of the leading authorities on the saturniids, there are four species in the genus *Rhescyntis*. One of them, *R. descimoni*, was described by him as recently as 1975. It is clear that science is just beginning to approach these moths. As far as I can tell, practically nothing is known about the larval stages. What they look like and what they feed on are equally undetermined. There is apparently some evidence that one of the species feeds on trees in the Myristicaceae, or nutmeg, family. It may well be that the habitats of these moths, the tropical forests themselves, will be gone (and the moths with them) before complete and certain knowledge can be acquired.

The adult moths are known, of course, because they come to lights. Most of the research expended on these creatures so far has been in the realm of taxonomy (classification). The four species are superficially very similar, and only minute examination, especially of the genitalia, can determine which are separate species and which are subtypes.

The specimen depicted in the painting came to a mercury vapor light hung out near Manaus to attract such moths. He looked huge on the wing and was a powerful flier.

One hope of discovering the nature of the larval stages would be if somebody is lucky enough to find a gravid female at the lights and has the further good fortune of finding a plant that the hatchlings from her eggs will eat. Unfortunately, female moths, gravid or otherwise, are much less likely than males to be found at lights, though it does happen.

The moth is shown in the painting with flowers of *Allamanda*, or golden trumpet vine, which, like *Rhescyntis hippodamia*, is native to Brazil, although it is now everywhere in the tropics worldwide.

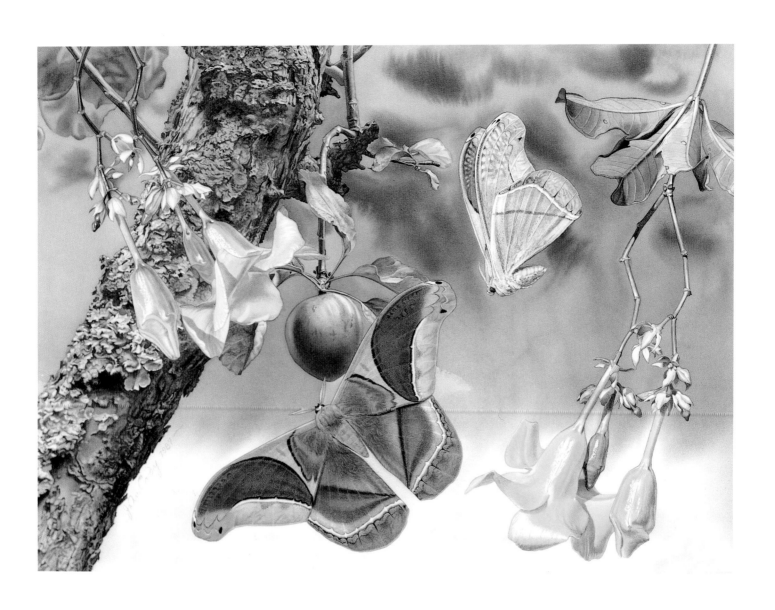

PLATE 31

Luna Moth, *Actias luna*, 1987

Collection of Dr. Graham Cody

Size:
120 mm.
Range:
Eastern
North America

The luna has tantalized me all my life. Though so accessible to some collectors, it has always proved exceedingly coy with me.

One of my greatest buildups and letdowns in the pursuit of saturniids occurred when I was a teenager. Agnes Rand, my lepidopterist friend and neighbor, had chanced upon a hobby shop in Manhattan that sold materials for making "butterfly pictures"—things such as dyed strawflowers and picture frames with padded backs. The flowers, dry and brittle, were used to set off the butterflies when they were mounted and put under glass. In the files and cabinets of this old and shabby little store was a huge collection of mostly tropical butterflies in glassine envelopes, most of which sold for a quarter or fifty cents.

Once Agnes splurged and bought a *Papilio blumei* from Java, one of the most gorgeous swallowtails in the world. She paid two dollars for it—an exorbitant price considering that we were then just emerging from the Great Depression. It proved a bad omen. My sister Evelyn turned a corner of the house too quickly and crashed into Agnes, and that was the end of the specimen.

For me, the most exciting things in the shop were live cocoons. They even had lunas—not ones raised under artificial conditions, but the best kind: wild gathered ones, big, fat, and lively. We saved our pennies, and after a few months we were able to buy a dozen at fifty cents apiece. I remember the joy of holding them in my hand. Brown, papery, and about the size of a walnut, they had a certain heft to them. When we shook a cocoon, the pupa inside shifted from end to end and felt like a bullet. The pupae were extraordinarily restless; they did a great deal of twisting and turning, causing the silken chamber to rattle.

We acquired them in the fall, so they went into the screen-covered orange crate in the backyard along with cecropia, polyphemus, and other cocoons to await spring. What we did not know was that luna cocoons need protection from the weather. Normally they spend the winter under a covering of leaves that shields them from the violence of freezes and thaws. That winter was a severe one, and our cocoons were often embedded in ice, the result of snow melting on the bottom of the box and freezing again. When spring came we reveled in the beauty of many fine moths, but no green ones. Every day, many times, we visited the box. May passed, then June. When we handled the cocoons, the pupae were no longer restless; the "bullets" felt light. Reluctantly and sadly, we accepted the truth. That year the little shop, for reasons unknown, stopped selling cocoons.

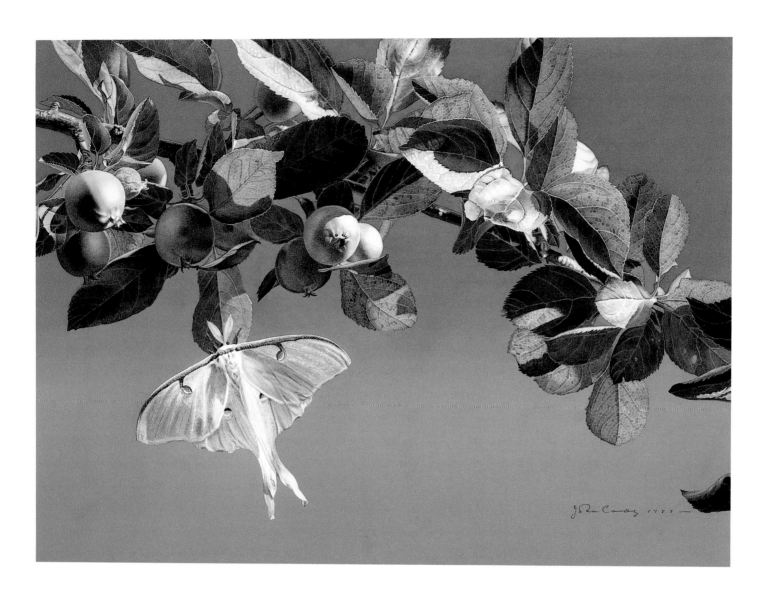

PLATE 32

Ponderosa Moth, *Arsenura ponderosa*, 1987

Collection of Dr. Graham Cody

Size:
180 to 200 mm.
Range:
*Amazonia at
low elevations*

The genus *Arsenura* includes some twenty species of very large moths. Of these species, only *A. cymonia*, a montane species, is found at altitudes above 1,500 meters. They are rainforest creatures, not numerous and not well studied, except taxonomically. Very little is known about the caterpillars of most of them, and almost nothing about the early instars. Food-plants, also, are largely unknown.

Mature larvae of a few species have occasionally been found. They are largely lacking in the protuberances found in most saturniids, and they tend to be smooth, cylindrical, thick, and up to 120 millimeters in length. *A. armida* is dark brown with touches of orange-red on the head and just behind, and on the prolegs and claspers. The *Arsenura* do not spin cocoons; instead they burrow into the ground and hollow out a cell for pupation.

Claude Lemaire has produced a taxonomic monograph on the *Arsenurinae* ("Les Attacidae américains") containing black-and-white photographs of many of the species. The patterns of most of these huge moths are of great beauty, though their coloring is said to be subdued, consisting mostly of shades of brown, sepia, umber, ochre, and the like.

Of all the *Arsenura*, the one I have painted, *ponderosa*, may be the least striking. It is, however, the only one I have been able to obtain. I hope someday in the future that a second *Arsenura* will come my way. At this writing I am anticipating another trip to the Peruvian Amazon, and maybe I'll be lucky.

The plant shown with the two male moths is *Thunbergia grandiflora*, or sky vine, a plant that is everywhere in the tropics and one of the most beautiful.

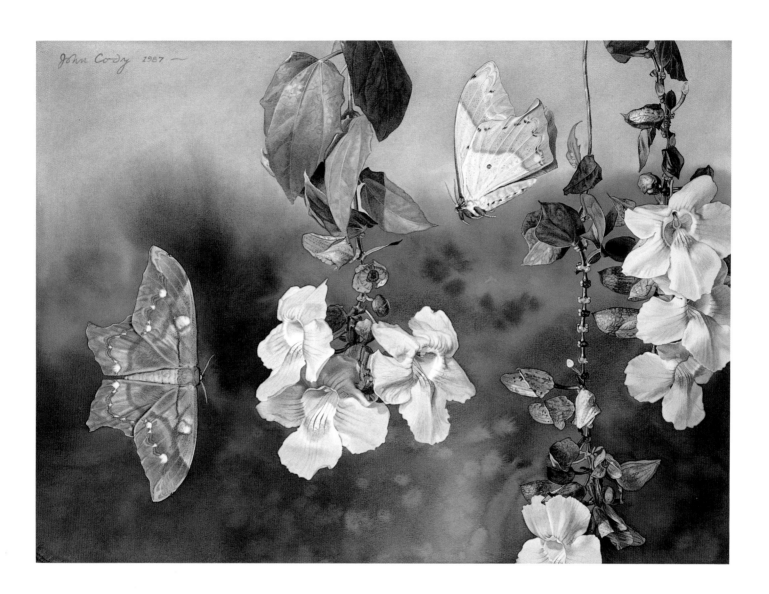

PLATE 33

Ceanothus Silkmoth, *Hyalophora euryalus*, 1987

Collection of Mr. and Mrs. Joseph Russell

Size:
110 mm.
Range:
Pacific Coast from British Columbia to Baja California; also, western Nevada, Idaho, and western Montana

As is evident from the painting, *euryalus* strongly resembles its relative, the cecropia, and both are in the same genus. Though the general pattern is the same, euryalus—sometimes called *rubra*—is much redder in coloring. Rarely, if indeed ever, do their ranges overlap. Therefore, hybrids between the two species would not be expected and, in fact, do not seem to occur.

Yet all four species of *Hyalophora* have been crossed by breeders, producing some beautiful blends and variations. *H. cecropia* has been crossed with *H. gloveri* and with *H. columbia* and so on. There is some evidence that in the wild, cecropia may sometimes cross with both gloveri and columbia, whose ranges do overlap. Usually, the females resulting from these crosses are infertile, but this is not true of the males. Through back breeding via the males, genetic material may enter the mainstream of the other species and produce local variations that maintain themselves. But this tendency to crossbreed seems weak and must occur infrequently. Areas where cecropia and gloveri are both abundant have been studied for decades, for example, yet it has not been observed that the two species produce hybrids; what has been noted is that they exist side by side and independently.

Nature seems to have designed them in such a way as to prevent mixing. No matter how superficially similar two moths of different species may be, minute examination usually reveals marked differences. These differences are most notable in the structure of the genitalia, though to appreciate these differences, one must perform microscopic examination of special preparations. The comparison of genitalia has become the standard way of deciding whether moths are of one species or another. Such studies have occasionally yielded surprises. Moths that look almost identical have turned out to be of different species. Conversely, moths that are markedly different in size, coloration, habitat, and so forth have been proven to be mere variations of the same species. Such studies have brought order to the hitherto chaotic area of classification, where constant argument among lepidopterists was once the rule.

So, in addition to species-specific odors (pheromones), discrepancies in size and form in genital structure tend to discourage the pairing of males and females of different species.

Besides *Ceanothus thyrsiflorus* (blueblossom), euryalus larvae feed on red alder, willow, wild rose, maple, and many other trees and shrubs.

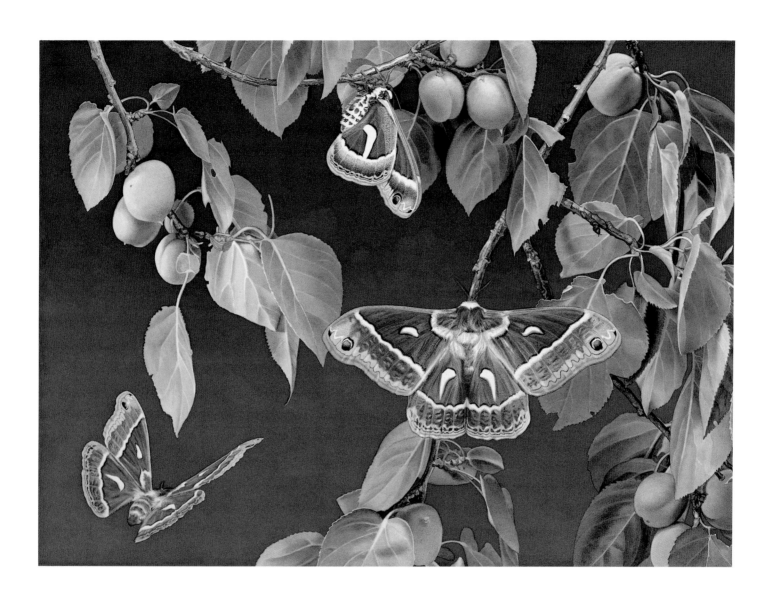

PLATE 34

African Emperor Moth, *Bunaea alcinoë*, 1987

Collection of Mr. and Mrs. Joseph Russell

Size:
120 to 160 mm.
Range:
Most of sub-Saharan Africa and Madagascar

When my print of this painting first appeared, I received a well-intentioned letter from a scandalized entomologist. He complained that I often showed saturniid moths on flowers or fruit. This was misleading because, he informed me, these moths do not eat *anything*, much less flowers and fruit. His letter gave me an opportunity to offer my views and defend my practice. I do not know whether I convinced him. Perhaps I did, as I never heard from him again. Or perhaps he merely crossed me off his list as incorrigible.

In reply, I granted him a valid point, though I felt it did not apply. I said that I was aware that saturniids did not eat flowers and fruit. But, I went on, neither did they spend their entire brief life on the wing. Considerably more than half the time, in fact, they rested on something—something they did not eat. How then should one portray them?

Would not portraying them always in flight suggest they never landed? Would showing them on the ground, where I have often found them, suggest they ate grass? Did the master artists of the past mislead when they portrayed people of modest means dressed in lace and velvet finery? Must viewers conclude that the subjects never took off these clothes? There are certain time-honored artistic practices, and one of them is to show things at their best in surroundings that enhance their appearance.

It is no part of my intention to paint gross incongruities or mislead. I would not show an Amazonian moth on an arctic poppy. I always try to find a *plausible* background, to create pleasing juxtapositions that could conceivably occur in nature.

I have shown the African emperor on trumpet-creeper (*Campsis radicans*), mostly, I admit, because it looked handsome with the moth. The plant, unlike the moth, did not originate in Africa. But it is now widely distributed there, as on most of the continents, as a longtime importation from the New World. As *alcinoë* caterpillars are polyphagous (eat almost anything green), they might conceivably even eat *C. radicans* if given the chance.

My primary purpose, however, is an artist's purpose. My aim is not to create a visual treatise on foodplants or moth physiology. My message to the viewer is simple: observe the beauty of moths; be concerned that they are dwindling; do what you can to see that our planet suffers no further poisoning and impoverishment. That's what I want to get across.

It may be of interest to point out that alcinoë, which eats promiscuously, is itself eaten enthusiastically—by human beings. It is a good source of protein in a land that has a limited supply of that essential nutrient.

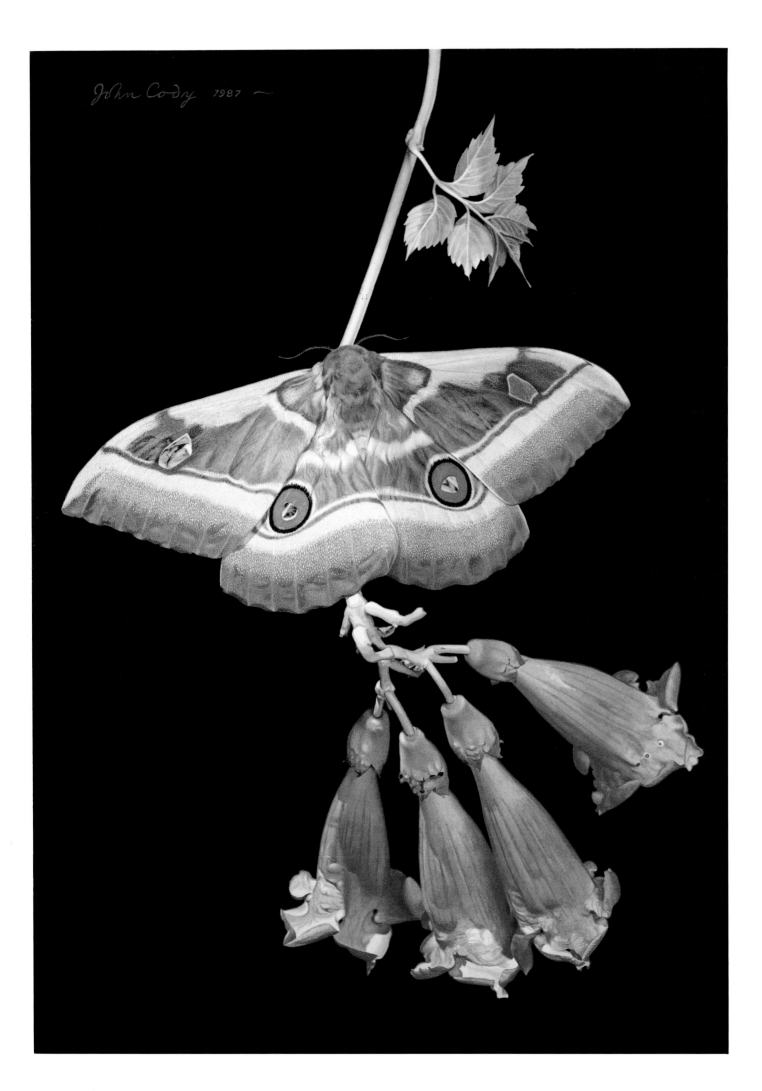

PLATE 35

Chinese Oak Silkmoth, *Antheraea pernyi*, 1987

Collection of Mr. and Mrs. Mark Shaiken

Size:
110 to 114 mm.
Range:
Amurland to
South China

A friend once mailed me a few cocoons of this species, one that was then new to me. The first moth to emerge was the one shown at the bottom of this painting. Note the costa, the leading border of the forewing. It is concave—a most unusual configuration. One not infrequently encounters asymmetrical, deformed moths with crumpled wings, but this specimen did not look malformed. It was symmetrical and perfect otherwise. In my ignorance I took its peculiar shape as the norm for the species. When the second moth emerged I was surprised that its shape was different from the first's and altogether unremarkable, resembling the form of many other saturniids. I concluded that there must be two conformations and went on to paint them both.

Later, I learned that the concave shape is so rare—maybe unprecedented—that none of the saturniid specialists I know had ever met with one.

In the Fall 1993 issue of the *American Entomologist* (vol. 39, no. 3), this painting appeared as the cover. I expected a barrage of criticism or at least questions regarding the atypical moth, but I heard not a peep.

The Chinese oak silkmoth is universally regarded as the easiest of all moths to raise from the egg and is the one most often recommended to beginners. It seems immune to the viruses that kill many other species, it can endure a certain amount of crowding, and it will eat a wide range of leaves: all kinds of oaks, birches, beeches, plum, apricot, cherry, peach, and many others.

It spins a large, beautiful cocoon of tan silk, smooth and oval. An excellent grade of cloth, known as Chinese tussore silk, is made from these cocoons and exported from the moth's homeland.

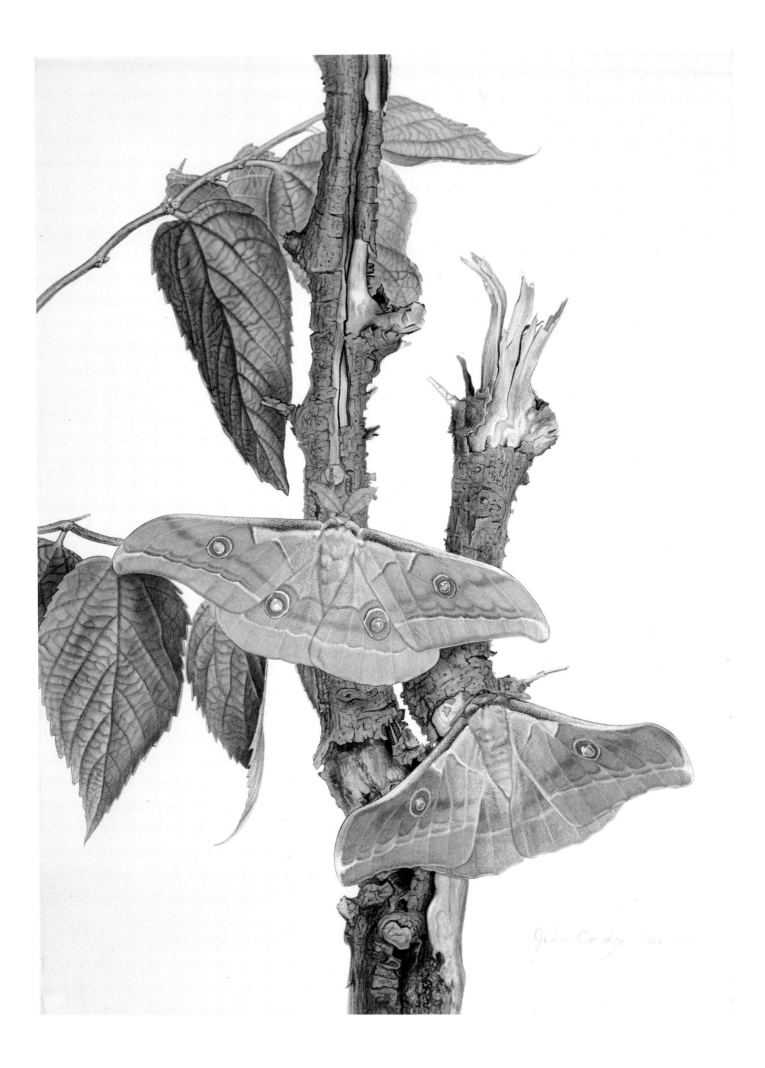

PLATE 36

Stained Glass Moth, *Graëllsia isabellae*, 1988

Collection of Mr. and Mrs. Joseph Russell

Size:

70 to 100 mm.

Range:

*Central Spain,
the Pyrenees, and
the Hautes Alpes
of France*

More than a bit of good luck lay behind the painting of this fine moth, generally put forth as Europe's most beautiful insect. Though most, if not all, of the world's saturniids appear to be decreasing in numbers, the stained glass moth is the only one so far officially declared in danger of extinction. As with many vulnerable animals, a problem is that it has a small range geographically. A montane species that feeds on various pines, it is found only in central Spain, the Pyrenees, and the Hautes Alpes of France. Because it is protected, it is illegal to collect *isabellae* and take them out of Spain and France. When I read in Gardiner's "Silkmoth Rearer's Handbook" that "the chances of obtaining stock of this species are now very remote," I despaired of ever obtaining a model to paint.

But here and there, before the ban, lepidopterists obtained eggs and established small breeding programs on an amateur basis in England and in this country. One such lepidopterist was Molly Monica of New Jersey, so I contacted her. She seemed willing to sell me four of her precious isabellae cocoons for what seemed to me the very modest price of nine dollars apiece. Overwhelmed by the opportunity, I sent my check and included one of my limited-edition moth prints in appreciation. I hope Molly got half as much joy from my gift as I got from her cocoons.

That was in February 1988. Fortunately, isabellae likes the cold. Indeed, for lack of a cold spell, it may stay in its cocoon for an extra year. I say "fortunately" because my mailbox is in the open, and on occasion, small parcels have stayed there for days in Kansas blizzards. (I later discovered that two of the pupae had indeed died, though probably from other causes: pupae are vulnerable.)

Less that two weeks after the cocoons arrived, I was scheduled to go to Brooklyn to celebrate my mother's ninety-first birthday. I doubted the moths would emerge soon, and I about decided to leave them behind. Then I considered that, as they might well represent the only opportunity I would ever have of seeing a live isabellae, it would be wiser not to take any chances. At the last minute, I slipped the four cocoons into the pocket of my overcoat and arrived with them in New York on February 22.

On March 6, my mother knocked at the bedroom door to tell me that the fluttering of a big moth against her window had awakened her. I had left the cocoons on damp soil at the base of one of her houseplants. There it was, a perfect male, far more splendid than any of the pinned specimens I had seen. A couple of days later a female emerged. Two rare, superlative models!

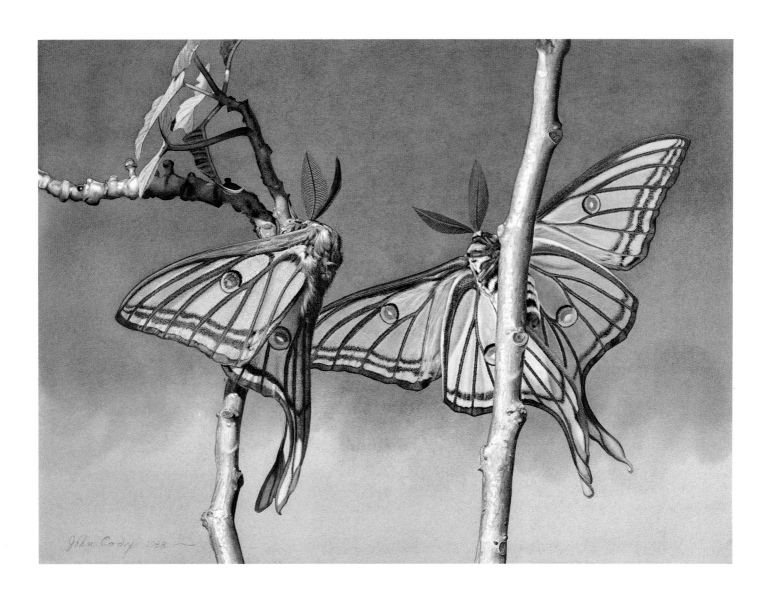

PLATE 37

Hercules Moth, *Coscinocera hercules*, 1988

Collection of Dr. Graham Cody

Size:
250 to 360 mm.
Range:
*New Guinea and
the Australasian
archipelago*

In May 1979, I read an article in *Smithsonian* by Noel Vietmeyer on "butterfly farming" in New Guinea. Included was a photograph of a young man with a hercules moth in his hand. It was huge, as large as an atlas moth, but entirely different in shape. Fourteen months later, after receiving advice from Robert M. Pyle, who had been instrumental in setting up the farms, Dot and I were off to New Guinea. Ultimately, we arrived at Maprik, the highland jungle village that had been mentioned in the article, and checked in at a so-called bush chalet.

All was halcyon for four days and, although our room was "without facilities" (as was every other room), we enjoyed ourselves hiking and exploring. Saturday, August 7, was payday in Maprik, and the chalet bar was jammed with hundreds of young male Melanesians consuming great quantities of "greenies" and "brownies"—their names for the local beers, based on the color of the bottle. Suddenly, a riot broke out. The locals, having successfully stoned the chalet's previous manager to death a month before (we learned later), decided to do the same to his successor, who, like the first, was of the wrong tribe. There was much yelling, furniture breaking, bottle smashing, and lots of general noisy slamming-around. From our window we saw a hailstorm of large stones flying through the air. Under this downpour, the manager, his leg bloody, was running for his life. He managed to lock himself in his office as stones and bottles bounced all over the tiny building.

At the height of the uproar, a vanload of people from the Bishop Museum happened to arrive. The driver jumped out, took one wild look around, shouted to the others in a British accent, "To them, we're just like a red flag to a bull, you know," hopped back in, and roared off, never to be seen again.

When things quieted down, I ventured out to the bar at the rear of a vast veranda and discovered squashed on the floor my first hercules moth, a victim of the recent melee. It was a male and had long tails, like a huge chocolate-colored luna. I did not recognize it as a hercules, having previously seen photographs only of the tailless female. Later, I saw one incorporated into the headdress of a man otherwise wearing only "ass grass."

Finally, the moths began coming to our lights in ample quantities. I picked up an empty cocoon wrapped in avocado leaves, one of the foodplants. It caused a bit of consternation in Papuan customs as we were leaving, as it is illegal to export live insects. Understandably so. One of the few items New Guinea has to sell to other countries is its great moths and brilliant birdwing butterflies, and it does not want outsiders to breed them elsewhere.

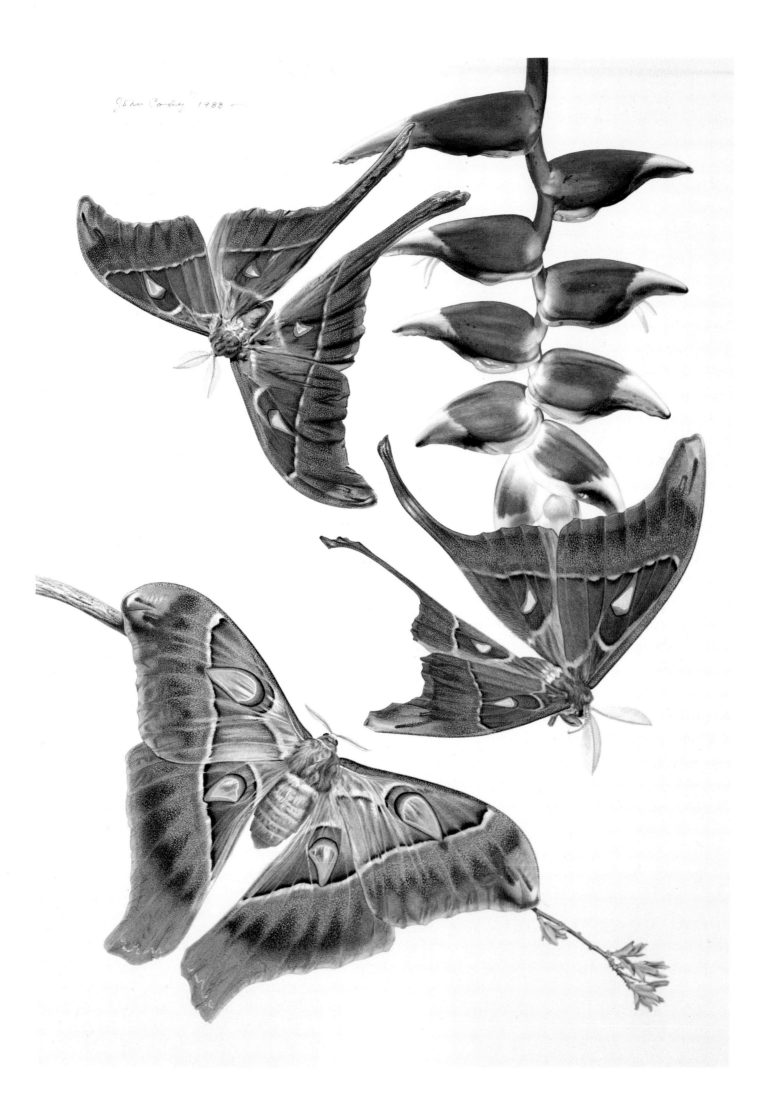

PLATE 38

Simla Moth, *Caligula simla*, 1988

Collection of Dr. Graham Cody

Size:

140 mm.

Range:

Himalayan region

If I were superstitious, I would maintain that the name "simla" was my harbinger of good fortune. It has entered my life on two occasions, decades apart, each time ushering in unforeseen affirmations.

Its first appearance occurred when I was twenty-five. It was all the more telling because it followed a time of discouragement. I had gone to great effort to arrange for a trip to Africa to raise, study, and paint the native saturniid moths. I had a place to stay and a senior lepidopterist mentor willing to place his insectory at my disposal for the rearing of larvae. All I lacked was money. I applied for a Guggenheim Fellowship as an artist-scientist, but I was rejected. I was told later that I had fallen between two stools, being neither an artist nor a scientist but a hybrid.

One of my sponsors had been William Beebe, then at his field station in Trinidad. I had met him once briefly and shown him my moth paintings. His electrifying response to the Guggenheim rejection was to invite me to be his staff artist on his next expedition! The name of his jungle villa and laboratory was "Simla." At the completion of that incomparable experience, the name faded from my life for the next forty years.

In August 1984, I was in England, where I was given cocoons by a young British lepidopterist, Len Hart. Two moths emerged while I was still at the hotel in South Shields, and there I drew and photographed and laid out a painting. They were simla moths from India, named, as was Beebe's villa, after the lovely resort town on the lower slopes of the Himalayas.

When I went for an interview at the Smithsonian on March 2, 1987, to see about the unlikely possibility of having an exhibition there, a mishap occurred that is too complicated to go into here. The result, though, was that I had only two paintings in my portfolio, one of which was the only-half-finished painting of the simla moth. The background had turned out beautifully, but the moths were white blanks, because I had inadvertently left my models in the hotel in South Shields! (A year and a half later, a lepidopterist in England, D. P. Kaye, kindly sent me three moths so I could finish the painting.) I showed what little I had to the chairman of the Smithsonian exhibitions committee. He looked at the white silhouettes and did not seem impressed.

But I misread him, and in 1990 the one-man show of my moths took place—probably the climax of my life as an artist. "Simla" had worked its charm! I published the painting as a "Smithsonian Commemorative" print. Incidentally, the Indians have reclaimed the word from the British and returned to its original pronunciation: "SHIM-la."

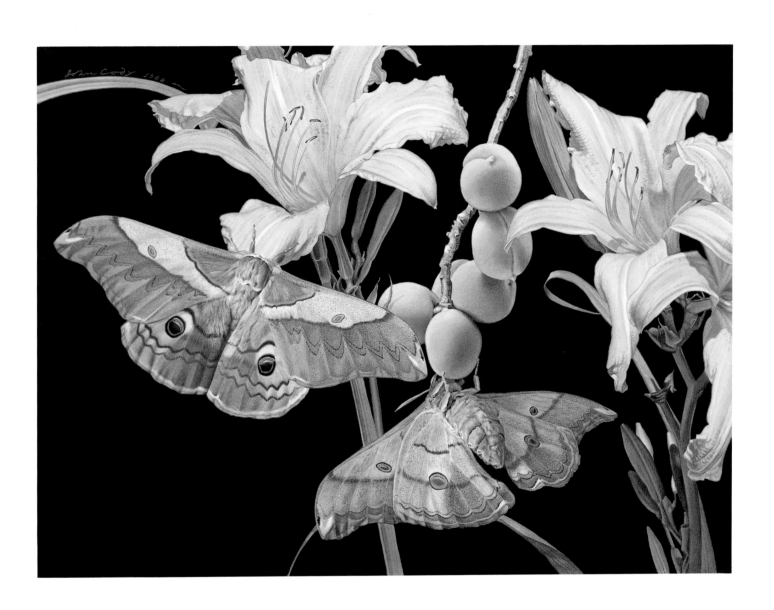

PLATE 39

Semiramis or Oar Moth, *Copiopteryx semiramis*, 1988

Collection of Mr. and Mrs. Mark Shaiken

Size:
*Male 100 mm.,
tails 100+ mm.;
female 110 mm.*
Range:
*Southern Mexico to
north central Argentina
and southeastern Brazil*

There are seven subspecies of *semiramis*, according to Lemaire, and four other species in the genus *Copiopteryx*. All look much alike, and all raise cryptic coloration and obscurity of image to new heights. The males have long thin tails, and in the subspecies *phoenix* they reach a length of 130 millimeters or more, about thirty millimeters longer than the moth is wide. The tails on the female are shorter, but more irregular and perhaps more interesting in shape.

Both the configuration and coloration of the wings cause *Copiopteryx* moths to resemble curled, dead leaves with patches of fungi. The areas of light and dark in their patterns are contrasty and disruptive, so that amid the splashes of light and shadow that dapple the jungle, the outline of the wings is broken up and hard to perceive. In daylight, the moths remain absolutely motionless for hours, as though secure in their invisibility.

The painting is of a male moth resting on a fuchsia, a plant native to the same area. I chose to surround the moth with bright colors—reds, greens, and blues—as removed as possible from its browns and tans to show that it is not just the insect's protective color that makes it hard to see. As I think the painting shows, complexity of outline and juxtaposing of light and dark contribute as much to the obscuring effect.

An all but virgin field is open to research into the larval stages of *Copiopteryx*. Nothing is known about the caterpillar's feeding habits or even what it looks like. Sadly, the rainforests may well be gone before anyone has a chance to make these studies. The moths themselves, like many other saturniids, are dwindling numerically. A couple of years ago I was talking with Tina Garzon of Tinalandia, Ecuador, who has lived in the jungle there for many decades. Señora Garzon told me that until a few years ago several *Copiopteryx* moths could be expected to visit the lights on her veranda almost every night. Now, she says, she scarcely sees one a month. She attributes this to the extensive deforestation going on throughout the country and all around her property.

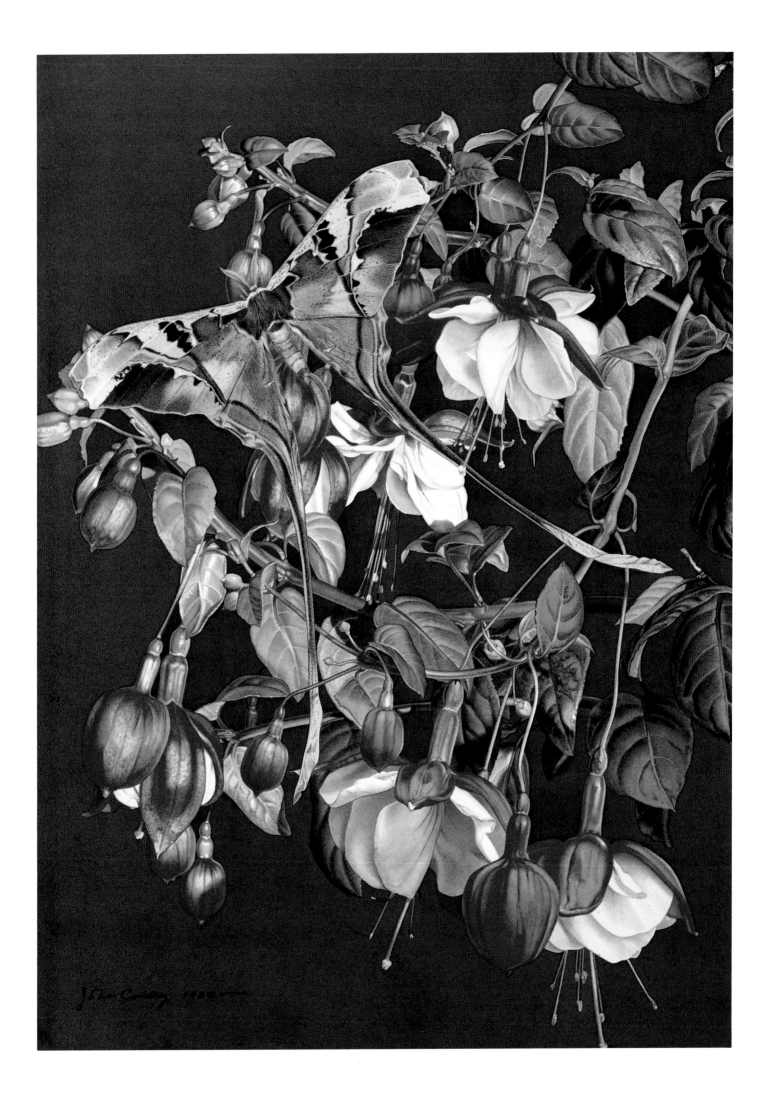

PLATE 40

Australian Silkmoth, *Opodiphthera eucalypti*, 1988

Collection of Dr. Graham Cody

Size:
120 mm.
Range:
Australia and
New Zealand

Not many laymen ever get more than a passing glance at a fine moth or butterfly. Yet the many beauties of these creatures cannot be fully appreciated, or even perceived, from a distance. To do them justice, one must look at them very close up, and for a longer time than normal circumstances allow. By painting moths larger than life-size—and sometimes much larger, as in this painting—I attempt to afford the viewer a chance not only for prolonged observation but also for a really close-up view.

Here the moths are magnified, so the effect from a normal viewing distance in a gallery is about like having the moths eight or ten inches from one's face. With a live moth this would be uncomfortably close for many people. In a painting, though, it is acceptable. Under these conditions, details of pattern and texture became readily available to everyone.

To my eye, even the enlarged faces, bodies, legs, and antennae of the moths are attractive. Not only are the plump bodies velvety and unlike the alien, crusty hides of other insects, so also are the legs, which, in their relative shortness and furriness, take on a kindred look, congenial to us mammals. To many people these qualities have something in common with the comfortable features of the soft toys of a child. They are also the answer to the question, asked me by so many people, "Why paint moths and not butterflies?"

I have painted butterflies enough to know that they are not for me. A few years ago I had a go at some magnificent examples. One was a brilliant New Guinea birdwing, *Ornithoptera priamus*, in all its fluorescent green-and-black splendor. Another painting was of two crimson-and-black Asiatic swallowtails. From the standpoint of wings alone, they made superb subjects.

But enlarge their heads, bodies, and legs proportionately—say, two or three times life-size—and you have something skinny and awkward. Unlike saturniids and many other moths, butterflies have naked, wormily segmented bodies that, when depicted the size of sausages, are not terribly attractive—at least to me. Furthermore, butterfly legs are usually extremely long, sometimes three times as long as saturniid legs, and they are meager, shapeless, and shiny. If all six of them are on display, the effect is of a bundle of varnished sticks. Add to these the equally long and threadlike antennae, and one has a plethora of narrow, stiff forms extending in every direction. Out of these one must create an integrated, flowing composition.

Why did Rubens and other old masters chose as models robust, generously proportioned women? Not because they extolled obesity. It was because these overflowing women filled up the canvas with abounding volumes and provided a surface ample enough to show all that could be done with paint.

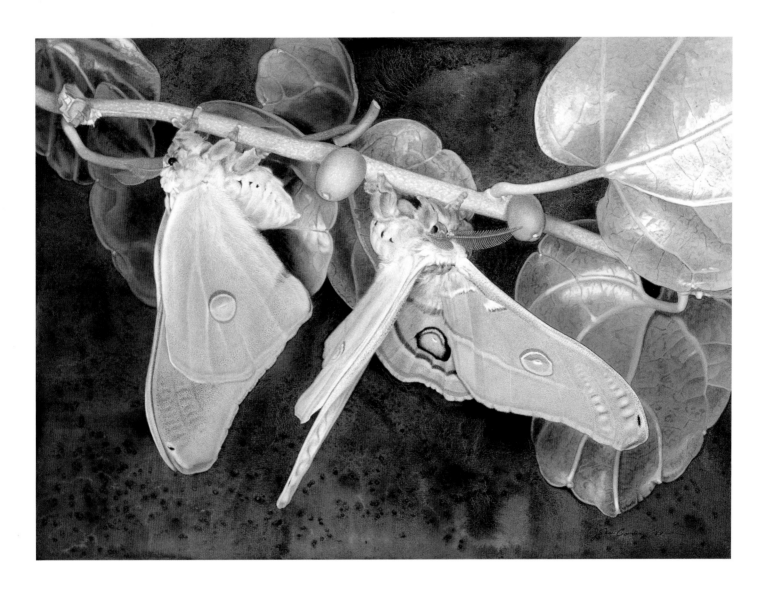

PLATE 41

Pine Emperor Moth, *Imbrasia cytherea*, 1989

Collection of Dr. Loren Genevieve Shaiken

Size:
110 mm.
Range:
South Africa

This beautiful moth, whose caterpillar is said to be equally beautiful, is one of the very few saturniids that is considered a pest. It feeds on pines in its native land, but to what extent it really injures them I have been unable to find out. In captivity in England, the caterpillar has proved polyphagous, and it is known to feed on cypress, wax myrtle, ebony, tulip-tree, buckthorns, sumac and, of course, pines. It is mostly black, with bands of brick-red between segments, and dotted all over. On the sides, the dots are green and yellow on black; along the back, they are green and silver. It is covered with nonstinging spines.

In the painting I have shown a full moon to suggest the importance to moths of lights, especially the moon and stars. It is a truism that moths come to lights, and it is often said that they are "attracted" to them. The truth seems to be that they are not attracted to them at all but, rather, come to them inadvertently.

Here is how it seems to work. The female emits scent molecules of pheromone to "call" the male. These molecules disperse in all directions. The antennae of the male detects them, and it becomes his aim to follow the trail to his mate. He goes from molecule to molecule until he finds their source, the female.

But the molecules are not distributed in two dimensions like Hansel's linear trail of bread crumbs. Instead, they spread out in all directions in an expanding sphere. What then keeps the male from zigzagging and backtracking and going off on tangents of all kinds? The answer is: the moon, or a star. The male locks himself into position relative to one of these celestial lights. He chooses one and "fixes" on it. Then, keeping the star constantly on, say, his left, he does not deviate but proceeds roughly in the same direction. Never losing his sense of where he's going, never backtracking because of his orientation point, he at last comes to the source of the pheromones.

But what if he fixes on a man-made light? An earthly creature cannot move past a star, but this is not so with man's little lights. If the moth keeps a man-made light always on his left, he will begin to swerve as he flies past it. So he turns. The constant left-side orientation will then draw him into ever-tighter turnings until at last he spirals into the light, leaving the "calling" female miles away. It is this role played by lights in mate-finding that has led many entomologists to conclude that light pollution is a cause of the decline in moth populations.

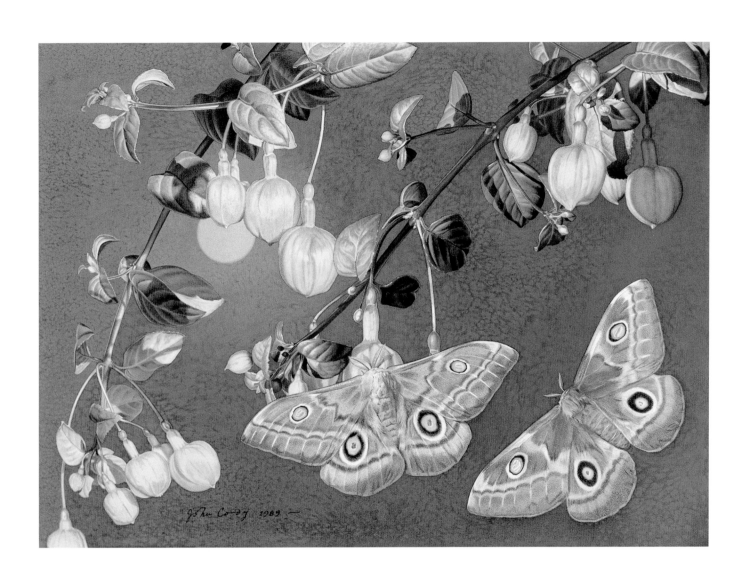

PLATE 42

Malaysian Moon Moth, *Actias maenas*, 1989

Collection of Mr. and Mrs. Joseph Russell

Size:
Male 115 mm.;
female 140 mm.
Range:
India to southern China
down to Java

The *maenas* cocoon is brown and substantial, about 60 millimeters long and 30 millimeters wide. Compare these dimensions with those of the moth: the tails of the male are 150 millimeters long, its wings 115 millimeters wide. How can a moth measuring 115 × 150 emerge from a 60 × 30 cocoon? All moths look enormous in comparison with the silk chamber they emerged from, but maenas, with its extraordinarily long tails, dramatizes the discrepancy.

The wings, before emergence, are not folded, crumpled, wrinkled, or otherwise crammed into the small space. There is plenty of room. Rather, the wings are simply miniature, with all the characteristic markings already on them, somewhat like the Lord's Prayer etched on the head of a pin. Each one is about the size of a fingernail, but much thicker. Near the medial side of each hind wing there is what looks like a deep notch or nick. What will become the long tail appears as a mere remnant of wing medial to the notch. At this stage it is only about three millimeters long—in other words, tiny—and it does not project beyond the rest of the wing border. As the moth wriggles out of the cocoon, the wings on each side look somewhat like ear flaps or, if that is too fanciful, gills.

As soon as the moth settles on a stable perch at the angle all moths prefer for this process, it begins to pump certain body fluids into the veins of the wings. One cannot actually see the wings expanding, as one sees a balloon enlarge as it is blown up. But if one looks away for a few seconds, then looks back, one sees that the wings are bigger.

In about fifteen minutes, the forewings are full-sized, but the hind wings are still tiny and becoming wrinkled, and the tail is still a speck. At this point the moth is a curious sight—a soft jumble of color, a tiny heap of laundry. In another fifteen minutes the hind wings have achieved their full size, but the tails are still almost invisible. Then they begin to elongate, and they grow and grow. In three-quarters of an hour the tail has increased to fifty times its starting length. The moth now appears almost as it does in the painting, except that the wings are still soft and hanging straight down. They cannot yet stand out at an angle. If one blows gently on them they billow like curtains. After the passing of another hour the wings are firm and relatively stiff, and if provoked, the moth will fly.

It is a rapid and marvelous transformation.

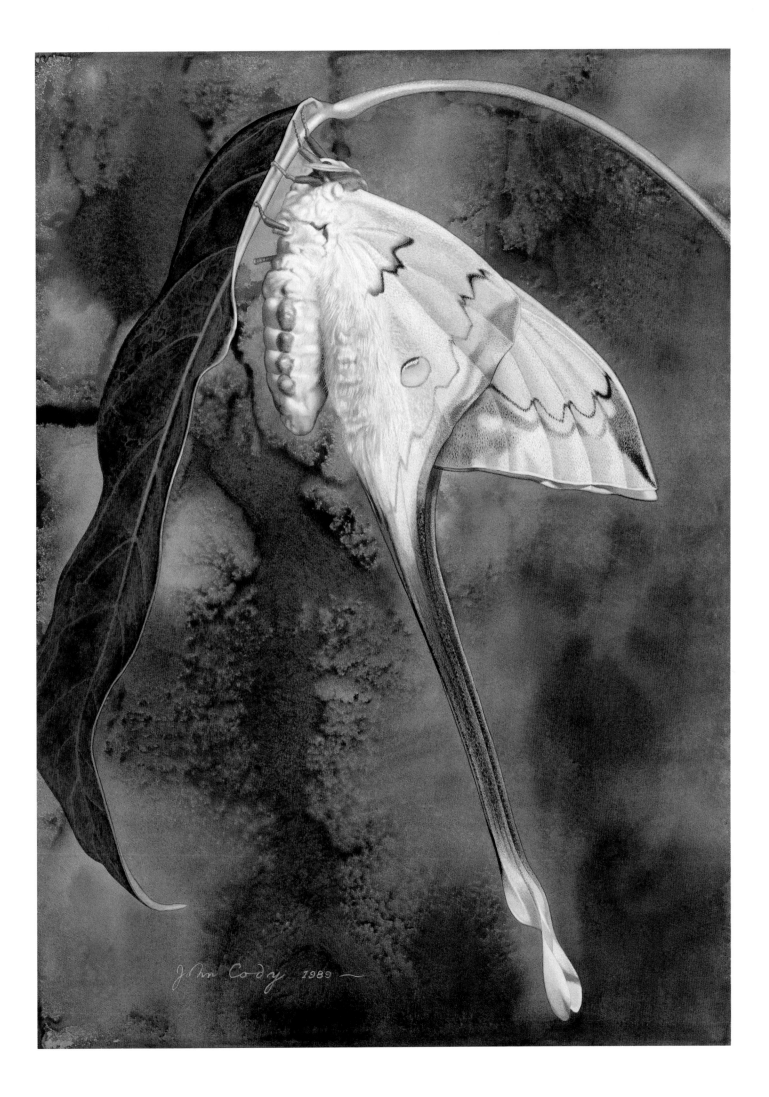

PLATE 43

Eupackardia calleta, 1989

Collection of Mr. and Mrs. Joseph Russell

Size:
110 to 130 mm.
Range:
Southern Texas,
southern Arizona,
and Mexico and
into Guatemala

In their very dark coloration, both male and female *calleta*s resemble the male promethea moth, though considerably larger. Morphologically, they appear to be midway between the *Callosamia* species, of which the promethea is one, and the *Rothschildia* moths. In other ways, however, they are unique, so taxonomists place calleta in a genus of its own.

An example of its peculiarity is its flying habits. The male is a day-flier. He is on the wing between 8 and 9 A.M. and has usually found his mate before noon.

Surprisingly, the female is nocturnal. As is typical of most nocturnal species, her eyes are relatively large, while the male's are not. She leaves her perch, seeks foodplants, and lays her eggs only after dark, and like most male moths of other species, and unlike most females, she is "attracted" to lights.

Unusual too is calleta's emergence schedule. In March, only some of the moths exit their cocoons, leaving the preponderance still dormant. The remainder emerge in September and November. In Arizona, their emergence occurs in August, where it is triggered by the first rains.

The caterpillars feed on the shrub ceniza, often used as a hedge plant, and on the desert plant ocotillo. In captivity, they will feed on privet, ash, willow, lilac, and various species of plum and cherry. In the painting, the moths is shown on lilac.

The caterpillar attracts attention. Villiard calls them "gaudy" ("Moths and How to Rear Them," p. 117), and Ferguson says that the general effect "is of a strikingly colored, bright green caterpillar with red and black markings" ("The Moths of America North of Mexico," p. 231). Gardiner adds the further detail that the rows of tubercles are blue with red bases ("A Silkmoth Rearer's Handbook," p. 145). Neither Lemaire nor any of these authors say anything about what happens to the eggs laid in November. I assume they feed throughout the winter in their usually warm environment.

Whenever I travel in the United States, I take my most indispensable cocoons with me. The calleta shown in this painting was my first; it emerged with several others in Georgia, where I was having an exhibition of my paintings at Callaway Gardens. I believe one of them was the first moth to be released into that enclosed butterfly paradise.

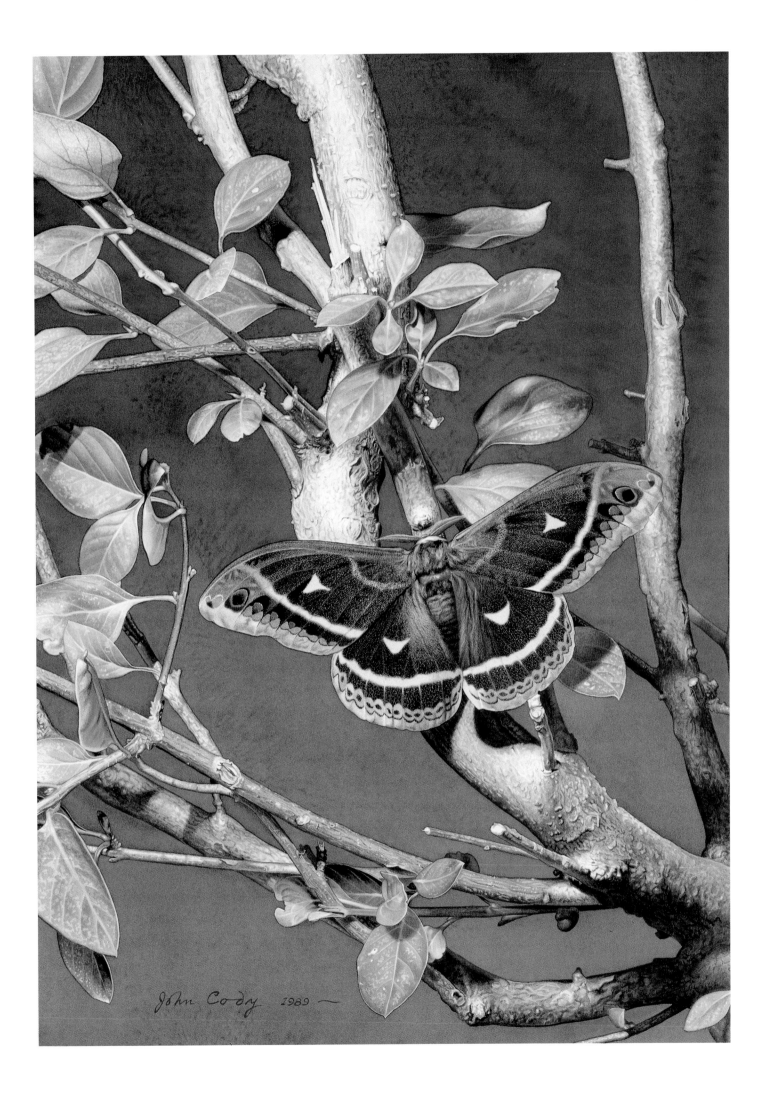

John Cody 1989

PLATE 44

Rothschildia forbesi, 1989

Collection of Dr. Graham Cody

Size:

90 to 100 mm.

Range:

Lower Rio Grande Valley, southeast and adjacent areas in Mexico

I have little specific information to convey about this moth from my personal experience, and the literature is not abundant on the subject. What I will say here will be in the way of generalization, followed by a specific comment about the relevant painting.

The saturniid moths, like all insects, have six legs. When they are determined to cling to something, they can be extraordinarily tenacious and difficult to pry loose. The "foot" has at its end a little claw, the pretarsus. Like the metal hooks of rock climbers, the pretarsus digs securely into the crevices of a rough surface, such as that of a twig. To displace a resting atlas moth, particularly, or any of its relatives, the *Rothschildias,* it is almost necessary at times to proceed leg by leg. At other times, however, the same moths seem remarkably blasé about falling and, as this painting shows, may cling with fewer than their full complement of legs. In this case, the moth hangs on by only one, the other five nonchalantly tucked in against the thorax. I suppose a certain casualness with regard to heights is both a hallmark and privilege of creatures that can fly.

Though this one-legged hold is not at all an uncommon posture for saturniids, I used it to suggest that the family's purchase on existence is, in increasing numbers of species, becoming precarious.

Furthermore, I chose to place a green, smoky, speckled sky behind the moth for at least two reasons. The first is, of course, aesthetic. I felt that the color (along with the bit of pink bougainvillea) contrasted nicely with the colors of the moth. But the second was to suggest some unnatural and sinister alteration in the atmosphere, some kind of pollution. Acid rain, I know, is not green; besides, lepidopterists are not entirely sure that acid rain is partly responsible for the decrease in saturniids, though it seems likely. I chose the color because, of the entire spectrum, only a yellow-green seems to suggest to very many people something noxious.

Primarily, I wanted to make a beautiful painting that did the moth justice. Secondarily, I tried to convey the message that priceless forms of life are imperiled by the pursuits of humanity. Be concerned about cleaning up the earth.

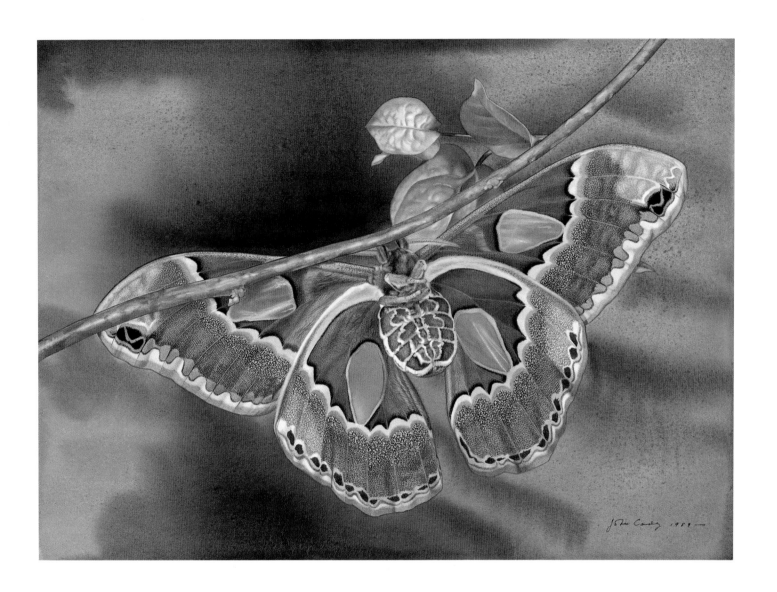

PLATE 45

Royal Walnut Moth Caterpillar, *Citheronia regalis*, 1990

Collection of Dr. Graham Cody

Size of mature
caterpillar:
150 mm.
Range:
*Eastern
North America*

Occasionally, the nomenclature of entomology is unintentionally symbolic of larger things. The hickory-horned devil, the most fearsome-looking of all caterpillars, emerges from its pupa case as the demure regal moth or royal walnut moth. The substitution of moth for caterpillar thus elevates devil into king, a sort of "born again" conversion and coronation. Even its Latin name, *regalis*, signifies royalty. One does not have to delve deeply into the history of rulers to find parallels to this metamorphosis.

So frightening is this dragonlike larva, with its long, curving red horns and formidable size (it can be six inches long when mature), that even entomologists have shied away from touching it. The lepidopterist Paul Villiard, for example, in his book "Moths and How to Rear Them," writes that regalis "is one of the very severely urticating species, and should be handled with care." Scared by this, I tried to keep a respectful distance from the first of the species that came my way.

I was given some regalis eggs by a physician friend of mine, Mark Schmidt, which in time hatched into half-inch baby caterpillars that even at this stage were complete with a cluster of long, nasty-looking horns near the head. I fed them on lilac leaves, transferring them to fresh leaves every day and always being paranoid about letting my skin so much as brush one of them. Over the course of weeks, familiarity bred carelessness. As the caterpillars grew ever more threatening in appearance, I grew ever more blasé, and soon I was bumping into them right and left. I felt no sting, developed no hives. Emboldened, I experimented. I handled the full-grown larvae, stroked their horns, touched them to the tender underside of my arms. Nothing happened.

Were these specimens somehow a peculiarly harmless variation on the norm? I have an unusual resistance to poison ivy—did I have an unusual resistance to regalis poison too? Or was Mr. Villiard peculiarly allergic to regalis caterpillars? These are the questions I asked myself. Time, newer research, and the experience of other lepidopterists answered them. The regalis looks malevolent, but it is completely harmless.

One more observation: before my caterpillars burrowed into the ground to undergo their transformation (they do not spin cocoons), they turned from green to a strange dusky turquoise color, looking like patients who had become cyanotic from lack of oxygen. They also became unceasingly restless and wandered everywhere in seeming agitation, as though they realized that a great change was about to come over them. Perhaps that is how a pretender feels just before ascending the throne.

The painting shows regalis in its normal resting posture.

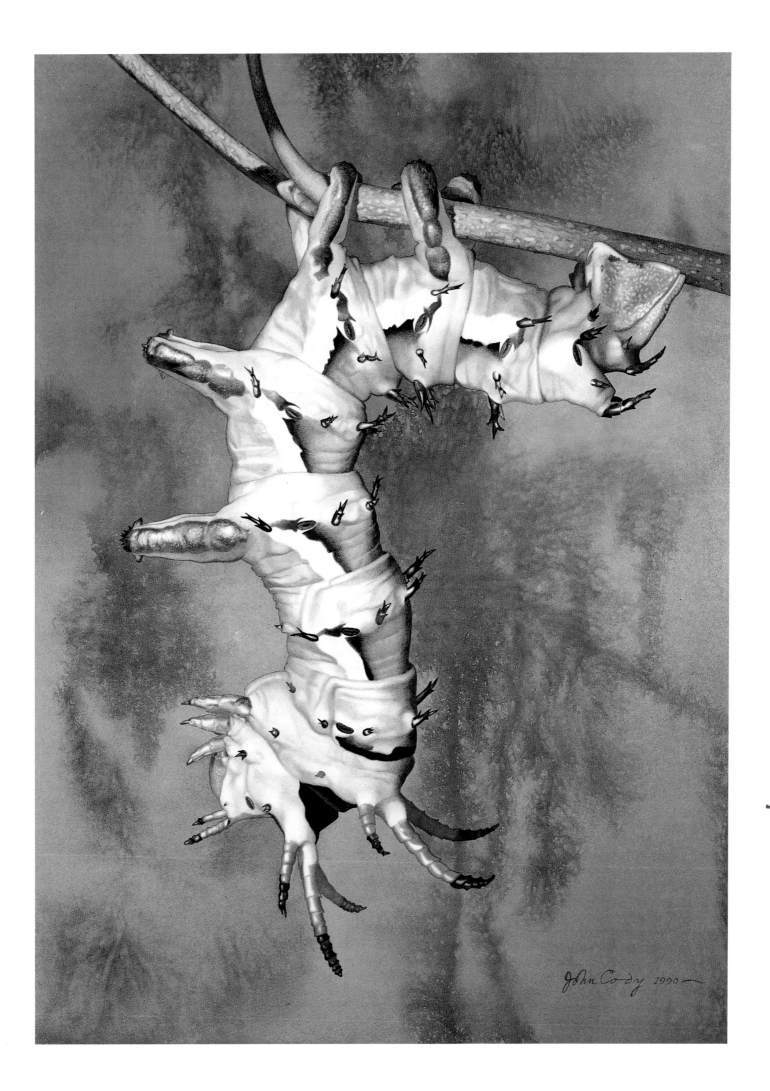

PLATE 46

Automeris postalbida, 1990

Collection of Mr. and Mrs. Mark Shaiken

Size:
150 mm.
Range:
*Tropical South and
Central America*

I spent my sixty-fifth birthday in Tinalandia, Ecuador, where nature, with the help of a young friend, gave me a handsome present—the moth in this painting.

I was with a large group of mostly amateur lepidopterists. By day they maniacally wielded their nets in pursuit of their goal, the amassing of the largest possible quantity of butterflies. That day, as most days, I split off from the group to wander alone and without a net in the lovely jungle, pondering what it meant to have reached so advanced an age. That night, as every night, the trees were festooned with illuminated sheets everywhere one looked. Though moths were a distinctly secondary interest for all but myself, most of the collectors were not averse to going home with one or two provided they were large and impressive enough. To attract these, they strung up against their sheets immensely bright mercury vapor lights, and the moths came.

That evening we were all having dinner as usual on the open porch. Some of us were seated around a twenty-foot table; others were deployed at a number of smaller tables. The porch was jammed, with hardly enough space for the servers to get through. The room was illuminated by a few weak incandescent bulbs, to the extent that we could hardly see what was placed before us in the dim yellow light.

Suddenly a large dark moth flew into the room, landed briefly on the table, and then darted here and there, flying just over our heads. Pandemonium! Everyone exclaimed at what a beauty it was, and several jumped up and grabbed their ever-ready nets. It seemed ironic that no similar moth had come to the terrific mercury lights, while here what brought it were those yellow bulbs. The man at the head of the table, who was generally regarded as the most specimen-greedy and who had the most room to maneuver, scrambled around heedless of everyone, and succeeded in clutching the moth in his hand, killing it (and mangling it in the process) with a powerful pinch to the thorax. Then he displayed it to everyone. I admit I felt envy and wished I could paint it. My young friend, Paul Schulz, said, "Oh, please give it to John. He's the one really interested in moths. Besides, it's his birthday." When the man refused, I said, "I don't blame you. You came here to collect, just as I did."

Then the incredible happened. An identical moth, though a better specimen, followed the choreography of its forerunner to a T. This time Paul was ready. He leaped over the unprepared collector, caught the moth in his net, and presented it to me wholly undamaged—all in a twinkling. Everyone applauded, and we had mangos for dessert.

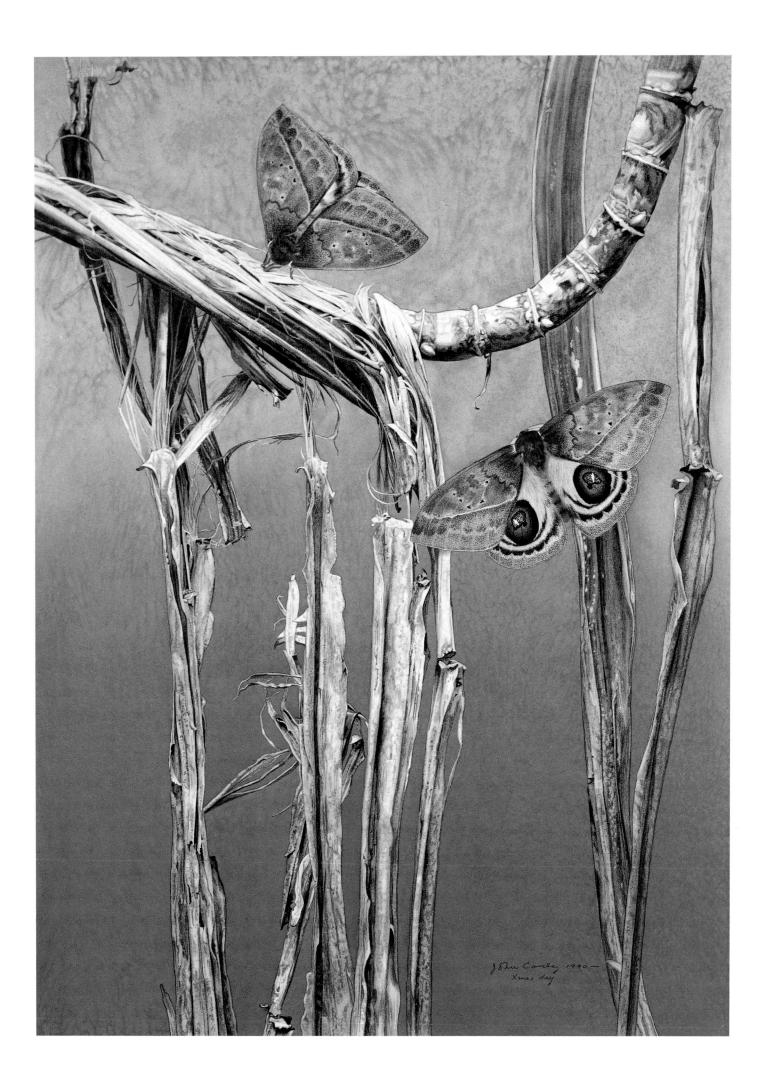

PLATE 47

Titaea lemoulti, 1990

Collection of Mr. and Mrs. Joseph Russell

Size:

135 mm.

Range:

*Most of tropical
South America east
of the Andes*

There are four known species in the genus *Titaea*, and four subspecies of one of them, *Titaea tamerlan*. All are large, fine moths and much alike in their coloration, which consists mostly of soft and subtle shades of brown, tan, beige, and sepia. Both sexes have short tails on the hind wings. In the males, these are squarish, longer and more prominent, resembling the tails of tropical *Papilio* butterflies.

In most saturniids, the sexes can be distinguished at a glance because of the broad, plume-like antennae of the male, compared with the much narrower antennae of the female. The *Titaea* genus is an exception: both sexes have antennae that resemble the usual female type. The moths have large eyes, a hallmark of night-fliers. The caterpillar of *T. tamerlan* is said to feed on various species of kapok trees, but nothing is known about the larvae of the moth in the painting, *T. lemoulti*. Related species sometimes have different and mutually exclusive feeding habits.

The moth in the painting (actually, three views of the same specimen) came from the vicinity of the Explorama Lodge on the Peruvian Amazon, where I stayed in July 1989. Resting on a branch in broad daylight, this nice male was found by a Canadian lepidopterist, Gilles Deslisle. There is an amusing irony in this. Every night, dozens of enthusiastic moth collectors set out their mercury vapor and "black" lights in hopes of attracting such moths. But Gilles's was the only *lemoulti* obtained by anyone. He very kindly traded this treasure to me in return for one of my limited-edition moth prints. When the creature was alive, the dark patches on the forewings had a distinct deep green cast. Both Gilles and I were impressed by this. But within weeks the green had vanished, leaving only dark brown, even though the specimen had in the meantime been kept in the dark.

The thick-petaled, waxy flower shown with the moth is torch ginger.

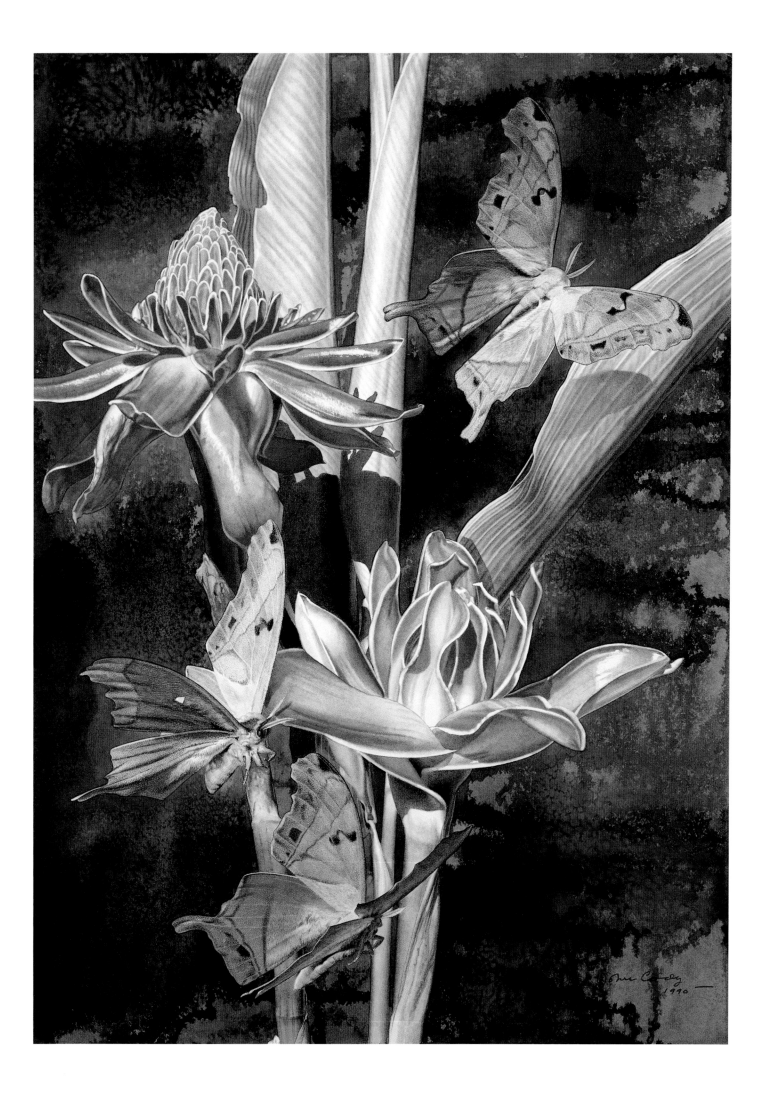

PLATE 48

African Moon Moth, *Argema mimosae*, 1991

Collection of Dr. Graham Cody

Size:

125 mm.

Range:

Most of sub-Saharan

Africa

This elegant moth, a little larger than our luna, is endemic to eastern and central Africa. Its name is a puzzler. The larvae would be expected to feed on mimosa, but they do not. As the name of the tree, "mimosa," is derived from the Latin *mimus*, meaning "mime," perhaps the insect acquired the name because it mimics something in its environment, a common phenomenon in the lepidoptera world. But what that might be is anyone's guess. What the caterpillars do feed on is sandalwood, wild mango, and a resinous tree, the paper tree. And that, little as it is, sums up about all the literature has to say about this species.

I have shown it with *Pyrostegia ignea*, the flame vine, found in central Africa and many other tropical areas.

I bought the pair pictured, already dead and in glassine envelopes, from a dealer in Wisconsin. They were fresh and unfaded and newly arrived from their native continent. Contrary to my usual practice of working only from specimens I have seen alive, I yielded to the temptation to make an exception in their case, because it is hard to resist moon moths.

Actually, there *is* something more I know about *mimosae*. I know what it looks like sailing through the air. Having seen luna, maenas, mittrei, sinensis, selene, and other long-tailed moon moths alive and flying, I knew that mimosae could not help but look similar.

I have often been asked what methods I use to depict moths in flight. I will use the rest of this space to explain that.

I had a carpenter make, according to my design, special spreading boards for mounting dead moths in flight positions. The standard spreading board has a groove down the middle into which the body of the moth or butterfly, transfixed on a pin, is inserted. On either side is a flat piece of wood over which the wings are spread and fastened with strips of paper and pins until they dry permanently in the desired position. Usually, the plane on either side is not absolutely horizontal but inclines upward slightly, producing an angle of about 5 degrees between the two sides.

One of my flight boards departs from the standard in having the two sides raised 45 degrees from the horizontal. This puts the pinned body in the corner of an angle of 90 degrees between the two sides, thus producing the up-flap position. Another board has the sides lowered 45 degrees from horizontal, thereby putting the wings at right angles to each other in the down-flap position. Simple rotation on the pin of moths so mounted presents the eye with an infinite number of natural flight positions.

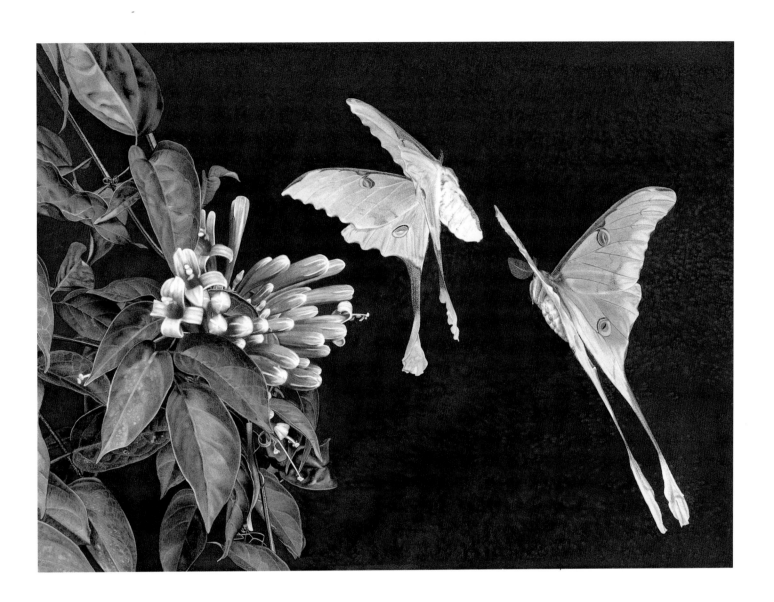

PLATE 49

Polyphemus Moth, *Antheraea polyphemus*, 1991

Collection of Mr. and Mrs. Mark Shaiken

Size:

Up to 150 mm.

Range:

The whole of the United States (lower forty-eight states) and deep into Mexico and Canada

As to which is America's most beautiful moth, a poll of lepidopterists would likely reveal a toss-up between luna and polyphemus. The polyphemus is certainly a marvel, and for sheer interesting variability it far surpasses the luna. The green of the luna varies too somewhat, but polyphemus ranges from smoky and dusky taupes, through all the ochres from deep earth tones to almost a golden, and on to many shades of reddish hue, from burnt sienna to Venetian red. Always, regardless of the ground color, the staring hind-wing eyespots remain jet black and clear blue.

As a child growing up in the Flatbush section of Brooklyn, I thought of the polyphemus as like dandelions in that they were ubiquitous and invulnerable. As I walked along streets lined with trees—mostly maples and sycamores—I picked polyphemus cocoons like cherries out of the privet hedges that outlined most of the small front grass plots. An hour's walk would gain me a fair-sized paper bag full. Although the trees and hedges are still there some fifty years later, the cocoons are not. A year ago with great joy I discovered one, the first in many years, in a sycamore near the house I grew up in. Their disappearance has scarcely been acknowledged, much less explained. Except that the motor traffic is tenfold what it was in my day, the neighborhood is hardly changed.

When the moths emerged in the spring in my screen-covered orange crate, I admired them, tried to produce portraits of them, and let them go. Occasionally, to keep it as a model, I killed one with Carbona (carbon tetrachloride), which was then readily obtainable, but doing so always went against the grain. It made me feel cruel and destructive. Producing a good likeness of the moths I had killed eased my conscience. After killing a moth I never felt justified until I had finished a drawing or painting of it.

Speaking of the great variability of the polyphemus, I once—and only once—saw a deep pink specimen, a perfectly resplendent male. I had interested a classmate in my hobby, and that fall he went hog-wild and collected enormous numbers of cocoons with the naive object of selling them. He kept them in a crate near the furnace. It was like talking to the wall to try to convince him that this was disastrous. The moths would emerge, I said, and because the leaves had already fallen, there would be nothing for the caterpillars to eat. This is exactly what happened. Out of hundreds of doomed moths, one was that unique pink. Unimpressed, he did not care to preserve it for himself, yet he refused to lend it to me to paint. For four days, until it died a wreck, I watched it batter itself to pieces in the crate.

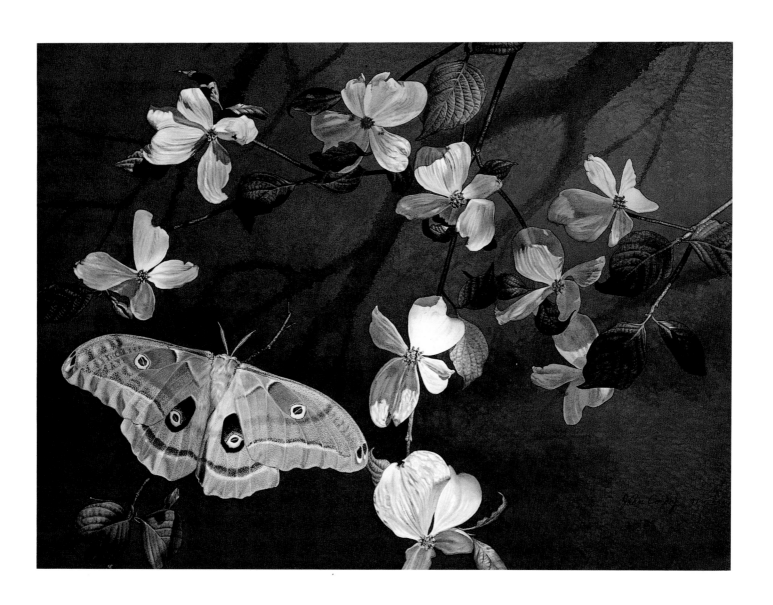

PLATE 50

Rothschildia aurota speculifera, 1991

Collection of Mr. and Mrs. Mark Shaiken

Size:

140 mm.

Range:

*Southeastern Brazil,
northern Argentina,
Paraguay, Uruguay,
southeastern Peru to
Bolivia; found at low
elevations*

What the caterpillar of *R. aurota speculifera* feeds on in the wild is unknown, but in captivity it will accept buttonbush, ash, privet, lilac, wild cherry, and ailanthus. Villiard says that the mature larva is "green-orange" ("Moths and How to Rear Them," p. 143), a color I cannot conjure visually. Gardiner, more imaginably, says that it is "bright green above, silky grey-green below" ("A Silkmoth Rearer's Handbook," p. 206). He also says that it resembles a small sea-mouse, which, again, is not an everyday observation. And that is about all I know about this species, except that I captured this representative in Manaus, Brazil.

As I am unable to say more about the moth, I will comment on the painting. The flowers are datura, also a native of South America. Because there is no relation, except proximity, between the beautiful but toxic plant and the insect, an explanation is in order.

I attempt to depict moths the way portrait artists have usually represented human beings — that is, in such a way as to create as decorative and appealing a picture as fell within the painter's ability. The portrait artists' subjects were shown in their finery, chosen for color, texture, and design. They were posed before rich hangings and elegant columns and balustrades, seated in opulent chairs and placed before windows opening on attractive landscapes. In other words, painters preferred to show sitters at their best, not at their worst or most everyday, and in surroundings that in themselves had color and visual interest. I try to do the same with moths.

In nature, moths do not necessarily associate with objects that enhance their beauty. Quite the contrary. They alight more or less wherever the wind happens to blow them. Here at home I have found them on sidewalks, neon signs, car fenders, fire hydrants, telephone poles, and many other objects few artists would care to paint. Although an unsightly thing in the jungle is a rarity, there is much that would fail to grace a moth. As one of my objectives is to evoke concern for the dwindling of saturniids, I feel that it is necessary first to demonstrate that what is involved is worth saving. So my emphasis first and foremost is on their beauty, not on their life cycles, foodplants, or other aspects primarily of interest to entomologists. I try to do the moths justice by depicting them accurately and at their freshest among handsome vegetation and in surroundings that show them to maximum advantage. Often I fall short, but sometimes I think I succeed.

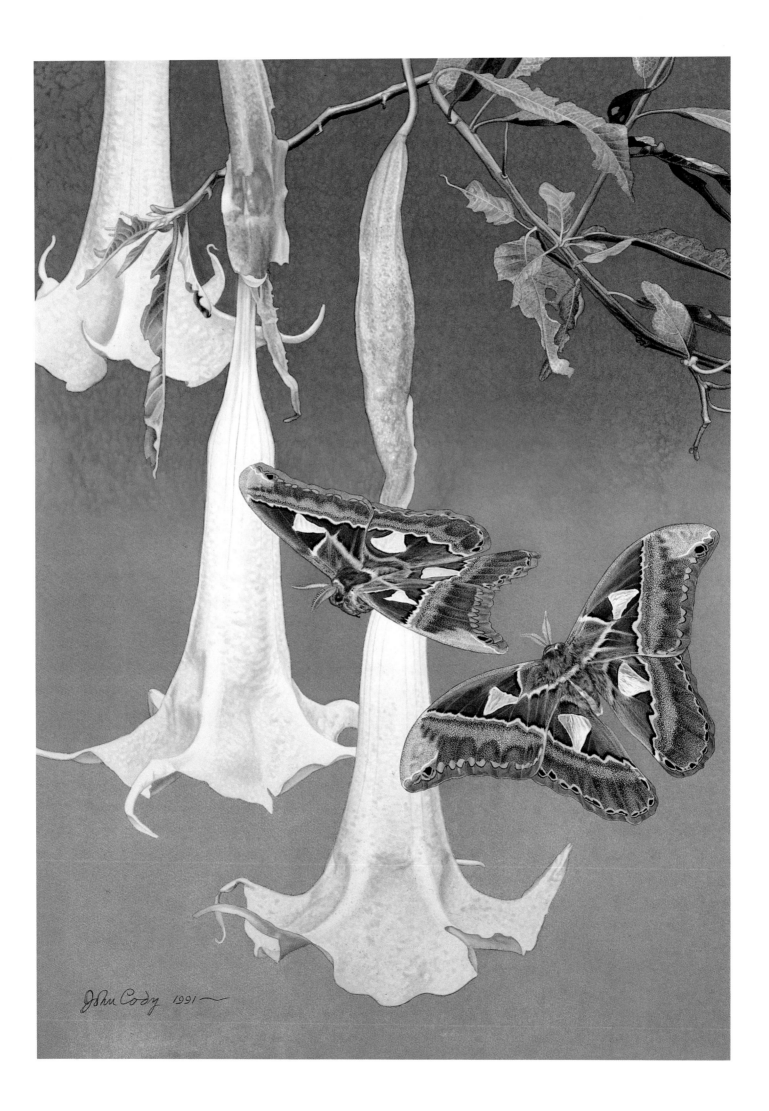

John Cody 1991

PLATE 51

Zig-Zag Emperor, *Gonimbrasia tyrrhea*, 1992

Collection of Mr. and Mrs. Joseph Russell

Size:
90 to 110 mm.
Range:
Central and southern Africa

Though I searched for the zig-zag emperor in Africa, I was unsuccessful and have never seen this species alive.

When I first began seriously to paint moths decades ago, I vowed that I would never depict one I had not seen alive or paint a specimen that had not been freshly killed. This led to some long dry stretches in which I found myself reduced to painting lunas, cecropias, and polyphemuses over and over again. From time to time, breeders and collectors would send me live cocoons or even live moths in glassine envelopes, but I could not count on this happening with any regularity. In fact, their arrival was always in the nature of a bolt from the blue. Furthermore, the more species of exotic moths I painted, the harder it became to find ones I had *not* painted. In the end, I was compelled to break my vow by the desire to extend my territory.

By then, however, I had learned that the variety of resting and flight positions among saturniids was limited and that taxonomic groups that resembled each other morphologically also behaved in similar ways. So I was able to extrapolate with accuracy from moths I knew well to those that were unfamiliar. I am virtually certain that *tyrrhea* in flight assumes the positions in which I have pictured it, even though I have yet to see it in the air.

Lepidopterists have been extraordinarily kind and generous to me and have sent my way all kinds of fresh opportunities for subjects. Their attitude is flattering to me: they often say that a given specimen could not be put to any better use. Richard Peigler, for example, has given me specimens of which he possessed only that one. The zig-zag emperor shown here was given to me—no strings attached—by another Denver lepidopterist, Steve Stone.

Tyrrhea is a montane species, and I depicted it among mountains. The larva feeds on acacia in the wild but will accept willow, apple, and hawthorn. The zig-zag emperor is a close relative of the famous mopane worm (*Gonimbrasia belina*), which is eaten by humans and even canned and sold in grocery shops. In tropical countries I have eaten certain purportedly edible caterpillars myself (not mopane worms, however) and always found them overwhelmingly flavorless. As the mopane is used as a relish in stews, according to Gardiner, it must, in contrast, have a certain character.

112

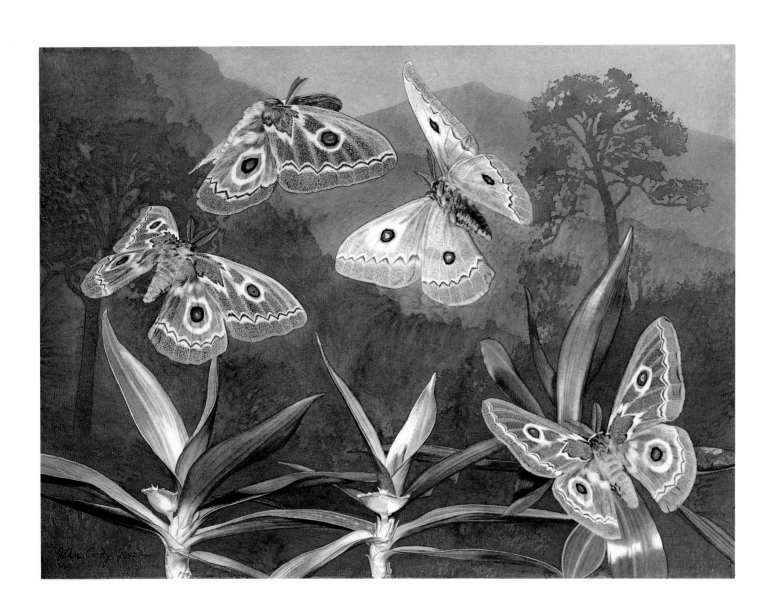

PLATE 52

Polythysana apollina, 1992

Collection of Mr. and Mrs. Joseph Russell

Size:
Male 80 mm.;
female 100 mm.
Range:
Northern Chile

The pair of moths that are the subjects of this painting were given to me by Kirby L. Wolfe, an outstanding lepidopterist from Escondido, California. He is the first person in this country, I believe, to raise the species, which is a rare one. For some reason, Lemaire does not include it in his extensive monograph on the American saturniids, and there is almost as little information about it elsewhere in the literature, except for a short write-up by Gardiner.

Apollina is obviously a sexually dimorphic species, the smaller male being silky white and blackish green, the female shades of brownish pink and faun color. The caterpillar, described by Gardiner, is pale green on the sides and rosy gray along the back and has startling black spots resembling a pair of eyes covering two segments near the head. It has rosy spines with black and yellow branches. It feeds on tropical trees of the laurel family. The cocoon, according to the same author, is a pear-shaped open mesh of yellowish silk.

The moths emerge in March and April—autumn in the Southern Hemisphere. In painting them, I searched for a color with which to surround them that would set off equally well all the complex, unmatched colors of the pair. Surprisingly, a rich purple presented itself as a likely choice, contrasting with, but not diminishing, the creamy whites and shadowed greens of the male or the warm pinkish earth tones of his mate. Besides, purple seemed a fittingly royal hue for a moth named for the god Apollo. The plant is the airplane plant (*Polyscias balfouriana*).

The sexes exhibit thoroughly polarized conduct, the males flying at midday, the females not until midnight.

I suppose everyone knows couples like that.

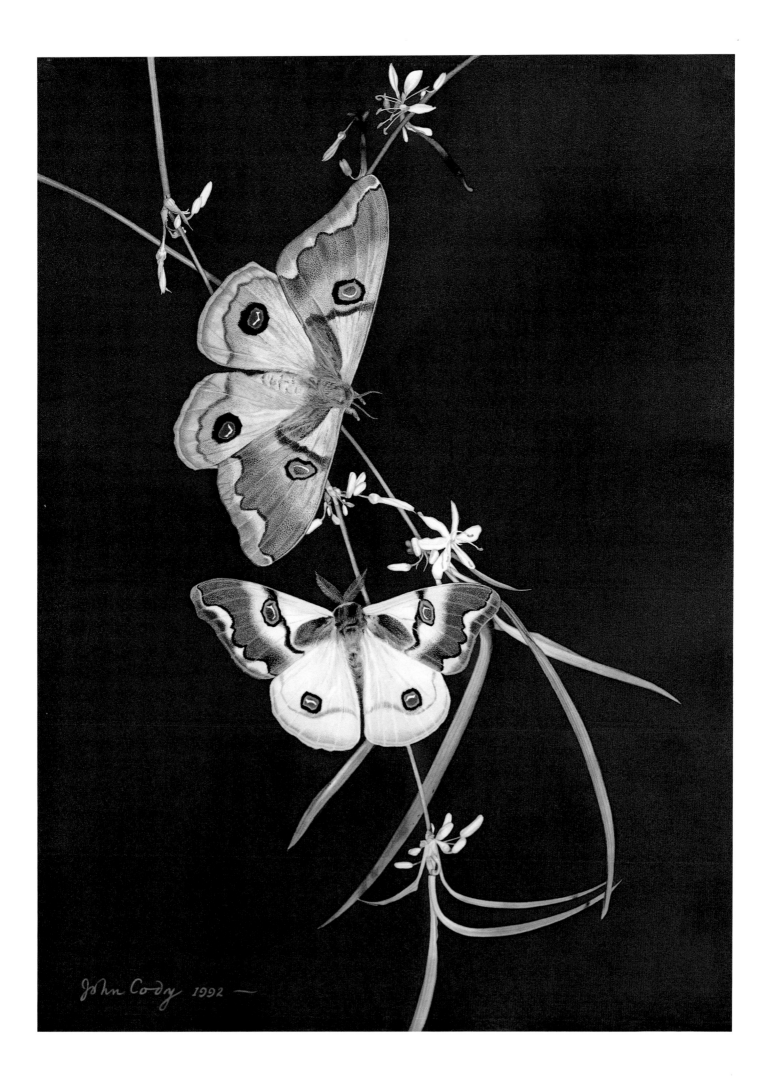

John Cody 1992 —

PLATE 53

Antherina suraka, 1992

Collection of Dr. Graham Cody

Size:
105 mm.
Range:
Madagascar

It has been my experience that lepidopterists in general, and saturniid specialists in particular, are the most helpful and generous people in the world. On innumerable occasions they have provided me with subjects for paintings, often exotic moths they have raised themselves and of which their own supply was not plentiful.

I can never forget the first *Antherina suraka* I ever saw. It emerged, live and in perfect condition, not from a cocoon but from a glassine envelope. Steve Stone had raised it in Denver in his "insectory" and sent it to me by next-day Federal Express. Stone had padded and protected and wrapped it with such exquisite care that if Hays had been leveled by a tornado it would have been the last living thing to succumb.

I could hardly believe my eyes when I released it from its paper compartment. Burnt orange and lurid crimson—what a combination! The moth shook itself and readjusted its wings as if to declare that a twenty-four-hour journey in a cramped paper Pullman is no picnic.

Suraka comes exclusively from Madagascar, land of the lemurs and other fauna and flora found nowhere else. I never expected to see a living suraka; still less did I expect ever to see one in the wild. Yet, not many months after Steve's gift, Dot and I were in Madagascar.

Beginning our plane trip from the rainforest at Ranomafana to the capitol city of Antananarivo, we reported at the little airport at Fianarantsoa. There, reposing serenely on a window frame, was a male suraka in all its splendor. It had been attracted the night before by the airport lights. The Malagasy stared at us in puzzlement as we coaxed the creature onto our fingers and exclaimed over it admiringly. I suppose it was like a cabbage butterfly to them.

A few days later, returning by van to the capital from Perinet, where we saw and heard the wonderful singing lemur, the indri or babakota, we stopped at the lepidoptery of André Peyriéras. Here Mr. Peyriéras showed us suraka in all its stages—oval brown cocoon, dazzling adult, and equally dazzling larva. The green-and-black caterpillars—some predominantly black and some predominantly green—were ornamented with chains of rose-colored tubercles. Such brilliance made me wonder if suraka is an unpalatable species that advertises the fact to would-be predators.

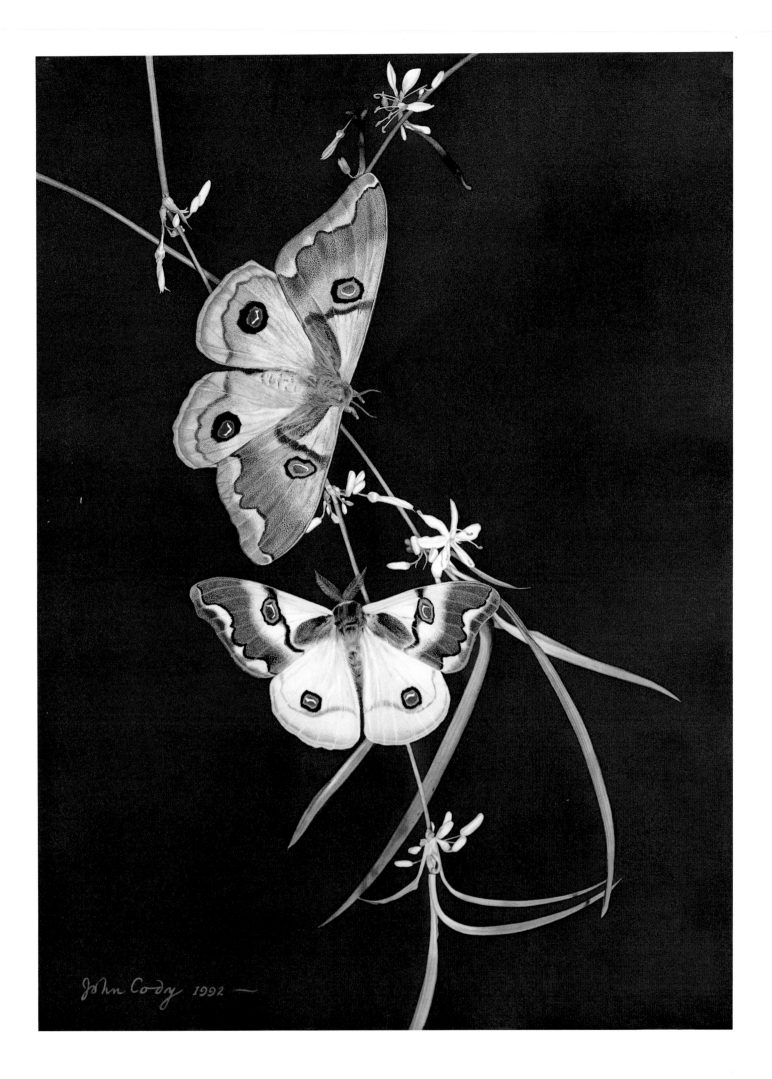

John Cody 1992 —

PLATE 53

Antherina suraka, 1992

Collection of Dr. Graham Cody

Size:
105 mm.
Range:
Madagascar

It has been my experience that lepidopterists in general, and saturniid specialists in particular, are the most helpful and generous people in the world. On innumerable occasions they have provided me with subjects for paintings, often exotic moths they have raised themselves and of which their own supply was not plentiful.

I can never forget the first *Antherina suraka* I ever saw. It emerged, live and in perfect condition, not from a cocoon but from a glassine envelope. Steve Stone had raised it in Denver in his "insectory" and sent it to me by next-day Federal Express. Stone had padded and protected and wrapped it with such exquisite care that if Hays had been leveled by a tornado it would have been the last living thing to succumb.

I could hardly believe my eyes when I released it from its paper compartment. Burnt orange and lurid crimson—what a combination! The moth shook itself and readjusted its wings as if to declare that a twenty-four-hour journey in a cramped paper Pullman is no picnic.

Suraka comes exclusively from Madagascar, land of the lemurs and other fauna and flora found nowhere else. I never expected to see a living suraka; still less did I expect ever to see one in the wild. Yet, not many months after Steve's gift, Dot and I were in Madagascar.

Beginning our plane trip from the rainforest at Ranomafana to the capitol city of Antananarivo, we reported at the little airport at Fianarantsoa. There, reposing serenely on a window frame, was a male suraka in all its splendor. It had been attracted the night before by the airport lights. The Malagasy stared at us in puzzlement as we coaxed the creature onto our fingers and exclaimed over it admiringly. I suppose it was like a cabbage butterfly to them.

A few days later, returning by van to the capital from Perinet, where we saw and heard the wonderful singing lemur, the indri or babakota, we stopped at the lepidoptery of André Peyriéras. Here Mr. Peyriéras showed us suraka in all its stages—oval brown cocoon, dazzling adult, and equally dazzling larva. The green-and-black caterpillars—some predominantly black and some predominantly green—were ornamented with chains of rose-colored tubercles. Such brilliance made me wonder if suraka is an unpalatable species that advertises the fact to would-be predators.

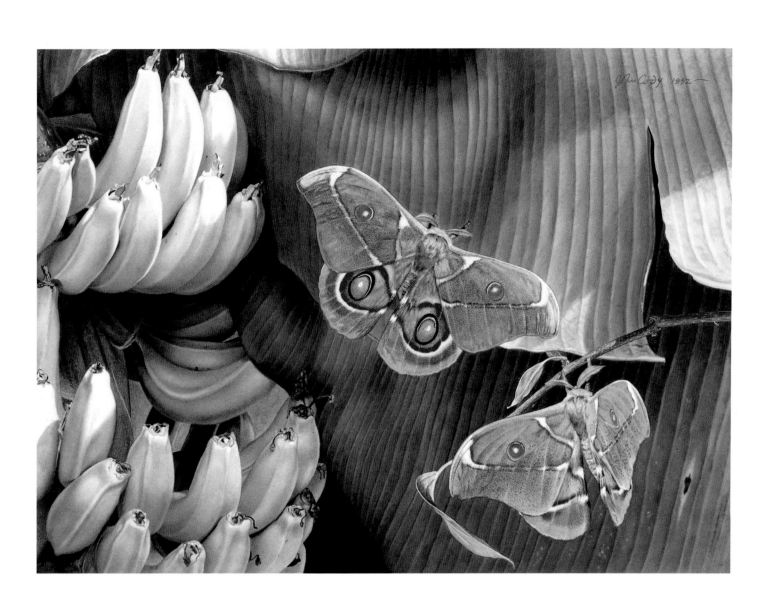

PLATE 54

Japanese Oak Silkmoth, *Antheraea yamamai*, 1992

Collection of Dr. Graham Cody

Size:
150 mm.
Range:
Japan

Whenever I have occasion to meet species new to me, I am as eager and curious about their cocoons as about the caterpillars and adult moths. Nature is so prodigal and replete with invention and ideas, so infinite in its variety of forms, that no two species have identical cocoons. Each is unique and full of individual character. Though cocoons of different species differ as cats' faces differ from dogs', even cocoons within a species vary just as much as human faces do. It is hard for the mind to imagine a new cocoon—all the possible variations seem to have been taken. Yet meet a new species and there it will be, unlike anything you've seen before. Love nature, love art, and the world will never cease to astonish you.

There are three species, however, whose cocoons stand out above all others. Third place for beauty must go to the Japanese oak silkmoth. They are a smooth, perfect oval, and their color is truly startling—a brilliant yellow-green. On the oaks the larvae feed on, they are typically mistaken for fruit.

Second place goes to a large opalescent-white moth from Madagascar, *Ceranchia apollina.* In size, shape, and construction its cocoon resembles a cecropia cocoon. It consists of a hard inner chamber inside a softer, looser outer one through which the inner one is clearly visible. About ninety millimeters long, the outer envelope is a meshwork of a splendid twenty-four-carat gold color. It is very lustrous, and one could easily believe it woven of actual threads of pure gold.

The most beautiful cocoon of all comes also from Madagascar. It belongs to the comet moth, *Argema mittrei.* When a friend in England sent me my first mittrei cocoon, I came to the conclusion that even if it never yielded a moth, just seeing the cocoon was a pleasure and privilege that could almost satisfy me. The mittrei cocoon is one of the most beautiful of all things made by creatures other than man. It hangs from a branch by a silver ribbon. A perfect oval almost the size of a hen's egg, it is perforated irregularly with pinhead-sized holes. The effect is of silver filigree of exquisite workmanship. The silk looks as if it could really *be* silver, polished and without a trace of tarnish. All silk is naturally lustrous, but mittrei silk has the highest sheen. The moth that emerged from *that* cocoon simply had to be magnificent—and, of course, it was.

Although *Ceranchia apollina* does not quite measure up to its cocoon, the Japanese oak silkmoth does. It is large and handsomely marked. It also displays a wide range of luscious colors, from faun to buttercup yellow. For unknown reasons, the yellower the moth, the more likely it is to be female.

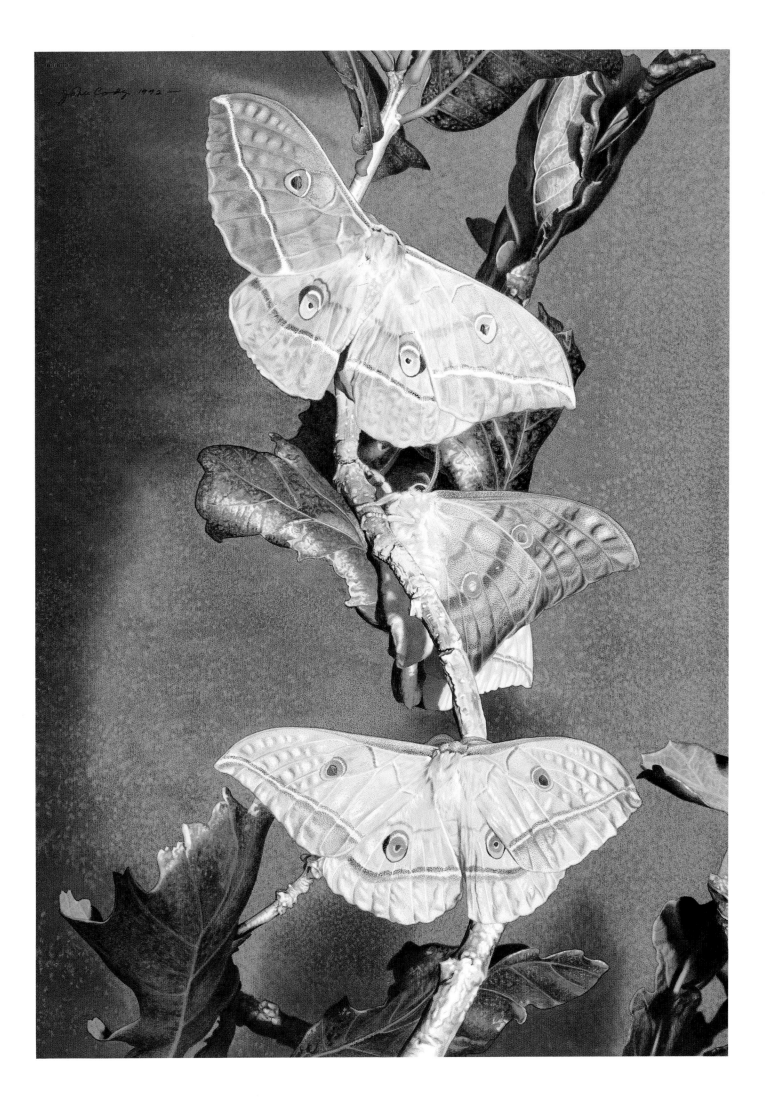

PLATE 55

Comet Moth, *Argema mittrei*, 1992

Collection of Mr. and Mrs. Joseph Russell

Size:

Up to 170 mm.

Range:

Madagascar

Until my first, solitary *mittrei* emerged so thrillingly beside our steaming tub, I had seen only pinned, spread specimens of this largest of the moon moths. I was very curious how mittrei looked in its normal resting position. Measured from the root of the hind wing, the tails of the male measure a full 110 millimeters. How does the moth position these long appendages when alight? To my surprise, it crossed them. With the exception of the African moon moth, no other moon moth crosses its tails, so that is how I painted it. An uncouth friend remarked that it resembled a ballerina who had to go to the bathroom.

Saturniids, like most other living things, look their best in positions they assume naturally. Their patterns then seem to flow without breaks in a harmonious design. Practically all moths look beautiful at rest. Mittrei is even more majestic in the air. As with birds, so with moths—the little ones flap their wings fast. The really large ones have an easier, more floating and graceful flight. Though it actually moves quickly, mittrei looks almost as though it flies in slow motion. So I painted it again showing two males against a dark sky, each in different flight positions, with their tails trailing gracefully. Although the tails are stiff and friable in mounted specimens, in life they are extremely supple and do not break even if a breeze should blow them almost double.

People often ask me what I conceive as the correct viewing distance for my paintings. I tell them anywhere from about eight inches to twenty or more feet away. The question may grow out of familiarity with the French impressionists, whose very popular oil paintings are designed for maximum effect at some distance—say, three or four feet at the very least—and whose landscapes, when examined too closely, dissolve into dots and dashes of paint. But watercolors such as mine invite the viewer first to draw nearer and then only later to step back. On the one hand, as the reader can see, the moths and foliage depicted in this book are extremely detailed, as this is the optimal way of portraying their subtle coloring and intricacies of pattern. Such detail is intended to reward a close-up look. On the other hand, the paintings are not small—twenty-two by thirty inches—and they have an overall organization and design that is meant to "read" clearly from across a large room. In this I have been influenced by Audubon and Redouté, whose works are both highly detailed and delicate and at the same time compositionally bold and decorative.

But what I am saying is perhaps a truism. A painting should give pleasure over a range of distances. I hope that mine do.

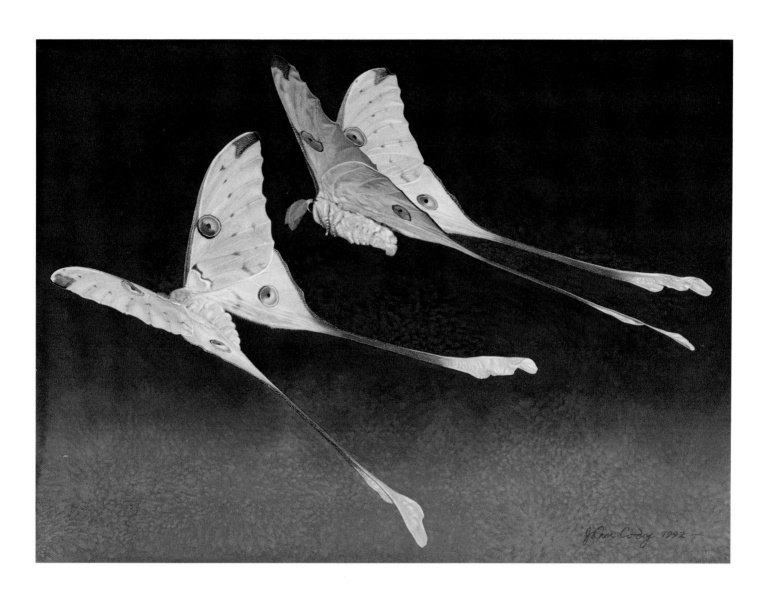

PLATE 56

Cecropia Moth, *Hyalophora cecropia*, 1992

Collection of Dr. Graham Cody

Size:

Up to 160 mm.

Range:

United States, east of the Rocky Mountains

Typically, the cecropia caterpillar hatches from its egg in June, feeds all summer, and spins its cocoon in late summer or early fall. The pupa then remains in its cocoon all winter, and the moth does not emerge until the following May. Let us say that a given cocoon is spun in early September. How is it that the moth does not mistake for spring the warm days of Indian summer that occur in October, or even early November, and emerge from its cocoon prematurely? This would be disastrous, of course; the moth would doom its offspring to starvation in the absence of leaves. But that never happens. No matter how mild the winter, no cecropia moth will emerge before the following spring.

Complex hormonal mechanisms are at work here. A partial answer to the question is as follows: the length of time a silkmoth spends in its cocoon depends, curiously enough, on the number of daylight hours the caterpillar has been exposed to. This determines the length of "diapause"—the state of dormancy undergone (usually) in the cocoon.

In the temperate zone, days of spring and early summer are long. Long days, say of twelve or thirteen hours, affect the caterpillar in ways that are transmitted to its next stage, the pupa, inducing in it the period of obligatory suspension. Like Sleeping Beauty under a spell, the cecropia cannot emerge until certain conditions are met. There has first to be a protracted period of cold—two to three months minimum—before the kiss of spring can have a wakening effect.

In the tropics, days and nights are always nearly equal. The shorter days subject the caterpillar to less light, and the result is a short diapause for the pupa. After a matter of only days, or up to a week or two, the moth emerges. In the rainforest a prolonged diapause is unnecessary, because leaves for the moth's offspring are always available.

Even after the conditions of diapause have been met it often takes some triggering environmental change to induce emergence of the moth. In the United States it is the onset of spring warmth. In very dry countries it is the onset of the rains.

The diapause of cecropia is, in technical language, "facultative light-controlled." In some species diapause is in the egg stage (for example, the Japanese oak silkmoth), and it is the egg, not the pupa, that overwinters.

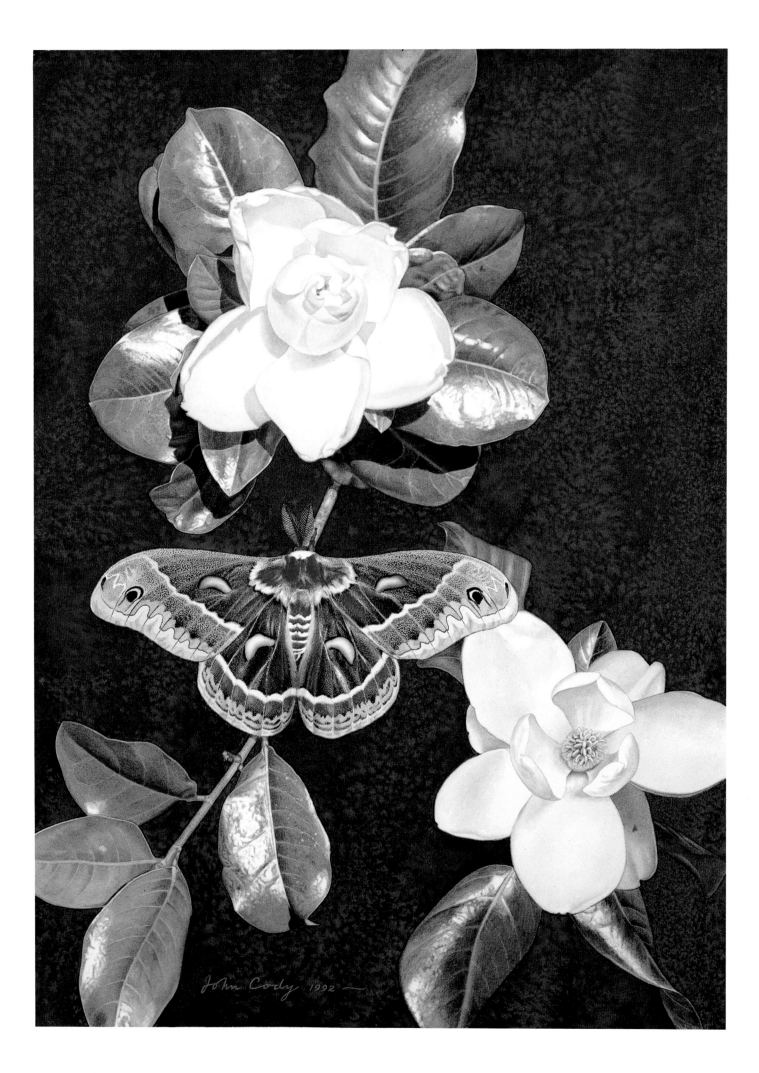

John Cody 1992

PLATE 57

Royal Walnut Moth, *Citheronia regalis*, 1992

Collection of Dr. Graham Cody

Size:
Up to 150 mm.
Range:
*Eastern
North America*

Following the magnificence of the caterpillar, the adult regal moth is considered, by some lepidopterists, an anticlimax. Though not as spectacular as the cecropia and polyphemus, it is a robust moth, a strong flier, and its gray-and-red-striped and yellow-spotted wings are unforgettable and unique among North American moths. *Regalis* is not a very common moth, and I myself have yet to encounter one in the wild.

Saturniids, of which regalis is one, are noningesters; they take neither food nor drink. The usual reason for this is their lack of mouthparts and of a functional digestive system. But according to Gardiner, some *Citheronia* "are capable of feeding, but do not normally do so" ("Moths and How to Rear Them," p. 121). It appears that they have lost the instinct for feeding, even when physically able to perform the motions.

Two species of moths, of which regalis was the first, have given me my greatest lessons with regard to diapause, the stage of dormancy. The second, the cynthia moth, taught me that when the moth is ready to emerge it will do so, and almost nothing can stop it. This enlightening experience occurred when I opened a paper bag full of cynthia cocoons that I had been keeping in the refrigerator for a couple of months to ensure (as I thought) a proper diapause. What I discovered to my guilt and dismay was a bag containing several dozen dead and dying moths. All were pitifully crippled because they had been deprived of room in which to expand their wings. But I never dreamed that they could ever have emerged in an environment of 45 degrees Fahrenheit. The lesson I learned here was that it is hazardous, at least with the cynthia, to try to prolong diapause beyond a certain point.

The lesson taught me by the regal moth was different, though just as painful. I kept the pupae in clear plastic boxes filled with sphagnum moss and wood chips, sprinkling them frequently with water to keep the pupae from drying out. But my studio was always warm. Therefore, not then recognizing the need for diapause, I was unknowingly preventing it. In effect, the pupae just lay there waiting for a winter that never came, and finally they gave up. I suspected something was wrong when I noticed that they had lost their flexibility, their abdominal segments locked into position. Later, I *knew* there had been a disaster when I discovered that the pupae were being eaten by those tiny scavenger beetles, the dermestids.

In spite of these unhappy experiences, diapause continues to remain a problem with species with which one is unfamiliar. Much depends on the history of the cocoons before one gets them and what conditions prevail in their country of origin.

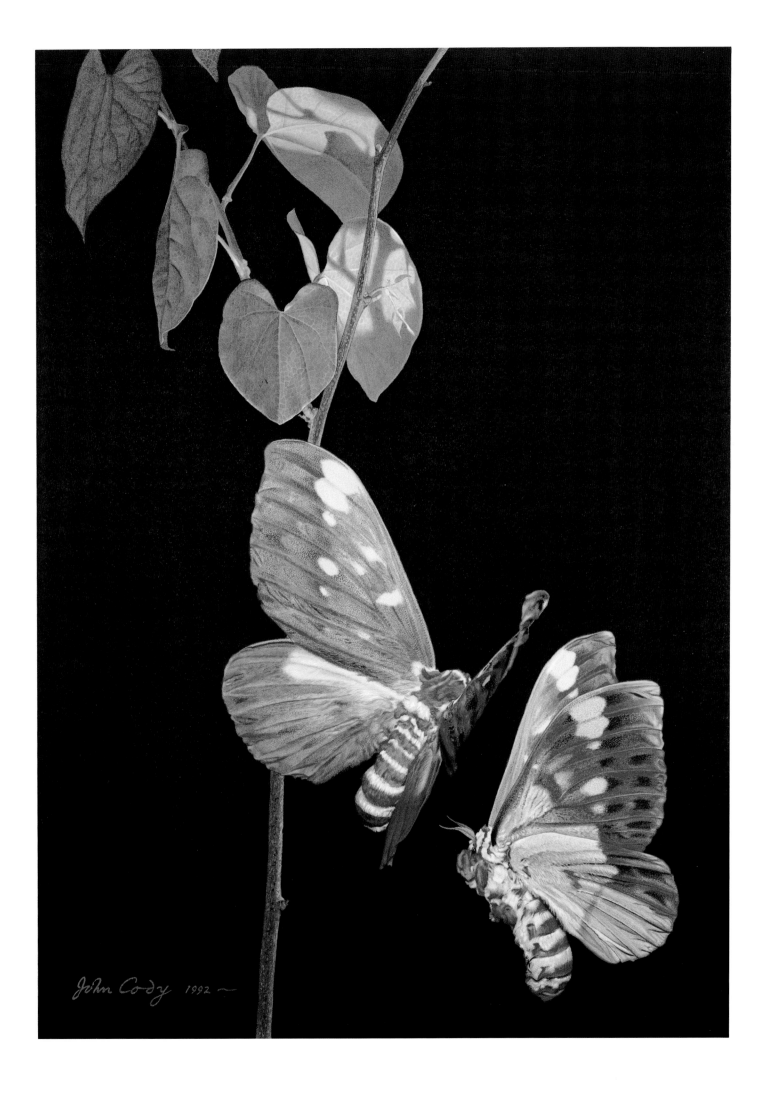

John Cody 1992

PLATE 58

Frosted African Emperor, *Athletes semialba*, 1992

Collection of Dr. Graham Cody

Size:
150 mm.
Range:
Eastern central Africa

As with most African saturniids, there is not much in the literature about this moth. The mature caterpillar is described, but I have never even seen a photograph of one, much less the larva itself. It is evidently a handsome animal with metallic markings. (Metallic markings are not rare in saturniid larvae; the polyphemus larva, for example, has brilliant spots of metallic silver.) Gardiner says that *semialba* is "pale blue or blue-green with rows of partially gold thorns" ("Moths and How to Rear Them," p. 96). The spiracles (circular formations along the sides through which the larva breathes) are dark red. It feeds on msasa and senna of various species. It pupates by getting a little way into the ground, where it spins a frail cocoon.

The specimen in the painting was part of the collection of Steve Stone of Denver. When I admired it and remarked that I would someday like to paint it, he handed it to me and said, "It's yours." The moth had been kept in the dark and was fresh and unfaded. It was on a pin with identifying labels attesting to its having been caught at an altitude of 2,150 meters (about 6,500 feet) in Tanzania—therefore a montane species.

As one might expect, it was mounted in the standard anatomical position. As I wanted to depict it in natural flight positions, I had to first relax it and then remount it. Like all such specimens, it was extremely stiff and brittle and had to be handled with great care, for if any attempt were made to move the wings the slightest bit they would immediately crack and fall off.

I put it in an airtight container on a piece of dry Styrofoam resting on a sponge that had been wet thoroughly with water and sprinkled with alcohol to retard mold. After two days the moth had soaked up the humidity and was as limber as if it were still alive. Even the antennae and legs could be positioned as desired.

I mounted the moth in the up-flap position on a special spreading board I had invented for the purpose. After a few days it was as stiff and set in the new pose as it formerly had been in Mr. Stone's cabinet. I drew it, then relaxed it again and mounted it on another special spreading board in the down-flap position. When it had again stiffened sufficiently, I drew it in that position. With the moth in just these two positions—wings up and wings down—one could cause its outline to change continually and yield an infinity of new images simply by rotating the pin and/or placing the moth at different eye levels. In the end, I used only the down-flap, but from three different angles.

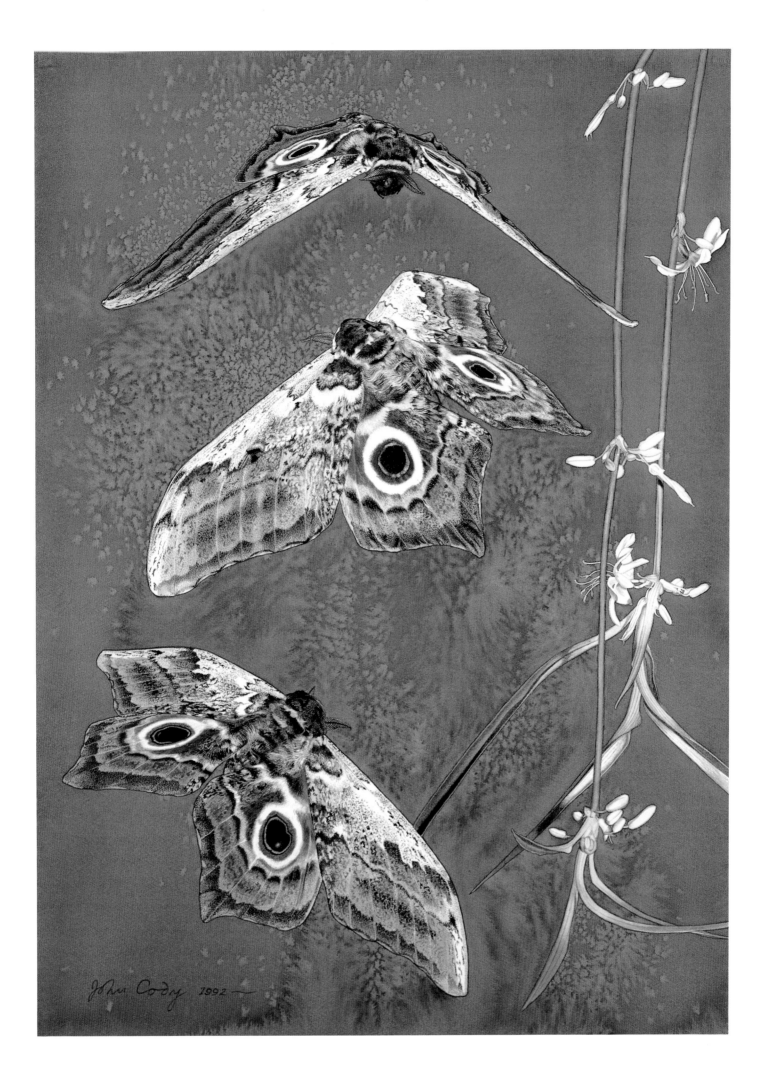

PLATE 59

Hemileuca magnifica, 1992

Collection of Dr. Graham Cody

Size:

90 to 100 mm.

Range:

*Southern Colorado,
northern New Mexico,
and northeastern
Arizona*

This striking day-flying moth has the distinction of being both cryptic and aposematic in its coloration. When the moth is at rest amid sagebrush, its black-and-white markings merge with the shadows and sunny highlights on twigs and branches, rendering it invisible. In flight the opposite is true: it is extremely conspicuous, as though advertising itself to every bird as a disagreeable morsel.

A further distinction is its two-year life cycle. The moths emerge from their pupa cases (there is no cocoon) in late summer. The eggs, laid in bracelets around twigs, somehow survive the winter. They hatch the following spring, and by fall the larvae descend the sagebrush stems to the ground, where, after much restless wandering, they form pupae amid plant debris. In this form they overwinter for the second time.

It is interesting that the pupae remain dormant throughout most of the summer heat, and some specimens remain in this state of diapause for another year or two. Apparently, they are remarkably resistant to dehydration.

The caterpillars are covered with clusters of spines that are very irritating to the touch. They feed on various species of sagebrush, especially *Artemisia tridentata.*

The lepidopterist Steve Stone once took me to a shallow little arroyo in Colorado spanned by a concrete bridge. I descended the dry banks of the extinct streambed, scaring off a badger in the process, and examined the sage growing there. Everywhere, there were black masses of these gregarious caterpillars. I had never before seen so many saturniid caterpillars at one time.

As for the painting, I felt that a sun-loving moth named *magnifica* deserved a grandiose presentation, hence the Egyptian gold "sky." It was painted with Daniel Smith metallic watercolor, covered lightly with picture varnish to vary the oxidation, and then given a second set of loose gold washes. Not many moths could hold their own against such an assertive background, but the bold black, white, and orange of this dauntless moth is not readily subdued.

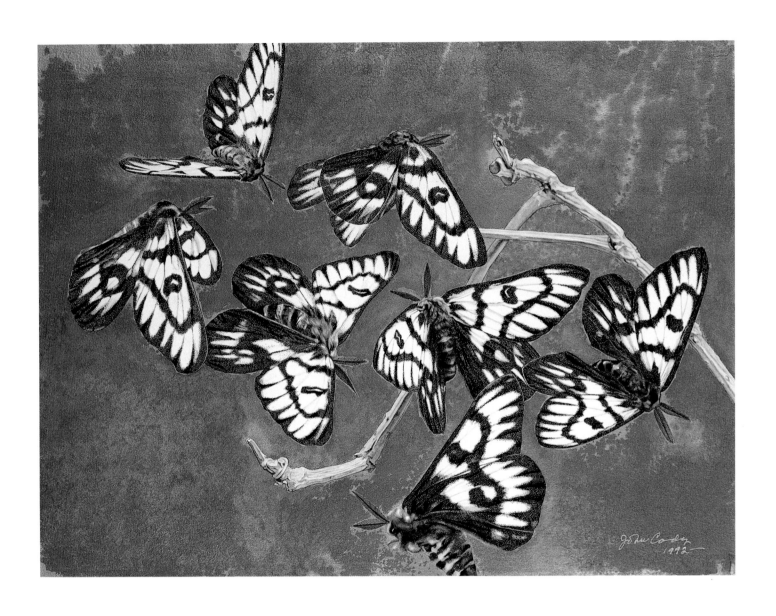

PLATE 60

Rothschildia forbesi, 1992

Collection of Mr. and Mrs. Mark Shaiken

Size:
90 to 110 mm.
Range:
*Lower Rio Grande
Valley, southeastern
Texas, and adjacent
areas in Mexico*

It is confusing for an amateur saturniidologist like me to realize the extent to which the experts disagree about certain things. The identity of this moth is a case in point.

Ferguson argues that the marked differences in the male genitalia between *forbesi* and *Rothschildia lebeau* establish the two moths as distinct species ("The Moths of America North of Mexico," p. 225).

Lemaire, seemingly shocked at this, insists that the resemblance between the dark forms of *R. forbesi* and *R. lebeau* "is so strikingly obvious that I am unable to agree with authors who, such as Ferguson, have dealt with *forbesi* as a distinct species, even if differences . . . have been found in the length of the finger-like apical process of the valves in the male genitalia" ("Les Attacidae Americains, Attacinae," p. 59).

And Gardiner, having consulted the above authors, cites further complications and confesses, "With this species the present editor is in considerable difficulty" ("The Silkmoth Rearer's Handbook," p. 208).

Someone has said, "When wise men disagree, fools can decide." Still, I will pass on this one. But my own hunch is that if two species cannot be told apart, either from appearance or from gross dissection, then chromosome studies are probably the next step.

The caterpillars that turn into this moth, whatever its identity, are positively known to eat willow, ash, cherry, orange, and grapefruit. It is disease-resistant and easy to rear in captivity. It does particularly well on privet. The tannish cocoon is small, compact, and shaped like a teardrop.

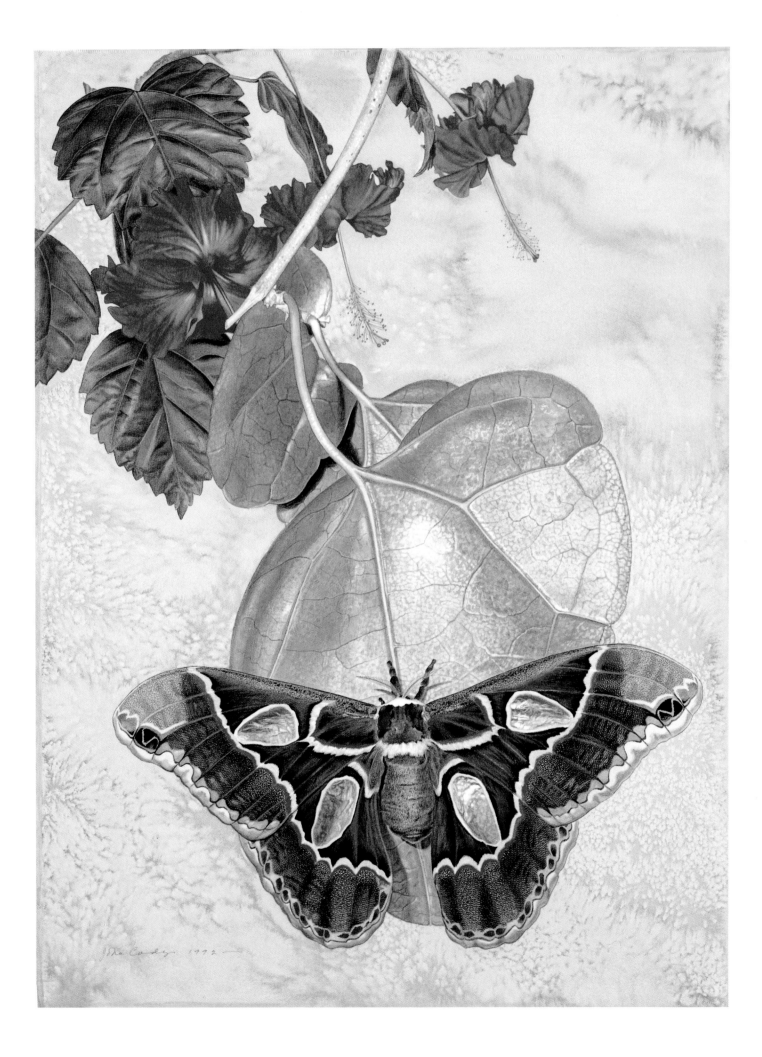

PLATE 61

Actias groenendaeli, 1993

Collection of Mr. and Mrs. Mark Shaiken

Size:

Male 115 mm.,

female 140 mm.

Range:

Flores Island in the

eastern Lesser Sunda

Islands, Indonesia

The male moth in the painting is a genuine rarity and a very recent discovery. It was first described and established as a distinct species only in 1992.

The female, whose history is rather curious, has not been known for a much longer time. Her description was first published in 1954 by the Dutch entomologist W. Roepke, who considered his dismembered specimen to be a subspecies of *Actias maenas* because the wings so closely resembled those of females of that species. The male moth continued to remain undetected.

The female had come to a light and had been caught by a boy and taken to the mission station. One of the missionaries had the odd idea that cutting off her wings would induce her to lay eggs. (Unfortunately, he was probably confirmed in this opinion, as almost nothing short of death will stop most female saturniids from laying eggs.) The medical officer, J. M. A. van Groenendael, preserved the wings and sent them to Roepke, who named it after him and published a description of it. He called it *Actias maenas groenendaeli.*

It must have come as a big surprise when, after four decades, the previously unknown male turned up in 1992. Not only were its beautiful orangy coloration, its markings, and its shape unlike those of the *A. maenas* male, but the genitalia were also different. So Ulrich and Laela Paukstadt described it and removed the "maenas" from its former name and thereby set it up as a separate species.

Left to my own initiative, I would undoubtedly never have come across an example of this so elusive and out-of-the-way creature. I had never visited the island of Flores and had no plans to go there, lovely as I've heard it is. The specimen came to me, as have many others, from Richard Peigler, and as soon as I saw it I was eager to paint it. I mounted the fine specimen in a flying posture and at first was afraid even to handle it.

When I paint a moth I generally push the pin into a large soap eraser, then tape the eraser securely to the slanting surface of my drawing table. But that is nevertheless a precarious situation for a delicate, easily broken specimen. My arms and hands sometimes fly when I am painting, and in concentrating on what the paint is doing, I can become oblivious to hazards. It has occasionally happened that moths have gotten smashed in the process.

To my great relief, the precious *groenendaeli* escaped all damage, and I was able to relax it, slip it into a glassine envelope, and get it back to Dr. Peigler in pristine condition.

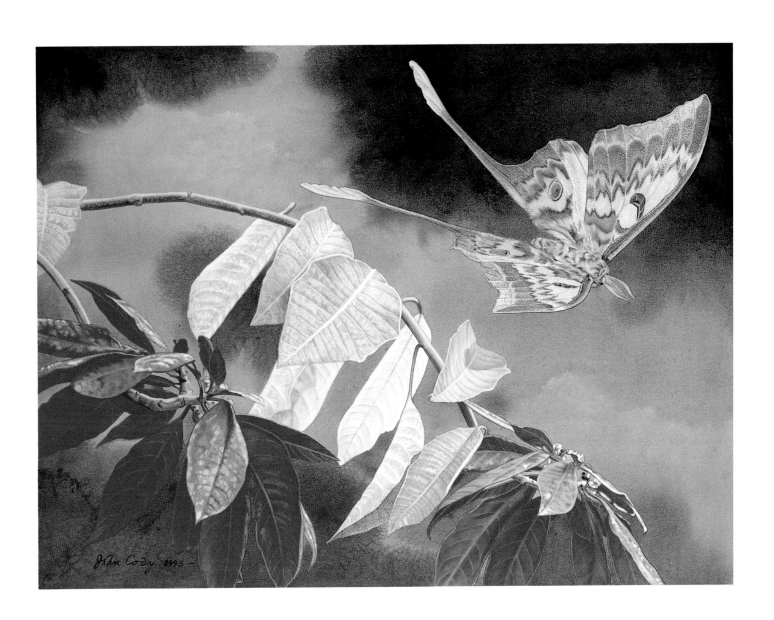

PLATE 62

Actias rhodopneuma, 1993

Collection of Mr. and Mrs. Mark Shaiken

Size:
Male 110 mm., female ?
Range:
*Naga Hills of Assam
in northeast India*

The first specimen that I ever saw of this beautiful "pink luna" was in the hands of a dealer who was asking three hundred dollars for it. Assam was closed to Westerners then, and perhaps the dealer was not too far out of line, considering the rarity of the moth and the inaccessibility of its habitat. Though I longed desperately to paint it, I had more urgent demands on my resources at the time, and regretfully had to pass it up.

I could find almost nothing in the literature about *rhodopneuma*—nothing about where in Assam it could be found, what the larva fed on, or what the female looked like. I still do not know the answer to these questions. A few years after my encounter with the dealer, I had the chance to go to Assam as a tourist and used the opportunity to make inquiries about this moth. In my ignorance, I imagined that in a relatively small state boasting so spectacular a moth, practically every educated person would at least have heard of it, even if he or she had never seen one. But I discovered that East Indians are as little aware of their moth fauna as Americans are of theirs. I did obtain a caterpillar or two at a remote little village, but they looked suspiciously like cynthias to me, and that's what they turned out to be. In the short time I was able to stay in Assam, this was as close as I was able to come to rhodopneuma.

After these frustrations, it was a great thrill for me when a real chance to paint the moth finally arose. The specimen in the painting was lent me by the ever-generous Richard Peigler. I spent about a month on the painting, working every day. In the end, it gave me a great deal of satisfaction and relief when, after painting its portrait three times, I was able to return the moth to Dr. Peigler minus one antenna but otherwise in good condition.

The name "rhodopneuma" means, roughly, "rosy breath" or "rosy spirit"—a fitting name for this ethereal creature.

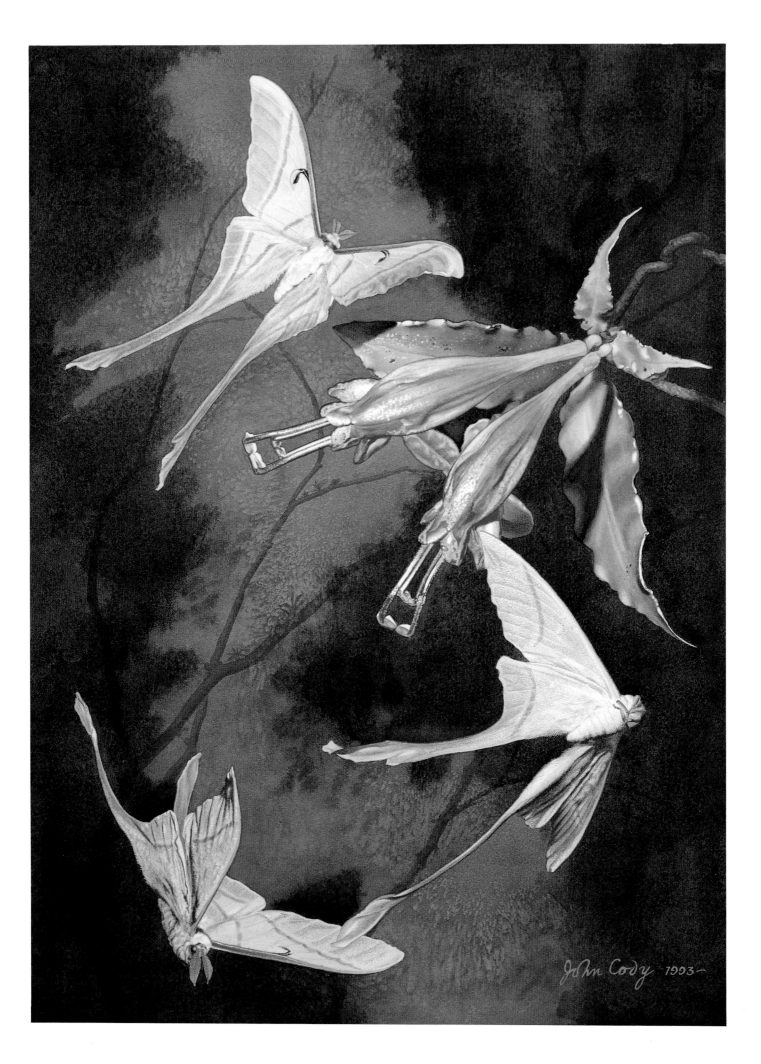

PLATE 63

African Atlas Moth, *Epiphora ploetzi*, 1993

Collection of Mr. and Mrs. Joseph Russell

Size:
Up to 190 mm.
Range:
West and central Africa

Of the thirteen species in the genus *Epiphora*, this is the largest. Though not as enormous as the Asiatic atlas or the hercules moth of New Guinea, it is nevertheless impressive. Some species in this African genus bear an amazingly close resemblance to the North American cecropia and its relatives, and even though *ploetzi* is not one of them, one can detect similarities even in it, especially in the "snake's head" of the forewings. It is certainly cause for wonder how moths geographically so far apart could have evolved such similar patterns. Probably they arose from a common ancestor before the continents became as dispersed as they are now.

The caterpillar, which I have never seen, must be as imposing as the adult. For size and coloring, few caterpillars surpass it. Gardiner describes it as orange with black tubercles and green spiracles. A broad black line runs along the sides. It feeds on a great many kinds of leaves in the wild. In captivity it has been successfully raised on prickly ash.

Unlike many African species, it does not go underground to pupate but, again like cecropia, spins a double-layered cocoon with an escape hatch.

The moth in the painting, a male, is shown with the berries of medinilla, one of the showiest plants in the tropics.

As a young man finishing up my training in medical illustration at Johns Hopkins, I had high hopes of proceeding to Africa to study and paint these moths. I wrote to universities all over the continent and corresponded with African entomologists. As a result, I was invited by lepidopterists in the Transvaal to use their facilities, where they were willing to offer me the benefit of their experience and expertise.

So I was all set to go—except that I had no money. I applied for a Guggenheim Fellowship. I don't think the Guggenheim people knew what to make of me, as I did not fit into any conceivable category. I was not applying for a fine arts fellowship (these were all awarded then to abstract expressionists), nor was I applying for one in pure science. Probably, also, I was too young and did not have a sufficient track record. In the end they turned me down, but I finally got to Africa, even though it did take twenty years.

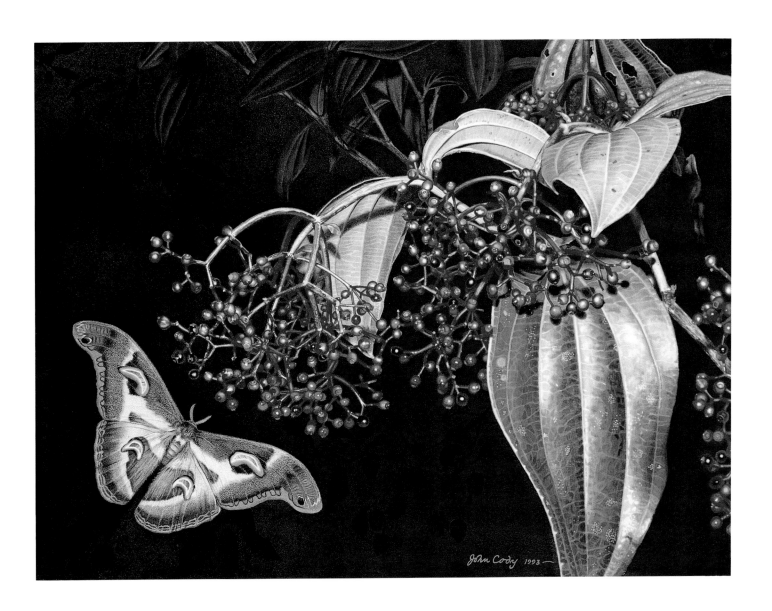

PLATE 64

Roseate Emperor Moth, *Eochroa trimeni*, 1993

Collection of Mr. and Mrs. Mark Shaiken

Size:

8o mm.

Range:

Namaqualand area
of southwest Africa
(an arid habitat)

Trimeni is a day-flying moth with a restricted range. It is the only species in its genus. The moths are sufficiently rare that dealers have been known to charge three hundred dollars for a perfect pair. The caterpillar, as showy as the moth, is frosted white ringed with black on the dorsal surface, and black on the ventral surface. It feeds on various species of *Melianthus* or honeybush. The brilliant colors of both larva and adult are aposematic and permit the insect to flaunt its unpalatability to predators such as birds.

Gardiner describes trimeni as "a lovely little moth" and, puzzlingly, gives its wing span as only twenty-five to thirty millimeters, which would be tiny indeed. The specimens I used as models—given to me through the kindness of Kirby Wolfe, who reared them in Escondido, California—were all at least eighty millimeters wide.

Wolfe raised them on *Melianthus dregianus* grown from seeds acquired from an importer of rare plants. He notes that the plants give off an unusual, sweet odor said to be poisonous. Apparently trimeni acquires its inedibility the same way the monarch butterfly does—that is, by ingesting toxins from a plant.

I have shown the moth with the flowering bracts of the purple heart plant, *Setcreasea*, ubiquitous as an ornamental in tropical and subtropical areas. The choice was purely aesthetic: the smoky purple of the plant sets off, as few colors would, the hot pinks and oranges of the moth.

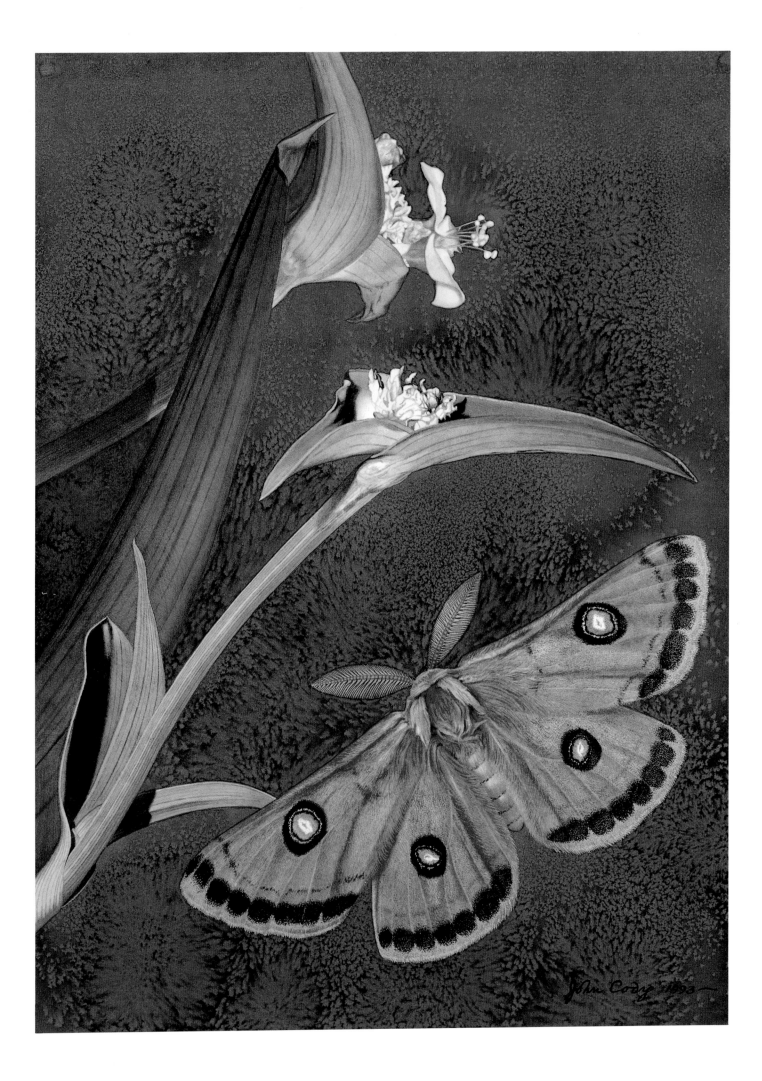

PLATE 65

Caligula zuleika, 1993

Collection of Mr. and Mrs. Mark Shaiken

Size:
140 mm.
Range:
*Assam and
surrounding areas*

This is a moth I know little about. Because the caterpillars are said to resemble those of the genus *Antheraea*, which includes our polyphemus, this species was formerly placed in that group. I remember my surprise at this, for *zuleika* and polyphemus, superficially at least, have patterns that to my eye could hardly be more dissimilar. Presently, however, zuleika is placed with the *Caligula*. The simla moth, which I first knew as *Dictyoploca simla*, is also now considered by some lepidopterists to be in the genus *Caligula*. Such is taxonomy.

The caterpillar feeds on maple, *Acer caudatum*, and on plants in the laurel family. It spins a cocoon.

As I can say nothing further about the habits of this insect, I will say something about what it is like to paint its portrait. I found it one of the most difficult.

There is a zigzag postmedial line that, tripled, extends from near the apex to the lower border of the forewing (where the medial line would be expected to end) and then continues, still tripled, across the hind wing. On very close observation, one can see that this zigzag is without breaks from start to finish. But if one looks more casually, it is discernible only here and there wherever the background tone allows for enough contrast for it to show up. In most areas it simply loses itself in tones and hues that it matches almost exactly. Moreover, it is superimposed over patches of light and dark that are disruptive, calling attention to themselves and making the zigzag as hard to follow as a stream meandering through rushes. The task for the painter is to depict the triple line in all its intactness, while at the same time keeping it unobtrusive—in places to the point of near-invisibility. I believe it is the most subtle pattern I have seen in a moth.

While I am on the subject of difficulties, let me mention one other. Moths are nearly perfectly symmetrical. As with a human face, however, one cannot draw half a moth, trace it, turn the tracing paper to the obverse, and use the same outlines for the other half. This results every time in a stiff, unnatural and ungraceful drawing, just as it would if one drew a human portrait that way. Actually, when one looks at a real moth, unless it is directly at eye level, equidistant from both eyes, and mounted in the anatomical position on a pin, there is subtle foreshortening of one wing or another. Capturing these slight distortions is what makes the drawing look lifelike. The trick is drawing the moth so that its shape on the paper is in fact unsymmetrical, yet perceived by the viewer as perfectly symmetrical.

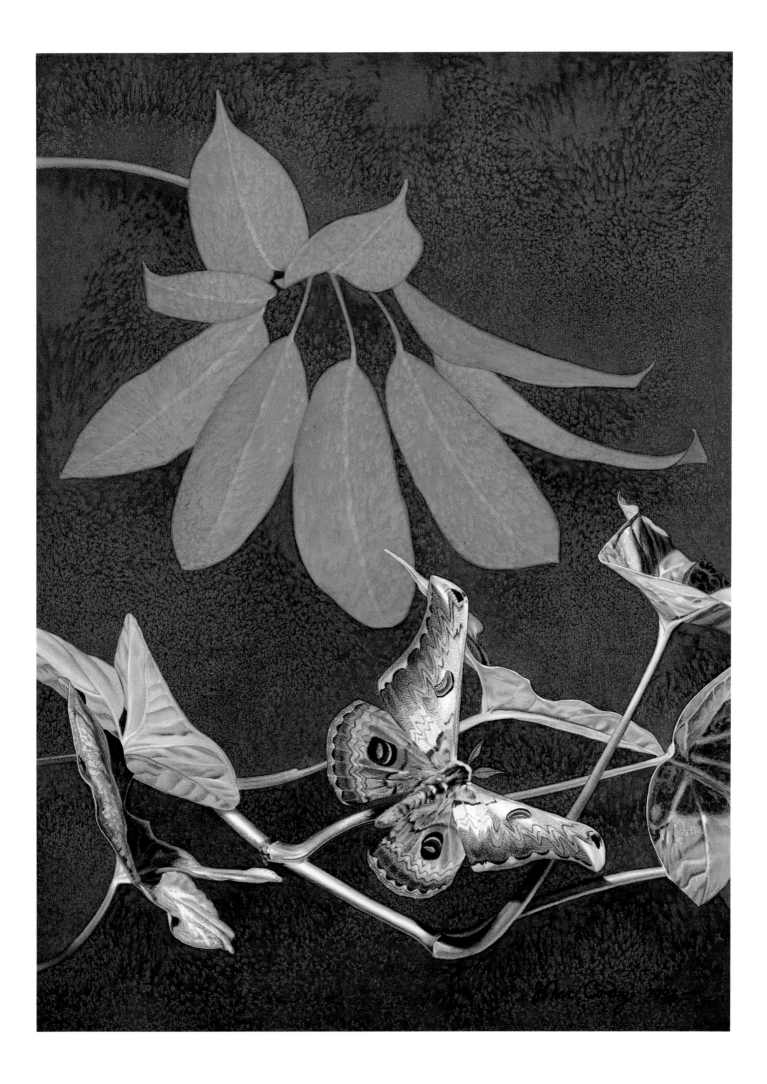

PLATE 66

Polyphemus Moth, *Antheraea polyphemus*, 1994

Collection of Mr. and Mrs. Joseph Russell

Size:

Up to 150 mm.

Range:

The United States (lower forty-eight) and deep into Mexico and Canada

There is one difference between butterflies and moths that I have never heard commented on. The patterns on the underside of the wings of butterflies are generally as well developed and striking as those on the upper sides. Often, in fact, the underside is even more elaborately decorated. I do not believe this is true of more than a handful of moths, and these are typically day-fliers. With moths, it is the general rule that the underside is simpler and less dramatic. Frequently it appears as a faded version of the upper pattern, as though that were being seen dimly through the wing. Rarely, if ever, it is a totally different and equally ornate design.

Perhaps a reason for this difference is that butterflies rest with their wings closed over their backs so that the underside is more or less on display. Whether the patterns are intricate or bold, they are certainly visible. If they are meant as camouflage or to advertise unpalatability, it is obviously important that they be well developed and effective.

Moths, in contrast, usually rest with their wings out flat so that the undersurface is against an object of some kind and therefore hidden. The *Automeris* moths, which always rest this way, are a particularly good example of what I am saying. Almost always, the undersurface is a faded version of the upper surface. Moreover, in the resting position looked at from underneath, the hind wings cover the forewings, whose pattern would be thus hidden in any case.

Not all moths follow this rule, though. The polyphemus, as shown in this painting, has a highly striking underside pattern that is as beautiful as that of the upper, and completely different from it. It is noteworthy that especially the female polyphemus, when resting, does sometimes carry its wings closed and over its back in the manner of a butterfly. Other moths whose resting postures resemble those of butterflies tend also to have well-developed ventral surface patterns, though, even so, not quite up to that of the upper side. The *Hyalophora* and *Rothschildia* moths and their relatives (the *Attacini*) are in this category. The sphinx moths—which invariably rest in the typical moth pose, with their undersurfaces hidden—have almost no pattern on these surfaces. The rule seems to be: if you've got it, flaunt it, but only if you've got it.

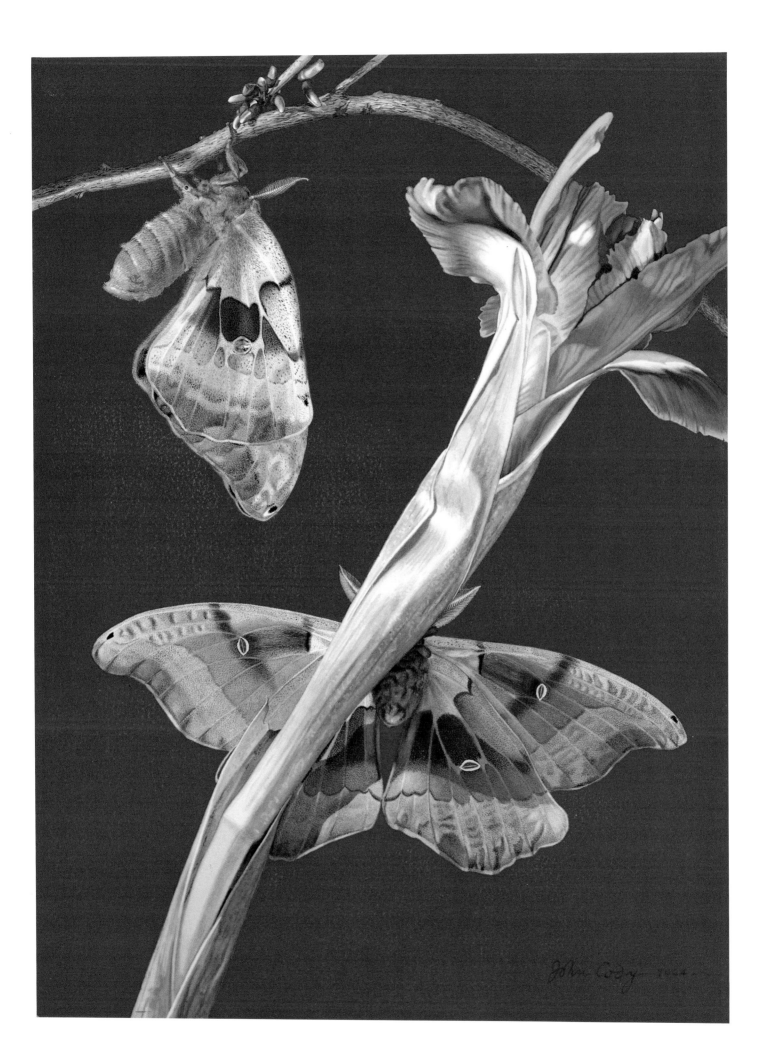

PLATE 67

Archeoattacus staudingeri, 1994

Collection of Mr. and Mrs. Mark Shaiken

Size:

170 mm.

Range:

Java, Borneo, Sumatra, West Malaysia

The literature is silent as to how rare this moth is in its habitats, but it is certainly uncommon in collections. The Museums of Natural History in Washington and New York have only one specimen each. The British Museum does better, but in all three museums the only specimens are males. None of these collections contains a female.

The models for this painting came to me through the kindness of Richard Peigler, the leading authority on the atlas moths. Someone may now be raising these moths in Malaysia, as papered pairs have recently been finding their way into the country and sold by dealers.

Nothing can be found in the literature about the foodplants of this species or about its early stages.

The moth differs in shape from other atlas moths chiefly in that the male has longer and narrower hind wings. Also, the forewings are prolonged in a broader and more produced "snake's head" projection.

It was exciting for me to work up this painting, knowing that it may provide many lepidopterists with their first look at this huge and handsome moth.

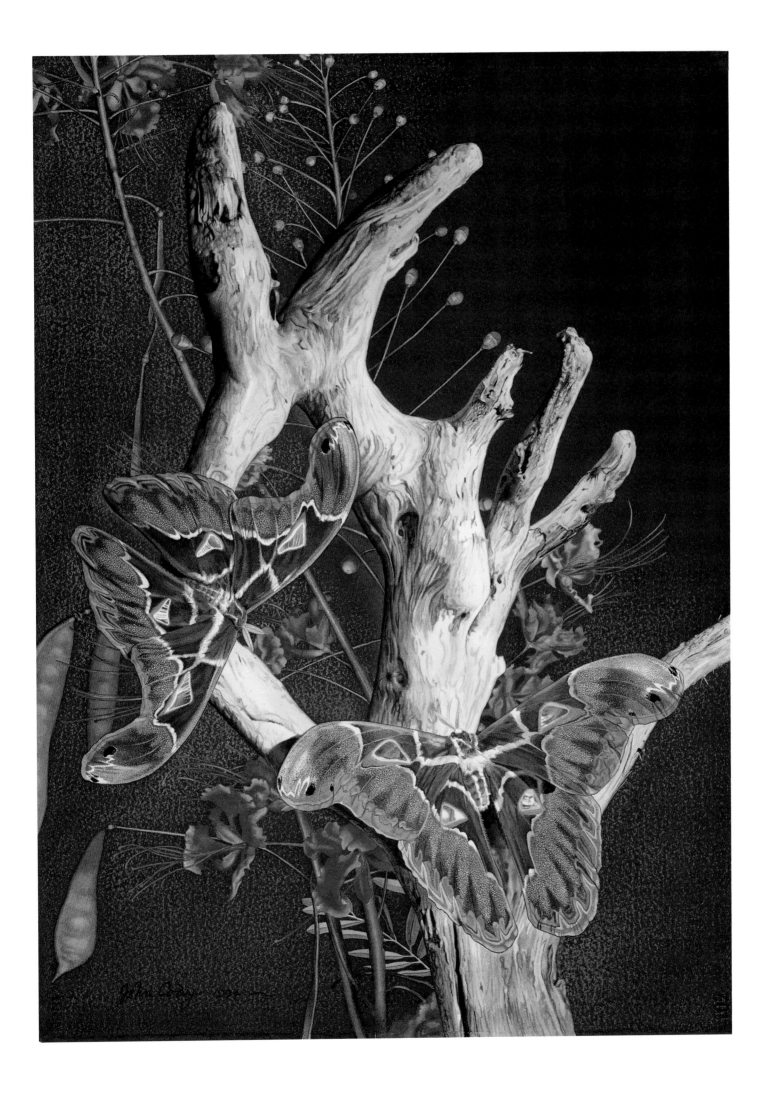

PLATE 68

Automeris orestes, 1994

Collection of Dr. Graham Cody

Size:
80 mm.
Range:
Central and
South America

This painting was made for a poster whose purpose was to imply the interconnectedness of all life. The juxtaposing of a water animal with an air and arboreal one makes the point in what I hoped would be a startling and arresting manner. The purity of the ultramarine background suggests the freedom from contamination desirable in both realms.

The quotation at the bottom of the poster came from a talk I gave a year or so ago to a class of eight-year-old grade-school children. They were all aware of the plight of the snow leopard and of certain other exotic animals that are threatened with extinction. It worried these children that they could do nothing to ease the situation of these animals they thought so "neat."

"Forget about the condor, the snow leopard, and the panda," I told them. "Find some little musquash, guib, or buzzing thingamajig that nobody else thinks about. You care about it. Adopt it. See that it gets what it needs—its space, its food, clean air and pure water. Succeed in that, and the condor, snow leopard, and panda will be okay too."

All forms of life need the same things. Making the earth a less toxic, less congested, and more natural place will benefit all living creatures, including ourselves.

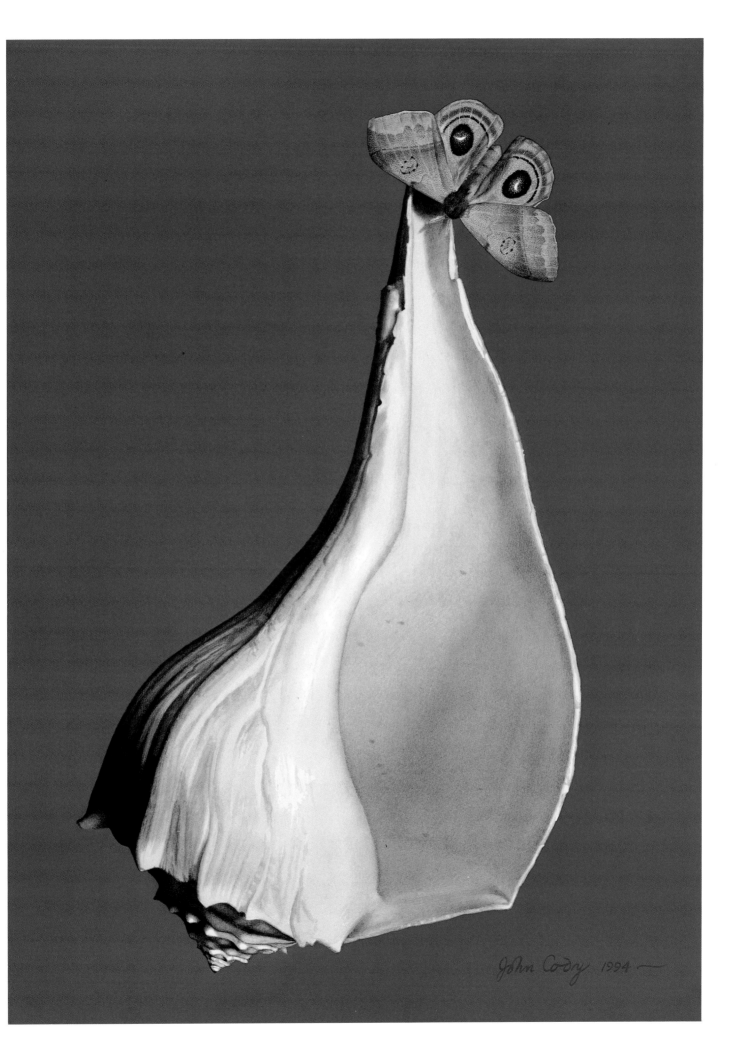

John Cody 1994

PLATE 69

Pale Sultana Moth, *Neoris naesiggi*, 1995

Collection of Mr. and Mrs. Joseph Russell

Size:
125 mm.
Range:
Montane areas of eastern Turkey

This recently discovered moth is endemic to Turkey, where it is found in the mountainous eastern areas. The moths emerge from their meshwork cocoons in October (the seasons in Turkey coinciding with those in the United States); they then mate and lay their eggs. The eggs overwinter and hatch in March. The caterpillars feed on a number of trees, among them almond, willow, and elm. A half-dozen caterpillars were given to me by Richard Peigler; they matured in Kansas on crabapple, on which they flourished.

As it happened, I was scheduled to spend a few weeks in Turkey that October and found myself in a peculiar fix. If I left the cocoons in my Kansas studio, I would miss their emergence and undoubtedly fail to secure a good model to paint, which was very important to me. If I took them with me to their native land in my pocket or suitcase, they would probably be confiscated at the Turkish customs as "foreign immigrants." And the likelihood of encountering one of them in Turkey was fairly slim: I was unsure exactly where to look for them, as they are not abundant or very widely distributed.

The dilemma was solved when the moths obliged me by emerging in late September before I departed, hastened perhaps by early "autumnal rains" in the form of my liberally sprinkling the cocoons with water, or, alternately, by the intensity of light in my studio, which may have mislead them into considering it later in the fall than it actually was. Emergence of moths from open-meshed cocoons is often triggered by light of a particular intensity and duration.

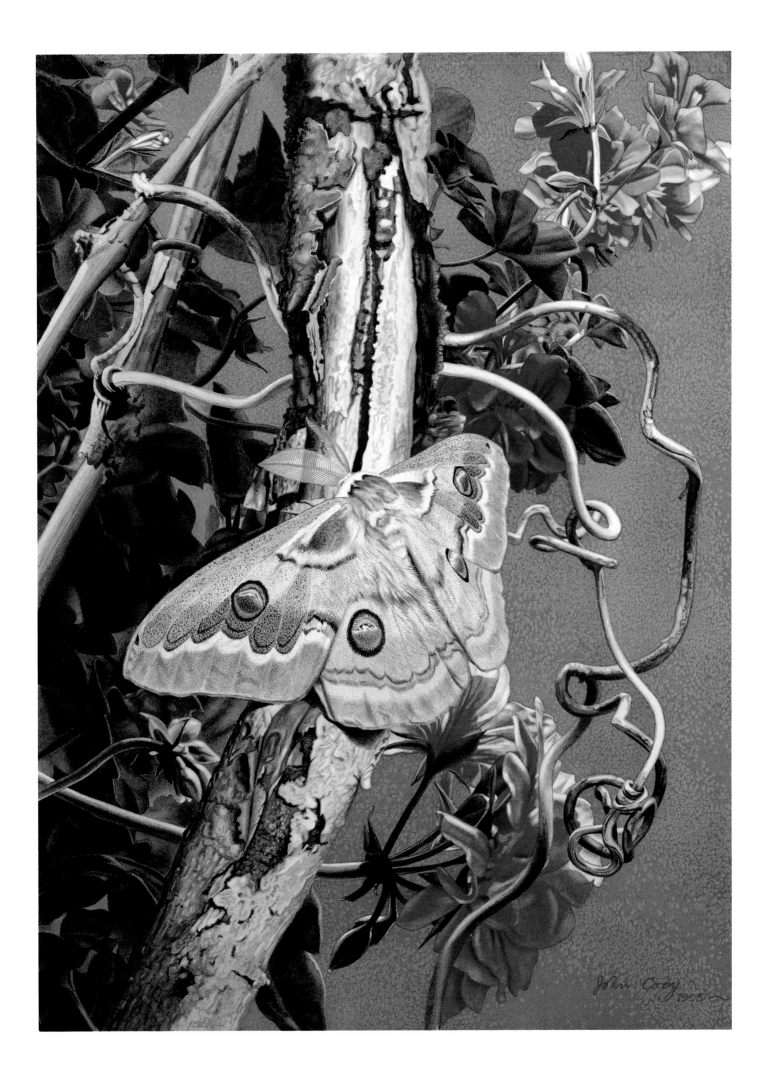

PLATE 70

MacPhail's Silkmoth, *Automeris macphaili*, 1995

Collection of Dr. Graham Cody

Size:
Male 100 mm.,
female 130 mm.
Range:
Southern Mexico and
Central America

The moth shown in this painting is a female. The male, equally beautiful, is smaller with forewings that are lighter, more homogeneous in value, and of an olive color, in place of the rich purples of his mate. The painting of the male was not finished in time to be included in this book. The female is shown on one of the *Heliconia* species from the rainforest, the moths' home. The other plant is a local bromeliad.

Gardiner lists over a hundred species in the genus *Automeris*, one of the largest in the family of Saturniidae. Many of these moths look much alike. They all show "the planet Saturn" emblazoned on their hind wings in striking colors, with two or more of the characteristic rings.

The larvae of all species have clusters of stiff, stinging spines—not dangerous to humans unless the sting is to one's eyes, but irritating for as long as an hour or so. MacPhail's moth feeds on a wide variety of leaves. This one was raised by Kirby Wolfe in Escondido, California, who generously shared his specimens with me.

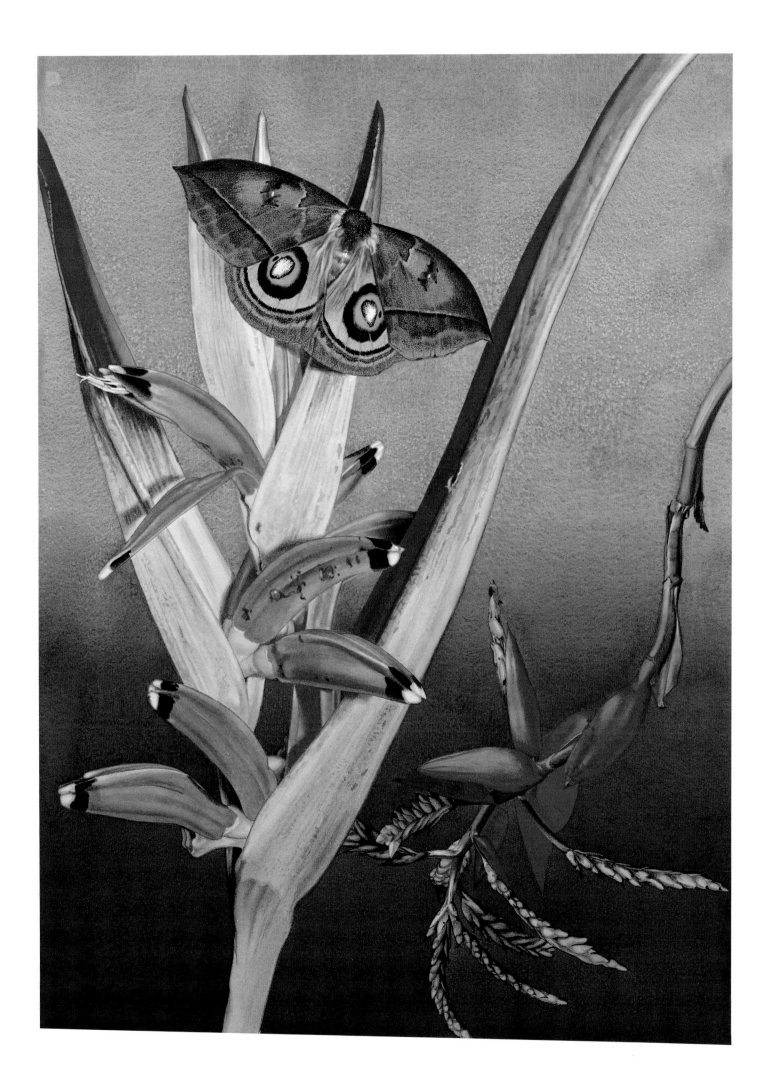

PLATE 71

Caio championi, 1995

Collection of Mr. and Mrs. Mark Shaiken

Size:

Up to 190 mm.

Range:

*Central America and
northern Andean region*

There appears to be almost nothing in the literature about this huge, impressive moth. It has been raised by Kirby Wolfe in California and by D. H. Janzen in Costa Rica. According to them, the larvae feed on the floss-silk tree and Tilia such as linden and basswood. The painting is of a female, as evidenced by the "tooth" on the outer border of the hind wing. In the male the tooth is replaced by a short, square tail. The specimen was given to me by Richard Hesterberg, director of "Wings of Wonder," the butterfly house at Cypress Gardens.

As I have nothing much more to say about the moth, I will talk a little about the watercolor technique itself.

Watercolor as a medium is considered both difficult and unforgiving. It is thought difficult because it seems to have a mind of its own. It does unexpected things. It flows where one might not have expected it to flow. It dries differently from the way it looks when wet and first applied. Different colors interact differently with the paper. Some are granular and settle out in a reticulated pattern; some are smooth as silk, without a trace of sediment. Some colors, after drying, can be lifted from the paper with a clean, wet brush; others stain the paper indelibly and cannot be lightened no matter how much one scrubs. Certain complementary colors, when mixed, produce brilliant darks; other produce mud. Though all colors are considered "transparent," some are much more so than others, and some even border on the opaque.

The medium is unforgiving in the sense that certain value relationships, once established, cannot be altered. For example, it is impossible to paint light details over a dark ground as one can in most other media. The reason is obvious. Because the colors are transparent, the initial dark color continues to show through the later, paler one, completely overwhelming it. Light areas that are to appear against darker ones have to be thought out in advance and spared any touch of dark pigment. Radical changes in color cannot be made midpainting. A red area, for example, cannot be replaced by a green one except when one is willing to settle for an extremely dull green. This is not the case in oils, acrylics, gouache, and most other color media, where a thoroughly opaque green will completely obliterate and replace an underlying red.

In this painting of *Caio championi,* the shapes that were to become the pale ultramarine red morning glories had to be "saved" so as to be painted on the virgin whiteness of the paper. If I had tried to paint them against the yellow-gray, quinacridone gold, and raw umber violet of the cloudy sky, the result would have been both muddy and darker than the sky itself, and all trace of the pale red would have been swamped in the stronger colors beneath it.

In my comments on the next plate, I will say something of the great advantages of this somewhat recalcitrant medium.

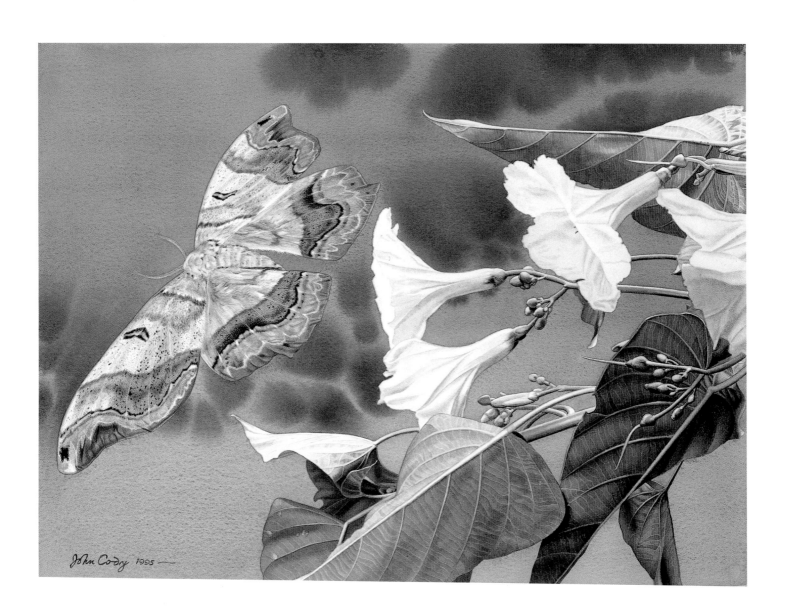

John Cody 1995

PLATE 72

Caio championi (two moths), 1995

Collection of Mr. and Mrs. Joseph Russell

Size:

Up to 190 mm.

Range:

Central America and northern Andean region

The previous painting did not show the subtly marked underside of this moth, so I immediately decided to do a second painting. I added a third moth in case the perspective in the first painting left some doubt as to the creature's actual shape. The plant, obviously a pepper of some kind, grows in the rainforest where the moth is found.

I have mentioned some of watercolor's disadvantages and its reputation for being trying and demanding. It also has unique virtues. For example, it is unsurpassed in its capacity for generating happy accidents. Practically all other media have to be pushed every inch of the way by the artist; little happens that he or she does not deliberately engineer. A brush stroke doesn't appear in a certain place unless the artist puts it there; a color doesn't appear and merge with another unless the artist situates it just so and causes it to merge. And then it merges only to the degree nudged by his or her hand.

Watercolor, by contrast, needs but little encouragement to go off on a tangent and do its own independent thing. This is a source of anxiety for the artist, but it can also bring him or her much excitement and creative joy by producing beautiful effects that could not be intentionally contrived. If one places washes of two different colors side by side and lets them run fluidly together, something unexpected will occur; and often it will be something interesting, and possibly something lovely. These accidental beauties can be encouraged to happen, but they can never be exactly predetermined. Spraying water on a damp glaze of color may produce elegant patterns, or it may not! Adding salt, sand, or alcohol to still-wet washes may cause all sorts of surprising and intricate things to take place. These unplanned happenings I have mostly reserved for backgrounds, allowing nature to prescribe the color effects of the actual moths and flowers.

Another way that watercolor is unique is in its transparency. Because the white of the paper shines through the color like daylight through stained glass, a brilliance can be developed that is unrivaled by most other media. Furthermore, the transparency allows integrating and color-modifying washes to be glazed over fine detail that has first been underpainted. This overglazing pulls together the discrete details that still glimmer through the transparent overlay. Now, however, instead of their appearing to be on the surface, they are submerged and take their place as integrated into the object's very texture. All this goes against good practice as taught in the art schools. Those teachers invariably advocate big washes in the beginning, little details at the end. Cody's rule is the reverse: detail first, integration afterward.

Furthermore, watercolors are tough. Oils darken. Acrylics mysteriously deteriorate. Frescoes crack. Pastels are vulnerable to smudging. But watercolors, painted with and on the best materials, last indefinitely. Naturally, the pigments must be the kind that do not fade, and the paper must be nonacidic. And of course they should be taken care of properly: watercolors, like all other paintings, require freedom from excessive dampness and light, from trauma, and from extremes of temperature. Given those few conditions, they are permanent as sculpture.

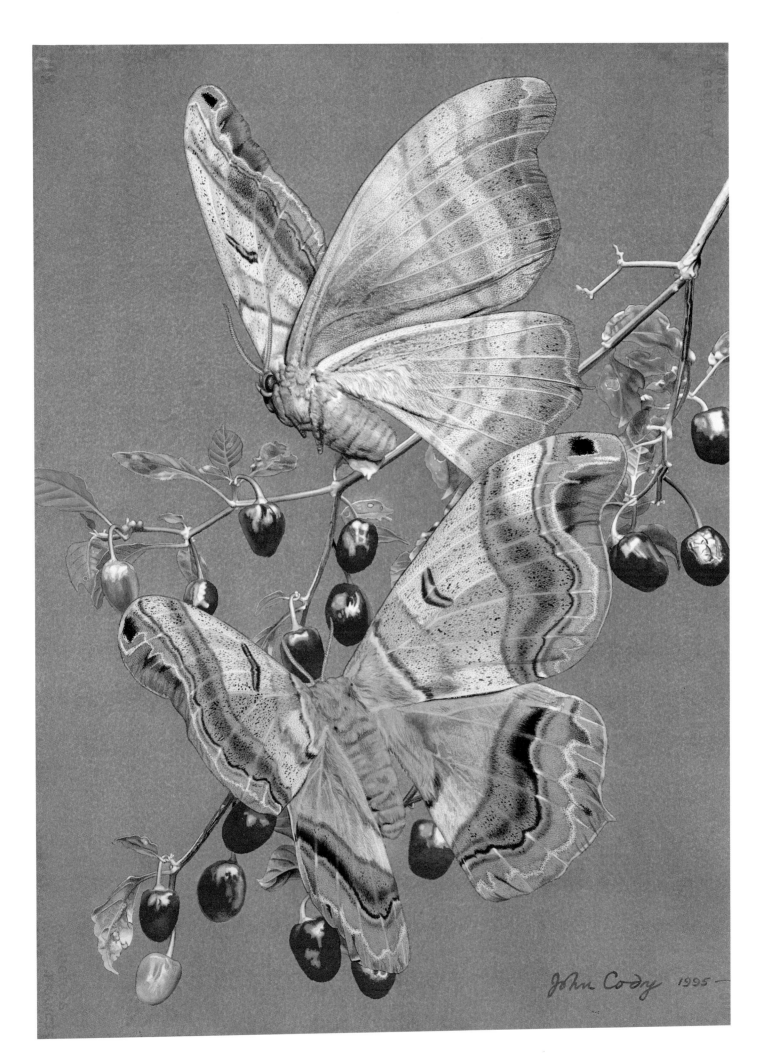

John Cody 1995

Selected Bibliography

Barlow, H. S. *An Introduction to the Moths of South East Asia*. Kuala Lumpur: Malaysian Nature Society and E. W. Classey Ltd., 1982.

Baxter, R. N. *Rearing Wild Silkmoths*. Ilford, Essex, Eng.: Chudleigh Publishing, 1992.

Brewer, J., and K. B. Sandved. *Butterflies*. New York: Harry N. Abrams, 1976.

Collins, M., and R. D. Weast. *Wild Silk Moths of the United States: Saturniinae*. Cedar Rapids, Iowa: Collins Radio Company, 1961.

Covell, C. S. *A Field Guide to the Moths of Eastern North America*. Boston: Houghton Mifflin, 1984.

Eliot, I. M., and C. G. Soule. *Caterpillars and Their Moths*. New York: The Century Company, 1902.

Ferguson, D. C. *The Moths of America North of Mexico*. London: E. W. Classey Ltd. and R. B. D. Publications, 1971.

Gardiner, B. O. C. *A Silkmoth Rearer's Handbook*. Hanworth, Middlesex, Eng.: Amateur Entomologists' Society, 1969.

Goodden, R. *The Wonderful World of Butterflies and Moths*. London: Hamlyn Publishing Group, 1977.

Holland, W. J. *The Moth Book*. Garden City, N.Y.: Doubleday, Doran, 1937.

Holloway, J. D. *The Moths of Borneo*. Kuala Lumpur: Southdene Sdn. Bhd., Malaysian Nature Society, 1987.

Lemaire, C. "Les Attacidae américains . . . The Attacidae of America (=Saturniidae)," Attacinae. Neuilly, France: 1978.

———. "Les Attacidae américains . . . The Attacidae of America," Arsenurinae. Neuilly, France: 1980.

———. "Les Saturniidae américains . . . The Saturniidae of America . . . Los Saturniidae americanos (=Attacidae)," Ceratocampinae. San José: Museo Nacional de Costa Rica, 1988.

Michener, C. D. "The Saturniidae of the Western Hemisphere." *Bulletin of the American Museum of Natural History* 98 (1952): 335–502.

Moucha, J. *Beautiful Moths*. London: Spring Books, Drury House, Artia, 1966.

Peigler, R. *Attacus: A Revision of the Indo-Australian Genus*. Beverly Hills, Calif.: The Lepidoptera Research Foundation, 1989.

Pinhey, E. *The Emperor Moths of Eastern Africa*. Capetown: C. Struik (Pty.) Ltd., 1972.

Pinratana, Bro. A. *Moths of Thailand*. Vol. 1: *Saturniidae*. Yannawa, Bangkok: Bosco Offset 599/182 Soi Yoo Dee, 1990.

Robertson-Miller, E. *Butterfly and Moth Book*. New York: Scribner's, 1912.

Rougeot, P. C., and P. Viette. *Guide des papillons nocturnes d'Europe et d'Afrique du nord*. Paris: Delachaux; Neuchâtel, Switz.: Niestlé, 1978.

Seitz, A., and M. Gaede. *The Macrolepidoptera of the World*, vol. 14. Stuttgart: F. Lehmann, 1927.

Stanek, Dr. V. J. *The Pictorial Encyclopedia of Insects*. London: Hamlyn Publishing Group, 1969.

Stanek, Dr. V. J., and B. Turner, eds. *The Illustrated Encyclopedia of Butterflies and Moths*. Secaucus, N.J.: Chartwell Books, 1977.

Stone, S. E. "Foodplants of World Saturniidae." Denver, Colo.: The Lepidopterists' Society, Memoir No. 4. 1991.

Stratton-Porter, G. *Moths of the Limberlost*. Garden City, N.Y.: Hodder and Stoughton, undated.

Villiard, P. *Moths and How to Rear Them*. New York: Dover, 1975.

Watson, A., and E. S. Whalley. *The Dictionary of Butterflies and Moths in Color*. New York: McGraw-Hill, 1975.

Whalley, P. *Butterfly and Moth*. New York: Knopf, Eyewitness Books, 1988.

Wolfe, K. L. *The Copaxa of Mexico*. Vol. 4, suppl. 1: "Tropical Lepidoptera." Gainesville, Fla., May 1993.

Index